WITHDRAWN
UTSA LIBRARIES

exploring

3D MODELING
WITH 3DS MAX 7

Steven Till

James O'Connell

D1025788

THOMSON

DELMAR LEARNING

Australia Canada Mexico Singapore Spain United Kingdom United States

Exploring 3D Modeling 3ds max 7

Steven Till and James O'Connell

Vice President, Technology and Trades, BSU
Alar Elken

Editorial Director
Sandy Clark

Senior Acquisitions Editor
James Gish

Development Editor
Jaimie Wetzel

Marketing Director
Dave Garza

Channel Manager
William Lawrensen

Marketing Coordinator
Mark Pierro

Production Director
Mary Ellen Black

Production Manager
Larry Main

Production Editor
Tom Stover

Technology Project Manager
Kevin Smith

Editorial Assistant:
Niamh Matthews

Cover Design
Steven Brower

Cover Image
Time & Tide
Oil on canvas
© David Arsenault

COPYRIGHT © 2005 by Delmar Learning, a division of Thomson Learning, Inc. Thomson Learning™ is a trademark used herein under license.

Printed in the USA
1 2 3 4 5 XX 08 07 06 05

For more information contact
Delmar Learning
Executive Woods
5 Maxwell Drive, PO Box 8007,
Clifton Park, NY 12065-8007
Or find us on the World Wide Web at
http://www.delmarlearning.com

ALL RIGHTS RESERVED. No part of this work covered by the copyright hereon may be reproduced in any form or by any means—graphic, electronic, or mechanical, including photocopying, recording, taping, Web distribution, or information storage and retrieval systems—without the written permission of the publisher.

For permission to use material from this text or product, contact us by
Tel (800) 730-2214
Fax (800) 730-2215
www.thomsonrights.com

Library of Congress Cataloging-in-Publication Data
Till, Steven.
 Exploring 3D modeling with 3ds Max 7 / Steven Till, James O'Connell.
 p. cm.
 Includes index.
 ISBN 1-4018-7109-7
 1. Computer animation. 2. 3ds max (Computer file) 3. Computer graphics. I. O'Connell, James (James Richard) II. Title.
TR897.7.T595 2005
006.6'93—dc22

 2005005759

NOTICE TO THE READER

Publisher does not warrant or guarantee any of the products described herein or perform any independent analysis in connection with any of the product information contained herein. Publisher does not assume, and expressly disclaims, any obligation to obtain and include information other than that provided to it by the manufacturer.

The reader is expressly warned to consider and adopt all safety precautions that might be indicated by the activities herein and to avoid all potential hazards. By following the instructions contained herein, the reader willingly assumes all risks in connection with such instructions.

The publisher makes no representation or warranties of any kind, including but not limited to, the warranties of fitness for particular purpose or merchantability, nor are any such representations implied with respect to the material set forth herein, and the publisher takes no responsibility with respect to such material. The publisher shall not be liable for any special, consequential, or exemplary damages resulting, in whole or part, from the reader's use of, or reliance upon, this material.

Library
University of Texas
at San Antonio

This book is dedicated to my parents Ron and Cheryl, and to my beautiful wife Wendy. You have always believed in my potential and have never let me doubt myself. Your unwavering love and support have truly been a comfort to me in all of my endeavors. I love you all.

—Steve

I would like to dedicate this book to my wife Courtney and daughter Carly who mean everything to me, my sister Lori who I have always looked up to, and to my parents Jim and Sherri for being there to support me in everything that I do.

—Jim

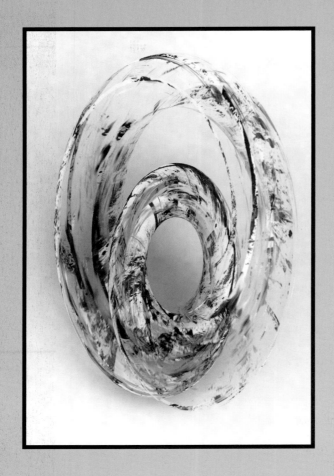

contents

CONTENTS

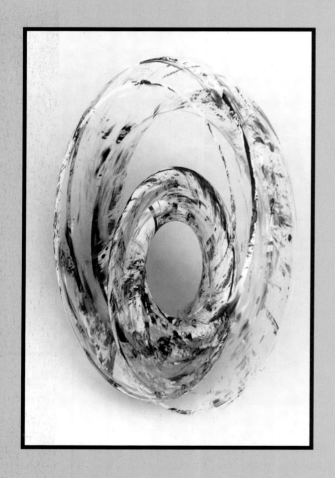

| preface |

preface

AUDIENCE

If you have an interest in computer animation or are a graphic designer curious about 3D design and want to learn more, this is the book for you. This text is geared toward those who have no prior experience with 3D modeling and animation tools. It is unfortunate that many of the texts and manuals out there for 3D software programs tend to be written with terminology and techniques that can sometimes confuse, perplex, and intimidate the reader. Because of this, many newbies get discouraged and give up without giving the learning process a chance. This book presents the information in a clear and concise manner, using plain English instead of the techno-speak that permeates many of the books published these days. We decided to put this book together for those of you who want to dig into the core fundamentals of 3D modeling with 3ds (3D Studio) max 7 to gain the foundation knowledge necessary to continue on to bigger and better things.

EMERGING TRENDS

With the seemingly unsure and unstable nature of our economy these days, more and more companies are foregoing the "in-house artist" and opting for freelancers to fulfill their design needs. Because of this, many artists and graphic designers are being forced to work in more and more capacities. One project might require them to be a graphic designer, whereas another project might make them a web or multimedia developer. To compete with the ever-growing population of artists who are vying for those same jobs, designers are constantly trying to acquire new skills they can market to potential clients. 3D artwork is becoming more and more

prevalent in a variety of industries, which gives freelancers a tremendous opportunity to break into this emerging field. With a little bit of practice and patience, artists who are willing to learn how to use a 3D software application can open up doors to employment involving 3D visualization, 3D illustration, forensic simulation and recreation, as well as tasks related to film, broadcast, and video games.

BACKGROUND OF THIS TEXT

As educators, we know how daunting it can be to learn such an in-depth program as 3ds max 7, and after sifting through countless books and resources we realized that there are very few books out there that cater to the novice. Unfortunately, the nature of 3D design requires learning a lot of terminology, tools, techniques, and concepts that can at times be intimidating. We wrote this text to distill the techno-lingo to simple concepts that allow you to digest and process the information a lot more easily.

Schools and other educational institutions that provide training in 3D production software have been sending a steady stream of 3D artists into an industry that until fairly recently has been rather stagnant. The good news is that the sector of the job market that offers opportunities that require 3D skills has been growing, and the trend now seems to be heading toward a new boom in 3D-related jobs. This is a very competitive field, and an artist needs to have a solid understanding of the core fundamentals of this unique art form in order to compete. This book responds to these trends by presenting core concepts clearly and simply, and by incorporating real-world industry scenarios that expose you to potential situations that might be encountered on the job.

As we tell our students, this text will provide you with the basic building blocks of the knowledge you need to get started. We strongly encourage you to continue your education by subscribing

to industry publications, visiting online message boards and 3D-related web sites, purchasing more advanced books on the subject, and doing as many tutorials as you can get your hands on. If you are seriously considering becoming a creative force within this industry, you might even want to continue your education at an institution that will allow you to specialize in this area. The more you practice the better off you will be. The book includes a list of resources that provides you with information on continuing your 3D adventure.

When we began to develop this text, we wanted to ensure that the material was presented in the best way possible. To achieve that goal, we surveyed our students extensively. They were able to give us valuable insight into their varied learning styles, as well as into the areas they really wanted to focus on. All exercises and projects found in this book have been tested within a real classroom environment, making this a great text for introductory courses or for individuals who wish to learn on their own. In addition to picking our students' brains, we also turned to the vast amount of information online, to industry professionals, and to literature in the industry such as *3D World* magazine.

We also had some basic assumptions in mind in regard to the knowledge base readers should have when going through this information. Because this book really targets graphic design professionals and design students, we are assuming you have at least a basic understanding of computer functionality such as opening, saving, and managing files. It is also recommended that you have some familiarity with some sort of image-editing application, such as Photoshop or Paint Shop Pro, as well as with page layout software such as Adobe InDesign or QuarkXpress. Even though the bulk of the exercises deal directly with 3ds max, some projects will require you to utilize some of the aforementioned software to create textures and materials, as well as final layouts for projects. If you do not have any prior design background, do not worry; we have included all of the files needed to complete all of the projects. The files are located on the companion CD-ROM at the back of the book.

ORGANIZATION

Chapter 1: A Brave New World

This chapter provides an introduction to various 3D industries, including an overview of current 3D software being used by professionals. You are also be provided with some background in 3D coordinate systems and an introduction to the 3ds max 7 interface and tools. This chapter is meant to ease you into 3D illustration and to provide fundamental information that will help get you into the mind-set of 3D design.

Chapter 2: Sculpting a 3D Form

This is an introduction to 3D primitives and polygonal mesh modeling. Sub-object manipulation and object modifiers are discussed and demonstrated. Polygonal modeling (often referred to as "box modeling"), which is one of the most common modeling techniques, is demonstrated in depth. Exercises dealing with this technique demonstrate how to produce more complex objects from simple primitive forms such as spheres, boxes, cones, and cylinders.

Chapter 3: Spline Modeling

This chapter introduces 2D spline objects. Exercises work through creating custom shapes with splines, as well as generating 3D forms using splines as a basis for these objects. Lofting and lathing modeling techniques are also introduced.

Chapter 4: Patch Modeling

In this chapter the basics of patch modeling are explored, as well as patch types and their functions. The subdivision and attachment of multiple patches are also discussed. Exercises introduce this alternative modeling method in an easily understood manner.

Chapter 5: Painting Surfaces on Your Sculptures

Chapter 5 introduces materials and textures in a 3D environment. Relationships between object color and lighting are discussed. You will learn how to access 3ds max's pre-made materials in addition to producing custom materials using Adobe Photoshop. Not only will material creation be explored but the process of aligning those materials onto 3D objects known as coordinate maps. You will engage with photorealistic texturing techniques and multi-object and sub-object mapping.

Chapter 6: Lights, Cameras, Render!

Virtual lighting is introduced in this chapter. Some fundamental lighting basics are discussed, as well as how those techniques can be applied in 3D software. Once you have had an opportunity to play with some of the standard lighting setups, you can explore intermediate and advanced lighting techniques such as Global Illumination and photometric lighting. Virtual camera rigging is then demonstrated, as well as various rendering output methods.

Chapter 7: Populate Your Portfolio!

This is where the real fun begins. You now have the opportunity to work on large-scale industry projects that mimic scenarios encountered in the industry. A variety of project types are explored, including print illustration and layout, product visualization, and architectural rendering.

FEATURES

The following are the salient features of the text:

● Learning goals are clearly stated at the beginning of each chapter.

● The text is written to meet the needs of design students and professionals for a visually oriented introduction to the basic principles, functions, and tools involved in working with 3ds max.

● Client projects involve tools and techniques a designer might encounter on the job in completing a project.

● A full-color section provides stunning examples of design results that can be achieved using 3ds max.

● A "Summary" section at the end of each chapter reviews the overall content and key points of the chapter.

● An "In Review" section at the end of each chapter tests your understanding and retention of the material covered.

● An "Exploring on Your Own" section at the end of each chapter offers suggestions for further study of content covered in the chapter.

● The companion CD-ROM at the back of the book contains exercise files for use with the book. In addition to the exercise and other chapter-related files, high-resolution image libraries have been included for your use in developing custom materials and textures. (See also the following section.)

COMPANION CD-ROM

The companion CD-ROM is where you will find some great resources that will help you as you work through the book. Here you will find companion files for the exercises found in each chapter, including project files for the larger-scale projects found in Chapter 7. We wouldn't give you a disc without some additional goodies, so we have included some great textures you can use to build some fantastic materials for your new creations.

E-RESOURCE

The CD instructor's guide developed in conjunction with this book is intended to assist instructors in planning and implementing their instructional programs. It includes sample syllabi for using this book in either an 11- or 15-week semester. It also provides chapter review questions and answers, exercises, PowerPoint slides highlighting the main topics, and additional instructor resources, including Camtasia video tutorials tht demonstrate each of the exercises found in the first six chapters. The International Standard Book Number for ordering this resource is:

ISBN: 1-4018-7112-7

HOW TO USE THIS TEXT

The following features can be found throughout the book:

✦ Charting Your Course and Goals

Each chapter begins with the sections *Charting Your Course* (a brief summary of the intent of the chapters) and Goals (a list of learning points). These section describe the competencies the reader should achieve upon working through and understanding the chapter.

✦ Don't Go There

Material with the heading *Don't Go There* appears throughout the text, highlighting common pitfalls and explaining ways to avoid them.

! DON'T GO THERE

In the prior process, you will note that I had you create two swatches of the same color with varying alphas. This was purposeful. If you blend two different colors with two different alphas some pretty strange things can happen. Typically you end up with some haloing effects—where there are hints of one or the other color in the transparency. To avoid haloing, anytime you are creating a gradient that gradates Alpha, use the exact same RGB values in the two chips.

✦ Sidebar Tips

Boxed sections present tips with useful insider information. These will give the reader a leg up in working with 3ds max 7.

▷ Material Libraries

Material libraries can be a tremendously powerful way of organizing your textures. As you progress and utilize 3ds max in your projects, you will most likely notice that you gradually accumulate a large number of textures. A helpful tip that can save time and keep you from hours of searching for that great material you once created is to categorize your materials into material types. You can place all of your woods, fabrics, metals, and other like surfaces together in their own libraries. This makes it infinitely easier to find what you need.

In Review and Exploring On Your Own

In Review and Exploring On Your Own are sections found at the end of each chapter. These allow the reader to assess his or her understanding of the chapter. The section Exploring On Your Own contains exercises that reinforce chapter material through practical application.

Adventures in Design

These spreads contain client assignments showing readers how to approach a design project using the tools and design concepts taught in the book.

Color Insert

The color insert presents work that can be achieved when working with 3ds max 7.

ABOUT THE AUTHORS

Steven Till studied Film Scoring and Composition at Berklee College of Music in Boston before undertaking Animation and Multimedia Design at The Art Institute of Pittsburgh. After attaining his Associate's degree in Animation, Steve acquired his BFA in Visual Communications from American Intercontinental University. While working as a multimedia animator at *Sightsound.com*, he helped create the groundbreaking made-for-Internet Hollywood film *Quantum Project* and the highly interactive 3D planetarium show *Gray Matters: The Brain Project* for the National Science Foundation and Carnegie–Mellon University. Steve has designed corporate identity and multimedia application packages for companies worldwide. He currently teaches Multimedia Design and 3D Animation at the International Academy of Design and Technology in Pittsburgh, and is a freelance animator and designer.

James O'Connell also studied Animation and Multimedia Design at The Art Institute of Pittsburgh and has worked in the industry as a multimedia developer, computer animator, and web developer, creating animations for interactive training CDs, web pages, and promotional materials. Jim recently taught at The International Academy of Design and Technology in Pittsburgh, where he specialized in multimedia design, 3D animation, and other visual communications courses. Jim has since left the world of academia and has joined the industry, where he is producing animation and interactive content for a variety of applications.

ACKNOWLEDGMENTS

We would like to take this opportunity to express our thanks to a few individuals without whom this book would not have been possible. Many thanks go to our friends and colleagues at IADT–Pittsburgh for all of their support and for putting up with us throughout this project. Gratitude must also go to all of our dedicated students, for inspiring us to share our knowledge with others. To Wendy Di Leonardo for planting the writing bug in us; thank you so very much!

A huge hooray goes to our wonderful staff at Thomson Delmar Learning for their unwavering support and understanding throughout production of this project. Among the many people who made this experience possible are senior acquisitions editor

Jim Gish, production editor Tom Stover, production manager Larry Main, marketing coordinator Mark Pierro, and developmental editor Jaimie Wetzel. They helped us through every step of this process. We can't thank all of them enough!

Last, but certainly not least, we would like to extend our overwhelming gratitude to all of the students and professionals who have graciously contributed their amazing artwork for this book.

Thomson Delmar Learning and the authors would also like to thank the following reviewers for their valuable suggestions and expertise:

H. Alexander Buffalo, Academic Director
Media Arts Department
Art Institute of Washington
Arlington, Virginia

Alexi Balian, Curriculum Leader/Director, 3D Animation Studies
Communication Technology
Rick Hansen Secondary School of Technology
British Columbia, Canada

A special thank you to Jon McFarland for ensuring the technical accuracy of this text.

Steve Till and Jim O'Connell
2004

QUESTIONS AND FEEDBACK

Thomson Delmar Learning and the authors welcome your questions and feedback. If you have suggestions you think others would benefit from, please let us know and we will try to include them in the next edition. To send us your questions and/or feedback, you can contact the publisher at:

Thomson Delmar Learning
Executive Woods
5 Maxwell Drive
Clifton Park, NY 12065
Attn: Graphic Communications Team
800-998-7498

Or the authors at: Steve Till: *still.when@verizon.net*
Jim O'Connell: *jimmyoc22@aol.com*

EXPLORE

| a brave new world |

1

 charting your course

Well, here we are. Your journey through the interesting world of 3D graphics has begun! You have your reasons for wanting to learn more about this fascinating aspect of art. Some of you might want to pursue a career in video game design or as an animator for motion picture studios. Before that can happen, however, you really need a solid foundation in the basics in order to be an effective 3D artist. We have seen many students go through our classes, and each student has had a different perception of what 3D design is and what it can do. Most of them say they want to make video games, whereas others say they want to work on the next 3D animated film. We always encourage everyone to dream big and work hard to make those dreams a reality. What most beginners don't understand, however, is that 3D design is more than just "really cool stuff" and that before any of those wonderful dreams can come true they need to learn the foundations and the terminology behind the art form.

Another common misconception people have is that the computer does all of the work for you. This couldn't be further from the truth. The computer is simply another tool for you, the artist, to use (just like a pencil, marker, paintbrush, or pastel), although it costs a heck of a lot more. If you are a designer in the industry, you are already well aware of this fact. The software used to produce 3D imagery could be considered the "virtual canvas" on which you can bring your imagination to bear. In these pages, you will be exposed to the fundamental concepts of 3D sculpting. Although the subject of 3D computer-generated graphics can be an intimidating one, keep in mind that like any discipline hard work, patience, and a lot of practice can make a 3D artist out of anyone. This book will try to explain the basic ins and outs of 3D modeling and animation and provide you with marketable skills you can use in your own design projects.

goals

- **Explore industries in which 3D is used**
- **Preview other 3D software packages**
- **Explore coordinate systems and why they are important**
- **3ds max 7 and the 3ds interface**

DEER IN HEADLIGHTS?

figure | 1-1 |

Illustration by Mike Martin.

As you sit at your computer staring blankly at the screen like a deer in headlights, the thought that might be running through your head right now is "Ok, so I bought this book, but I don't have the slightest idea what I'm doing trying to learn this stuff!" You may also notice some queasy, nauseous feelings welling up in the pit of your stomach. Perhaps beads of sweat are beginning to form on your forehead? Well, if this describes you right now then take comfort in the fact that you are not alone. Many individuals who begin the long journey of becoming a 3D designer have felt the same way, including the authors. You may become frustrated early on, and might even be tempted to throw your computer right out the window, but we assure you that destroying your machine is not the answer. Anyone can learn 3D modeling and animation as long as they keep a level head, take a lot of deep breaths along the way, and above all practice, practice, practice! As you read and work through

this book, you will notice that we attempt to translate all of the 3D "lingo" into terms you as a graphic designer might better relate to.

I SPY 3D... EVERYWHERE

As you go about your average day, stop and look around you. What do you see? Are you able to spot instances in which 3D design has been used? Have you been to the movies recently? What about a hospital? Have you sat down in front of your television recently? You might be surprised by some of the industries that utilize 3D imaging and animation technologies. In fact, many of these industries have made huge advancements because of 3D imagery. Perhaps some of these might look familiar.

Motion Pictures

If you have gone to catch the latest flick at your local theater, you might have seen some dazzling special effects. Many films now rely on computer-generated imagery (known as CG or CGI) to create breathtaking effects such as explosions, lasers, and environmental phenomena such as tornadoes, massive earthquakes, or a giant tidal wave. CG can also be used to create digital landscapes and cities that don't exist in reality, or to generate complete digital characters that interact with real actors. The technologies behind many of these effects are so good we "suspend our disbelief" and do not care that they are computer generated. For instance, the film *The Day After Tomorrow* (starring Dennis Quaid) depicted a scenario of what might happen if global warming were to trigger a new ice age in the northern hemisphere. Scenes in the film illustrated violent tornadoes ripping up Los Angeles and massive flooding in New York City. Obviously, it would be impossible for a film crew to simulate such an event without the use of miniature models, which would make it difficult to capture the full intensity and accuracy of the effect. The chance that the audience could tell that it was man-made would be greatly increased with the use of models and it would take away from the overall realism of the film. Creating the same atmospheric effects using CG, the 3D artists were able to add tremendous realism to the film by mixing the computer elements with actual film footage of the locations (known as compositing).

In addition to films incorporating digital elements in a movie, some movies are being created entirely using 3D software.

Probably the most recognized studio involved in innovative 3D animated films is Pixar. *Toy Story*, Pixar's first fully 3D animated film, launched moviegoers into a new world in which cartoons no longer had to be flat and, well, cartoon-like. It set the standard for similar projects to follow, including *Toy Story 2, Monster's Inc., Finding Nemo*, and most recently *The Incredibles*. These films not only keep the feel of a traditional cartoon but add a sense of realism to the work.

Some people take the position that CG characters (or "virtual actors") will eventually take the place of live action actors that live in the real world. Personally, we don't see this happening. There is no substitute for the real thing. *Scarface* just wouldn't be the same if Al Pacino had a CG character playing him. There is, however, a use for these digital actors. They make great stunt people. No, I'm not saying that stunt people are going to be out of work, but used with stunt men and women. George Lucas utilized digital stunt doubles when filming Star Wars *Episode II: Attack of the Clones*. There is a dramatic scene in which Obi-Wan (Ewan McGregor) is battling the bounty hunter Jango Fett and he is pulled across a landing platform in a very severe downpour. For this particular stunt, Lucas felt that it was too dangerous even for the stunt double. Lucas had the 3D artists at Industrial Light & Magic produce a virtual stunt double that looked like Ewan McGregor exactly. This was a much safer and cheaper alternative to using live performers.

Broadcast and Video

There are many aspects of broadcasting that incorporate 3D animation, making it nearly impossible to name them all. Examples of where you might have seen 3D on the television include commercials, those little animations you often see between news segments (often referred to as "bumpers"). We are even starting to see 3D animated television shows. *Jimmy Neutron: Boy Genius*, MTV's *Spiderman*, and Comedy Central's *South Park* are produced with 3D animation software.

Video Games

Being children of the eighties we grew up with the likes of Pong, Pac Man, Q*bert, and Pitfall. Well, anyone who doesn't live in a box can tell you that video games have come a long way from the good

old days of 2-bit and 8-bit graphics. Today, a gamer can expect to see eye-popping graphics in dynamic and interactive environments while attaining incredible game play action. This is probably the most recognized industry that utilizes 3D graphics.

Product Visualization

3D rendering has also made its way into manufacturing. Whether you're producing machine parts, walkmans, or even automotive concepts, this can be an invaluable tool companies can use to see what a potential new product line will look like before they spend the money on an actual prototype. This is also a great way to pitch new ideas to corporate bigwigs, and if done well can dazzle potential investors and backers of a project. Jewelry makers are even jumping on the 3D bandwagon by designing jewelry in the computer way before the melted gold is poured into a mold.

Multimedia

Multimedia design is another area in which 3D graphics can have a huge impact. One of the places you may see 3D graphics applied to this category is in interface design. Designers are utilizing 3D software in order to create some really cool interfaces for DVD movies, interactive training, and web pages. Let's say you are creating a multimedia program for an art museum intended to show the user various artifacts and exhibits on display at the museum. You could easily design a simple boring point-and-click style interface that displayed a still image, but with the power of 3D software you could design a virtual tour of the facility. This would be a major attention grabber and a much better approach if your budget allowed for it.

Architectural Design and Engineering

In the architectural design field, 3D models are created to help clients get a feel for what they are spending their money on. After drawings and concept sketches are created, 3D models are often built that show the client a much more realistic view of the new house, store, or building they are purchasing. Traditionally, scale models were built out of balsa wood, which were then laboriously dragged to meetings with potential investors. These traditional

models were much more time consuming and expensive, but with the use of 3D software architectural renderings and virtual reality walkthroughs can be e-mailed to any worldwide location at the click of a mouse.

3D also plays an important role in engineering. An example of this would be the creation of a thrill ride such as a roller coaster for a theme park. From blueprints of concepts, a 3D animator can design a simulation of the ride so that the designers can view the ride before construction begins to see if they wish to make any changes. This can be the difference between spending millions of dollars and not fully being satisfied with what you created.

TOOLS OF THE TRADE

Now that you have an understanding of the power of 3D modeling and animation, you are ready to learn more about the software used to create it. This section explores a few of the most popular animation tools and some of their features. Don't get nervous; we will not bore you too long, because we know that you want to start building projects as soon as possible. Like any endeavor, you need to have some basic knowledge before we unleash your creativity.

Maya is a high-end 3D animation package made by Alias that is used by many popular animation studios such as Pixar and Twentieth Century Fox. You have probably seen Maya used in films such as *Ice Age* and *Final Fantasy*. Although this is a tremendously powerful tool, it has a fairly high learning curve and is rather pricey for the average user. A less expensive alternative, Poser (made by Curious Labs), is an excellent 3D tool for producing figure design and animation. More and more designers are utilizing Poser for fine arts applications such as human and animal anatomy. Poser also includes animation tools that allow artists to see these figures with realistic motion. Carrara Studio is a low-cost animation and modeling package that is excellent for visualizations and organic models. This product is ideal for both professionals and hobbyists and can be a less expensive alternative to other high-end software applications.

The software we will be referring to throughout this book is called 3ds max 7, which is produced by Discreet. This design package is labeled by many as one of the most popular high-end 3D applications in the industry. It is also our specialty and personal favorite,

which is another reason we chose to use it for this book. We like 3ds max 7 because like all of the previous versions of max it is very straightforward, has an interface that is easy to navigate and find items in, and is simply a lot of fun to use.

GETTING COMFORTABLE IN THE 3D REALM

Working in 3D space can seem very difficult at first, but much like when you picked up your first pencil to draw or started to read you have to keep practicing in order to achieve your goals. Before we introduce you to the interface, we would like to give you some background information on the basics of working in a 3D environment. Don't worry, you can handle this. Besides, you already learned a few skills back in elementary school and high school that will play an important role in your career as a 3D designer. You are probably asking yourself, "What could that possibly be?" The suspense may be driving you nuts, and your old math teacher was right when he or she told you that someday you will use geometry in your everyday life. You must be thinking back to your days in math class, racking your brain trying to remember something about geometry; but don't worry, we are going to give you a quick crash course to get you started.

The key to understanding and manipulating 3D objects and shapes is learning how to work with a coordinate system, and modeling with geometric shapes. Whether you know it or not, you are already an expert at using coordinate systems. Almost every child has had their moment of glory working with a coordinate system, and many dreams of being a naval commander have been crushed with the words, "You sank my battleship!" Go ahead and smile a bit; the more fun you have the less stressful this will actually seem to you. We promise we are going to try to make learning 3D fun and painless for you. Okay, it's time to get back to work and learn more about coordinate systems.

Way back in 1637 the famous French mathematician and philosopher René Descartes developed a method for plotting points in 3D space. This has come to be known as the Cartesian coordinate system. A coordinate is simply a location in either 2D or 3D space that is represented by a point. Without this invention, plotting coordinates for 3D modeling, navigation, and even our beloved *Battleship* would not have been possible. Previously you may have only been exposed to a 2D coordinate system when working with geometry

in math class or in Photoshop, Illustrator, or other graphic design software. If you have ever used a graphing calculator in math class you are probably familiar with what we are talking about. Operating the coordinate system is also similar to using a ruler for measuring units in graphic design. You are simply plotting a series of points on a plane in order to create shapes and objects.

If you take a look at Figure 1-2, you will see a series of points plotted on a 2D plane. This plane represents two axes used to find these locations. An axis is simply an infinite direction along that plane. In 2D space, the axes are labeled X and Y. Note that the X axis runs horizontally and the Y axis runs vertically. The point at which these two lines intersect is called the point of origin (or just origin), and the coordinates for the origin are (0,0). Another thing you may notice is that there is a negative X and a positive X. Numbers running along the right-hand side of the origin on the X axis are positive numbers, and numbers running along the left-hand side of the origin are negative numbers.

This is also true for the Y axis. Numbers above the point of origin are positive, and numbers below the origin are negative. When plotting coordinates you always start by moving along the X axis and then the Y axis. So, if we told you to plot the value (2, 1) the number 2 would be how many units you move along the positive X axis. Once you are on point 2, you would simply move up 1 unit in the positive Y direction and plot a point. Okay, so now let's plot a point in the negative region. If we told you to create a point at (-3,-2) you would move 3 units along the negative X axis and then down 2 units along the negative Y axis. Refer to Figure 1-2 once again to see an example of the coordinates (2, 1) and (-3,-2) plotted along the 2D grid.

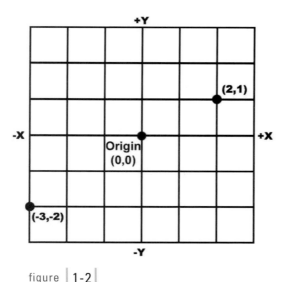

figure | 1-2 |

Points plotted on a 2D Cartesian grid.

Now that you understand the basics of the 2D coordinate system you are ready to add that third dimension, known as the Z

axis. The X and Y axes remain the same as in a 2D coordinate system, with X representing the horizontal value and Y representing the vertical value. These values are what provide us with our width and height of an object. The Z axis determines the volume (gives us its depth), resulting in a 3D object. Figure 1-3 shows an example of the three axes on a grid. When plotting points on the 3D coordinate system, their values are represented in the order X-Y-Z. Plotting a point along the Z axis is done the same way as for the X and Y axes. Positive Z coordinates are located above the XY plane, and negative Z coordinates are located below the XY plane. It's important to note here that most animation software utilizes Mr. Descartes' world-famous coordinate system, so in the event you end up learning a different software down the road the workspace you would be dealing with will look very familiar to you.

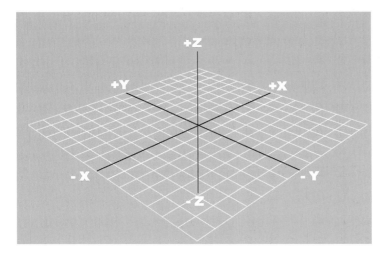

figure | 1-3

The XY grid with the Z axis added.

3ds max's Cartesian coordinate system is referred to as the World space, which is just Discreet's way of saying Cartesian system. This World space is the law of the land, in which all objects are contained. The X, Y, and Z axes are fixed and the orientation of them cannot be changed no matter how hard you beg the software. Within this World space, the grids are divided into generic units. It is possible to use a variety of types of units, such as U.S. standard feet and inches, metric, or even miles and kilometers. This provides the artist considerable freedom when creating models in a variety of scales. In addition to World space coordinates, 3ds max has coordinate "subsystems" the user can switch to from the World space. These various systems are often referred to as reference

coordinate systems. It is possible to tell the software to point the X axis toward the right-hand side of the viewport, and the Y axis toward the top of the viewport. This type of system is known as Screen. This generally makes it a whole lot easier to perform moves and rotations within your orthographic viewports (front, top, left, right, back, and bottom views).

If the World and Screen systems were to be melded we would end up with the View system. This is the default system for what is called the User view, which will be discussed a little down the road. The Screen system keeps the X and Y axes parallel to the edges of the screen, regardless of the user's viewpoint, whereas the View system obeys the same rule in orthographic views but reverts to the World system when in perspective.

Another type of reference coordinate system is known as the Local coordinate system. Every object you create in 3D space is automatically given its own set of coordinates that relates directly to that specific object. When the Local system is active on a selected object, any movements, rotations, or scaling done to that object will occur outside World space, as indicated in Figure 1-4. This system is a godsend when performing complex animation such as character motion. Have you ever tried to rotate a character's limbs in World space? Well, take it from us it's not a pretty sight. The Local coordinates allow the animator to make rotations around the axes of the object, allowing for a more believable animation.

figure | 1-4

In the Local coordinate system, the XYZ axes are reoriented to the selected object and work independently of the World coordinate system.

The next system you will see is the Parent system. When working with parent and child objects, the Parent coordinate system uses the coordinate system of the parent of the selected child object. If the selected object is not linked to a parent object, the world is considered its parent and it will be process via the World coordinate system.

Another 3ds max system you can use is the Gimbal system. This system is used with the Euler XYZ Rotation controller and is similar to the Local. The next system is the Grid which simply uses the coordinate system of the active grid. Finally the last is the Pick system which allows you to use the coordinate system of another object you select from your scene.

SAY HELLO TO 3DS MAX 7

3ds max 7 is the newest version of this award-winning program created by Discreet, and is used by many top professionals in the industry. According to recent figures from Discreet, 3ds max is the preferred application for roughly 80 percent of game developers. Some of the top gaming companies that have used this software include LucasArts, Microsoft, Ubisoft Entertainment, DreamWorks Interactive, BioWare, Blizzard Entertainment, Activision, Namco, Blur Studios, and Konami. One of the reasons this application is so popular for gaming development is because Discreet has incorporated many key features into the software geared just for gaming, such as the new Vertex Paint feature and event-driven particle systems (just to name a couple). We figure if the software is good enough for them it has to be good enough for us. It's easy to agree with such respectable talent in the 3D industry.

3ds max has also been used in some of the top-featured films. The movies *X2: X-Men United*, *The Core*, *Minority Report*, *Swordfish*, *Tomb Raider*, *South Park*, *Bulletproof Monk*, *Great Expectations*, *The Green Mile*, *Casino*, and *The Matrix Reloaded* all used 3ds max at some point in their production. As you can see, 3ds max has a very impressive resume.

The 3ds max 7 Interface

The interface for 3ds max 7 has not undergone any major changes from earlier versions, so if you have used the software before this

should simply be a review for you. When we first started working with this software we couldn't believe how many options, menus, and buttons there were to remember. Don't feel nervous about all of these buttons and gadgets. Once you start working on projects and using these tools on a regular basis the interface begins to look much smaller. Figure 1-5 shows the interface you will see when you first launch the software.

figure | 1-5

The 3ds max 7 interface.

Menus

The menu system is located at the top of the screen and consists of a wide variety of features and commands. One of the great features about the layout of the 3ds max 7 interface is that it provides you with many different ways to get to a particular tool. The menu system is one way of achieving this. The following outlines some of the most important menus that you will be using throughout this book.

● *File menu:* This is where you will find basic commands for creating a new scene, loading and saving scenes, and the Reset command that resets 3ds max back to its default settings. The File menu also contains commands for importing data from outside applications, or exporting data to non-max files or programs. You can also merge elements from multiple 3ds max scenes into one document.

- *Edit menu:* The Edit menu is used to duplicate objects and to manipulate selections of objects within your scene. This is also where you would find the Undo and Redo commands that will allow you to return to a previous step in your project or to redo something you may have just erased by accident.

- *Create menu:* The Create menu gives you access to 3D objects, virtual lights, cameras, and other objects that will aid you in object creation. If you need to create something, this is the place to look.

- *Modifiers menu:* Modifiers are used to manipulate the appearance of an object in order to create more complex forms. This is similar to using a filter in Photoshop to adjust the properties of an image selection.

- *Rendering menu:* Rendering is the process the software goes through in order to calculate all of the parameters of your project, such as object parameters and coordinates, surface materials, and lighting effects. In this menu you will find the tools needed to output your final image or animation in a variety of graphical formats.

- *Customize menu:* One of the features that draw so many industry professionals to this software is the ability to fully customize their work environment to suit their needs. This is where you would change all of your graphical elements (such as the color of your viewports, buttons, and window elements), as well as adjust unit measurements and viewport layouts.

- *Help menu:* Much like any other program, this menu provides you with a wonderful user reference section that can help you when you have fallen into a sticky situation. There are tips and tutorials to help you become more adept at using this software. If you have Internet access you can also get to online support, updates, and additional resources by clicking on the 3ds max on the Web option. We highly recommend reading and trying out some of the included software tutorials. You know what everyone always says: "Practice makes perfect."

Main Toolbar

The main toolbar, shown in Figure 1-6, contains many of the features you will need when working in Max. By default, this toolbar is located at the top of your screen just below the main menu. This toolbar includes buttons for selecting objects, scaling and

manipulating objects, and adjusting various snap properties (just to name a few). The following list provides you with a brief description of the tools you will be using the most from the main toolbar.

figure | 1-6

The 3ds max 7 main toolbar.

- *Undo:* The Undo button functions like the Edit > Undo feature in most other software packages. It allows you to backtrack through the steps that you have already created.

- *Redo:* The Redo button allows you to move forward through the steps you have previously undone.

- *Select Object:* This tool lets you click directly on an object or drag a selection box around a group of objects.

- *Select by Name:* This feature allows you to select an object from a list of all objects currently in your project. It is a good idea to name specific objects so that they can easily be found or referenced.

- *Select and Move Transform:* The Select and Move Transform button allows you to select an object and move it on various axes.

- *Select and Rotate Transform:* This tool lets you select an object and rotate it around a particular axis.

- *Select and Scale Transform:* This function allows you to select an object and resize it using one of the three types of scaling methods. These methods are Select and Uniform Scale, Select and Non-uniform Scale, and Select and Squash.

- *Snap Toggles:* The various snap toggles allow you to snap the mouse to grid points in your viewports; to an object's pivot point, vertices, or edges; and a number of other settings. If you right click on the Snaps Toggle icon you can change the various snap and grid settings. The three snap toggles are 3D, 2.5D, and 2D Snap.

- *Angle Snap:* Snaps your rotation to a specified increment in degrees.

- *Percent Snap:* Snaps the scale of an object at a specified percentage value.

- *Mirror:* This feature allows you to mirror and duplicate a selection.

- *Align:* The Align tool lets you orient one object onto a specified location on another object.

- *Material Editor:* This button provides you access to the Material Editor, discussed in Chapter 5.

- *Render Scene:* This button opens the Render Scene window, which allows you to set parameters for the final output of your project.

- *Quick Render (Production):* Quick Render takes the current settings from your current Render Scene window and calculates your final project output. (This is basically a shortcut for bypassing the Render Scene window.)

Reactor Toolbar

Reactor is a plug-in inside 3ds max that was given a snazzy user interface new to release 6. This utility allows 3D artists to simulate real-world physics. It can be used to simulate liquid buoyancy effects of objects in water, as well as chain and rope movement, and can even simulate various types of cloth (to name a few uses). Although we will not be using reactor in this book it is a valuable feature if you decide to pursue animation in depth.

Viewports

Understanding the 3ds max 7 viewports is one of the most impor-
tant elements to becoming a successful 3D animator. For all of you
graphic designers, a viewport is simply the 3D canvas or workspace
you will be designing in. The only big difference between working
with viewports and a canvas is that you can have multiple views
that allow you to see your 3D model at various angles. The four
main viewports you will primarily be working with are the Top,
Front, Left (known as orthographic views), and Perspective. One
way to help you understand this is to set up a design situation. Let's
imagine that you are modeling a 3D television set. Figure 1-7 shows
what a television would look like in the four main viewports.

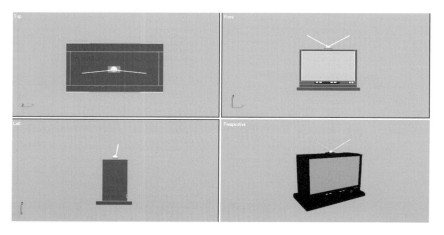

figure | 1-7 |

Television scene in three orthographic viewports and one Perspective viewport.

- *Top Viewport:* The Top viewport represents how an object
 would look if you were standing directly above it looking down
 on it. In Figure 1-7, this would be the top of the television set.

- *Front Viewport:* A Front viewport would represent how an
 object would look if you were standing directly in front of it. In
 regard to Figure 1-7, you would see the screen, control buttons,
 and front of the television.

- *Left Viewport:* The Left viewport displays an object from the left
 side. In regard to Figure 1-7, this would be the left side of the
 television.

● *Perspective Viewport:* A Perspective viewport displays the object in 3D space. The Perspective viewport can be rotated so that you can view the 3D object from any side, angle, or distance. In Figure 1-7, we have rotated the television set slightly so that you can see how you can easily view more than one side.

Another valuable feature of the viewport workspace is the ability to see your objects in a variety of ways. The viewports can draw your objects in a number of shading modes. These modes are known as viewport shaders. The following list describes each of these shaders, and provides you with a graphical example of each.

● *Smooth + Highlights:* This viewport shading mode, shown in Figure 1-8, displays your graphic as a solid object. It provides you with a skin on your object and allows you to see the highlights from the lights in your scene. This option is for the most part used in the Perspective and Camera viewports.

Perspective

figure | 1-8

Viewport displayed in Smooth + Highlights mode.

● *Wireframe:* This shading mode, shown in Figure 1-9, allows you to see objects in an outline form to make them easier to work with and manipulate. This means that they do not have a solid fill color and appear hollow. This option is used mainly in your orthographic viewports.

● *Smooth:* This shading mode, shown in Figure 1-10, is identical to the Smooth + Highlights mode but does not display the highlights from the lights in your scene.

figure | 1-9 |

Viewport displayed
in Wireframe mode.

figure | 1-10 |

Viewport displayed
in Smooth mode.

● *Facets + Highlights:* This mode, shown in Figure 1-11, is the
same as Facets mode but also provides you with highlights
from your scene lights.

● *Facets:* Faceted shading mode, shown in Figure 1-12, provides
constant shading across each facet of the object, resulting in a
flat type of shading.

● *Flat:* Flat mode, shown in Figure 1-13, renders each polygon as
a flat surface with no shading or highlights from other sources
such as lights.

figure | **1-11**

Viewport displayed in Facets + Highlights mode.

figure | **1-12**

Viewport displayed in Facets mode.

- *Lit Wireframe:* Lit Wireframe mode, shown in Figure 1-14, shows a wireframe the same way as a normal wireframe except that the color of wires appears in the highlights only. Portions of the wire that do not fall within the light appear as black lines.

- *Bounding Box:* Like many 2D graphics programs, objects in your workspace are surrounded by a box when they are selected. This shader mode, shown in Figure 1-15, represents each object in your scene as a wire box. It is primarily used in complex scenes

figure | 1-13 |

Viewport displayed
in Flat mode.

figure | 1-14 |

Viewport displayed
in Lit Wireframe
mode.

consisting of a lot of objects. The more complex the scene the more slowly you are able to move around the viewport. The Bounding Box shader allows you to navigate your viewport without placing a strain on the computer's processor.

● *Edged Faces:* Selecting this mode, shown in Figure 1-16, will result in objects that appear as solids, as in the Smooth +

figure | 1-15 |

Viewport displayed
in Bounding Box
mode.

figure | 1-16 |

Viewport displayed
in Edged Faces
mode.

Highlights shading mode, but you will also be able to see the
wireframe edges of the object.

Now that you have some basic knowledge about viewports you are
ready to learn about the viewport navigation tools that will allow
you to navigate within your viewport. These controls, outlined in
the following, provide you with buttons for panning, zooming,

rotating, minimizing, and maximizing your viewport. Figure 1-17 shows these tools, which can be found in the bottom right-hand corner of the 3ds max interface. Note that these viewport controls are for the orthographic viewports only and will change when other types are active. Also, some of the tools discussed below are hidden. Tools with similar functions are grouped together to save valuable space on the interface. Zoom Extents and the Arc Rotate tools are some tool types that have been grouped together.

figure | 1-17 |

The viewport navi-
gation controls.

Viewport Navigation Controls and Rollouts

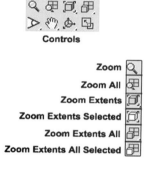

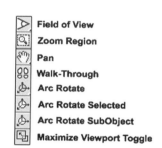

- *Zoom:* The Zoom tool allows you to zoom in and out to see your object closer or farther away.

- *Zoom All:* This feature allows you to zoom all of your viewports at the same time.

- *Zoom Extents:* The Zoom Extents feature zooms your viewport out to show all of the objects of your scene in the currently active viewport only.

- *Zoom Extents All:* This feature zooms and centers your viewport out to show all of the objects of your scene in all of your viewports.

- *Zoom Extents All Selected:* Centers the selected object, or set of multiple objects, in all viewports.

- *Field of View:* This tool is only available when the Perspective viewport is active. This button changes the field of view in a manner similar to that of a camera lens.

- *Zoom Region:* This feature allows you to drag a rectangular region in the active viewport and zoom that region to fill the viewport.

- *Pan:* This feature will move the viewport from side to side, or up and down, in order to view more objects in your scene.

- *Walk Through:* Enables you to begin walkthrough navigation of your viewport.

- *Arc Rotate:* This feature allows you to rotate a view by clicking and dragging a series of handles.

- *Arc Rotate Selected:* This feature uses the center of the current selection as the center of rotation. The selected object does not move, but the view will rotate around its center.

- *Arc Rotate SubObject:* This feature uses the center of the current sub-object selection as the center of rotation.

- *Maximize Viewport Toggle:* This function will switch your viewport between full-screen view and the multiple-viewport layout.

Command Panel Overview

The 3ds max 7 command panels are the set of tabs located on the right-hand side of your screen. These command panels are an area of the interface you will soon become very familiar with. Think of the command panel as a container that holds six panels, each containing a set of important controls. This panel contains the Create panel, Modify panel, Hierarchy panel, Motion panel, Display panel, and Utilities panel. The following outlines the information found in each of these panels. These interface elements are discussed in detail in later chapters.

- *Create panel:* This panel, shown in Figure 1-18, is where you will find all of the tools for creating 3D objects, 2D shapes, lights, cameras, helpers, space warps, and systems.

- *Modify panel:* The Modify panel, shown in Figure 1-19, contains functions that are

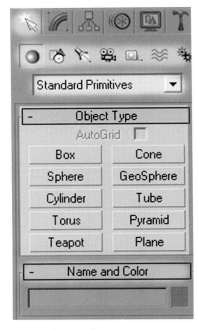

figure 1-18

The Create panel.

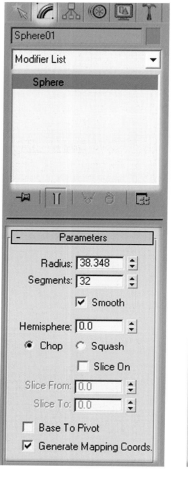

figure | 1-19 |

The Modify panel.

figure | 1-20 |

The Hierarchy panel.

similar to filters in graphical software. Modifiers are used to manipulate the appearance of an object in order to create more complex forms. As you learned earlier, another way to apply modifiers is through the Modifiers menu in the main menu bar.

- *Hierarchy panel:* This panel, shown in Figure 1-20, shows information for determining how linked objects will react when animated.

figure | 1-21 |

The Motion panel.

figure | 1-22 |

The Display panel.

- *Motion panel:* This panel, shown in Figure 1-21, provides you with tools for controlling animated objects through keyframe editing and controllers.

- *Display Panel:* The Display panel, shown in Figure 1-22, contains options that allow you to choose how an object appears on your screen and to hide or unhide objects by category.

- *Utilities Panel:* The Utilities panel, shown in Figure 1-23, contains various utilities for working with 3ds max.

The Utilities panel.

Animation and Track-bar Controls

The animation and track-bar controls, shown in Figure 1-24, make up an important part of the 3ds max interface. Although we will not be using them in this book, because they represent primary tools used in animation you should be aware of them. You may wish to explore these interface elements on your own. Animation controls are set up in a manner very similar to that of a tape deck or CD player. The controls allow you to fast forward, rewind, or play your current animation. The Time Slider allows you to "scrub" through the animation frame by frame.

figure 1-24

Animation and track-bar controls.

SUMMARY

This chapter provided an overview of various applications for 3D design, as well as an introduction to the software, which you will be using throughout the rest of this book. By now you should have an understanding of navigation within the 3D world using 3ds max 7. Our discussion included the various aspects of the Max 7 interface, commonly used tools, and the various methods of viewing your objects using the viewport displays. At this point you should be ready to move on to the next step in your 3D journey, in which you will begin to sculpt 3D objects.

in review

1. Name and describe three industries in which 3D design is applied.

2. What French mathematician and philosopher developed the Cartesian coordinate system, and when?

3. What is an axis, how many of them are there in the Cartesian coordinate system, and what are they called?

4. What type of view, respectively, is depicted in the top, front, and left viewports?

5. List the eight viewport shading modes.

↗ EXPLORING ON YOUR OWN

1. Create a number of different standard primitives, such as a box, sphere, pyramid, and so on.

2. Explore some of the menus, tools, and objects throughout the 3ds max 7 interface.

LEARN.

| sculpting a 3d form |

2

 charting your course

In the previous chapter you learned about some of the uses of 3D modeling and animation and the types of software used for creating them, and were introduced to the 3ds max 7 Interface. Now that you have a little more knowledge of the 3D world, it is time for us to take the next step in our adventure. In this chapter you will learn how to create 3D models using a number of methods, including mesh modeling, box modeling, and using Boolean functions to create compound objects. We will also discuss how to manipulate an object using modifiers and transform tools, as well as editing at the sub-object level. 3D modeling constitutes the basis of your entire project. It doesn't take a fashion designer to realize that without a model there can be no runway show.

One way to achieve our goals in modeling is to look at this task as a step-by-step building process. Remember back to the days when you used to play with building blocks and you would stack a few and then they would fall, and you then had to learn how to balance them correctly to build larger structures. 3D modeling works the same way. In 3D modeling you must start with a base object and then modify it using one or a number of the techniques discussed in this chapter. Another thing to remember is that those complex models you see in video games or on the big screen go through many phases before they look as good as they do when audiences see them. So do not be discouraged when we start to model our objects in this chapter if they look unrealistic. You will learn how to make your models look more professional in Chapter 5.

 goals

- **Introduction to object creation**
- **Provide instruction on mesh modeling**
- **Using Booleans for creating complex objects**
- **Adding modifiers to manipulate objects**
- **Creating an object using box modeling**

SCULPTING A 3D FORM

LET'S GET MESHY

One term you should become familiar with is the word *mesh*. Mesh objects are created by combining smaller pieces that in turn form the object as a whole. These smaller pieces (known as sub-objects) can then be manipulated to form more complex models. A good example of this technique outside 3D modeling would be carving a pumpkin. You start with a solid object (in this case, your pumpkin) and then carve away pieces of it in order to create the eyes, nose, and mouth. Mesh modeling is similar to this method. With mesh modeling you can create a sphere and through some modifications that sphere can become the face for a cartoon character. Mesh models break down your object into a number of individual flat surfaces known as polygons and faces. These polygons can be selected through various sub-object levels, discussed later in the chapter. This allows an animator to grab specific points, edges, or entire polygons and manipulate them without causing any changes to the surrounding areas.

figure | 2-1 |

Options for converting an object to an editable mesh.

It doesn't make much sense to keep talking about something you have never seen before, so let's create a mesh object that will make this easier for you to understand. To do this you must first create an object in your viewport. In the following exercise you will learn how to create an editable mesh, as indicated in Figure 2-1.

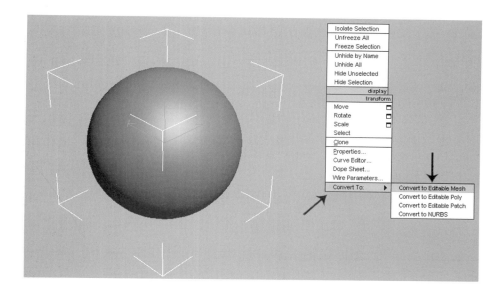

Creating an Editable Mesh

1. Select the Sphere button from your Create panel, and in your Top viewport click and drag forward on your mouse to establish a radius for the sphere.

2. In the Radius setting under the Parameters rollout, type in *40*, and in the Segments input box type in *32*.

3. Convert this object to an editable mesh. To do this, right click on the sphere and select Convert To. In the Rollout menu, click on Convert to Editable Mesh.

Okay, good work. You now have an editable mesh you can take a look at in order to follow along with us. This is much more fun than simply looking at screen shots, but in case you do not have a copy of the software or are not at your computer right now we will provide the images for you. The menu you just used when you right clicked on the sphere is known as the Quad menu, which contains a number of shortcuts to tools and options that will allow you to make adjustments to your objects.

One thing you may have noticed is that a different menu has opened on the right-hand side of your screen. If you didn't follow along and create the object you can take a look at Figure 2-2 to see this menu. Once you convert your object into an editable mesh you can no longer change any of the options in the Create panel, and 3ds max was kind enough to open the Modify tab for you so that you can begin manipulating your object.

Let's take a look at the Modify panel, shown in Figure 2-3. The first thing you will notice at the very top of the Modify panel is the name *Sphere01*. This is the name of the sphere you created. Just for practice, let's change the name. In the Name field, highlight the name and type in any new name you want.

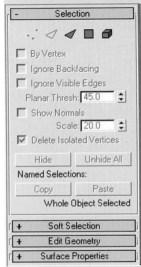

figure | **2-2**

New menu options that appeared once you converted the object to an editable mesh.

figure | 2-3 |

Modify panel showing Name and Color fields.

NOTE: A helpful hint when creating objects is to name each of them with a specific name so that you will be able to refer to them later on. It doesn't look too helpful now, but if you were creating a complex animation scene with thousands of spheres and you needed to select this one in particular you would thank us for this tip.

figure | 2-4 |

Modifier List drop-
down menu show-
ing modifiers avail-
able for the select-
ed object.

Next to the name you will see a color swatch. This color represents the default color of your object. Feel free to click on this color option and change the color of the sphere to anything you want. The next item you will see is the Modifier List drop-down menu, shown in Figure 2-4, where you would go to apply modifiers to your object. Remember that a modifier is kind of like applying a filter in graphic design software packages. Modifiers can be used to help enhance the surface quality of your object, and to manipulate its overall appearance.

The box just below this is your modifier stack, shown in Figure 2-5. This box will display any modifiers you have applied to your object. The modifier stack works in much the same way as the Layers palette from many of the popular computer graphics programs. Below this panel you will see a number of rollouts, which

are used to manipulate the settings of your object. There are quite a few of them, and depending on what type of modifier you have applied more will appear. So, just to give you a brief example, if you click on the Modifier List drop-down list and select Bend you will notice that the parameters for the Bend modifier will appear in place of all previous rollouts. This section is meant only to give you a basic introduction to the menus found under the Modify tab. Feel free to play around with any of the modifiers, settings, or options under any of these menus. Experimentation is the key when working with 3D modeling.

figure | **2-5** |

Modifier stack.

WORKING AT THE SUB-OBJECT LEVEL

In the previous section you learned how to create an editable mesh object. Now we are going to show you how to effectively manipulate a mesh at its sub-object level by using Mesh Select modifiers. If you wish to follow along with us from your previous file and have applied the bend modifier, we need to remove it before going any further so that you do not become confused. To remove the bend modifier from the stack, click on the bend in the modifier stack and then click on the remove modifier from the Stack button (which looks like a trash can and is located at the bottom of the stack). In sub-object mode you can select individual areas of the mesh and make changes to them without affecting the rest of the object. There are two ways you can access these selection commands in order to work at the sub-object level. One way is to click on the + (plus) symbol next to the term *Editable Mesh* in your modifier stack, which will open the sub-object rollout for you. The other way is to select one of the buttons under the Selection rollout menu below the modifier stack. In Figure 2-6,

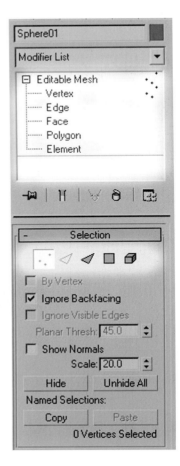

figure | **2-6** |

Sub-object levels highlighted.

both of these areas are highlighted for you in case you do not see
what we are talking about.

Types of Sub-Object Levels

There are five sub-object levels you can use to make selections to
your object. These sub-object mode options are Vertex, Edge, Face,
Polygon, and Element. The following list describes each of these
sub-object levels and explains what they are used for in 3D model-
ing. In the figures for this section you will note that we have
changed the viewport shader mode to wireframe so that you can
see the objects without the smooth and highlights shading getting
in the way. If you are working with the software while reading, you
can right click on the viewport name and select wireframe from the
list of shader modes. These figures will also look a little different in
your viewport in 3ds max because we cleaned up the images so that
details would be more readily discernible. The differences are that
the selected sub-object type would be red and the axis tripod
would be visible in your viewport.

- *Vertex:* With a vertex in sub-object mode (Vertex sub-object
 level), shown in Figure 2-7, you can select the individual points
 of each of the faces of your polygons. This is helpful when you
 want to move specific points of your mesh without touching
 any of the other points. Vertex points are connected by edges of
 your object

- *Edge:* With an edge in sub-object mode (Edge sub-object level),
 shown in Figure 2-8, you can select the edges of a polygon
 instead of selecting individual vertices. You will learn how to
 use this when we discuss box modeling (later in this chapter),
 in which you connect edges to create new polygons. Edges con-
 nect two vertices on your object.

- *Face:* With a face in sub-object mode (Face sub-object level),
 shown in Figure 2-9, you can select part of the polygon that is
 in the shape of a triangle. A group of faces is referred to as a
 polygon.

- *Polygon:* With a polygon in sub-object mode (Polygon sub-
 object level), shown in Figure 2-10, you can select the entire
 polygon section of your object. A polygon is made up of two or
 more faces. This is helpful for moving an entire block of your
 object.

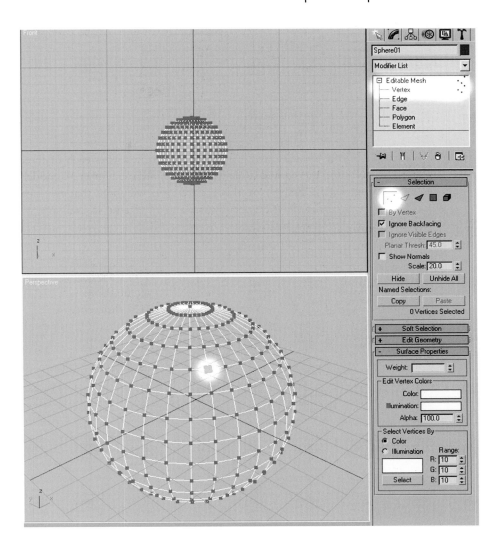

figure | 2-7

A selected vertex in sub-object mode.

● *Element:* Elements are noncontiguous parts of a mesh object and can be made up of one or more of the previous sub-objects. It is entirely possible to have an element that contains all of the other sub-object types. Figure 2-11 shows an element in sub-object mode.

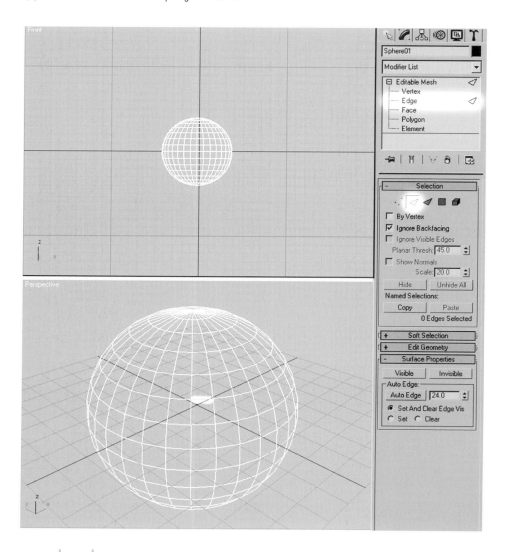

figure | 2-8 |

Edge in sub-object mode.

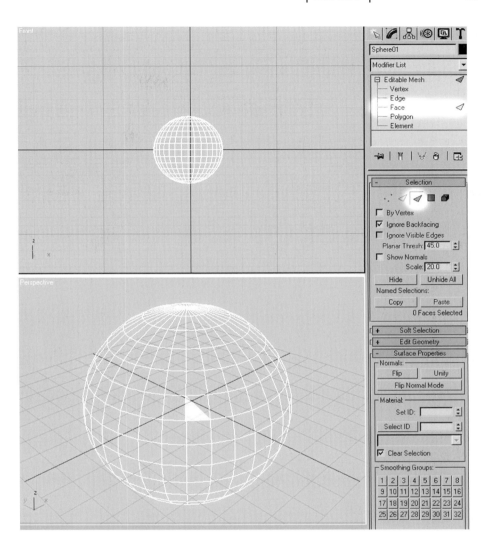

figure | 2-9 |

Face in sub-object mode.

figure | 2-10 |

Polygon in sub-object mode.

Selection Rollout

To see the objects listed in the selection rollout that we will be discussing, you need to create an object in one of your viewports and then convert it to an editable mesh. We created a sphere in case you want to work along with us. This menu is located below the mod-

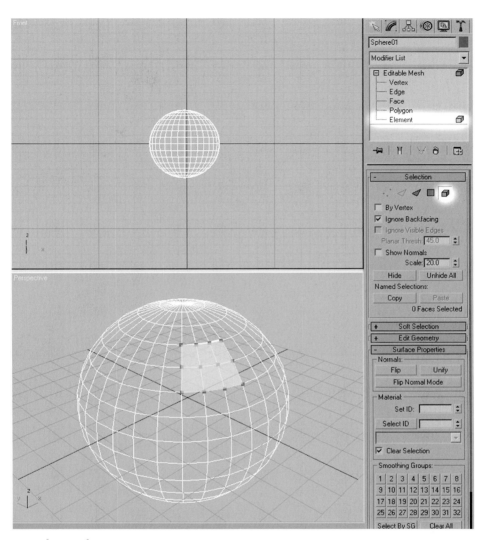

figure | 2-11 |

Element in sub-object mode.

ifier stack in the panel system on the right. At the top of the selection rollout you will see a row of buttons that will allow you to turn on and off the various sub-object levels discussed in the previous section. These buttons, outlined in the following, are shown in Figure 2-12.

figure | 2-12 |

Option buttons for selecting sub-object levels of your mesh.

- *By Vertex:* This feature allows you to select sub-objects by clicking on a vertex or selecting it by region.

- *Ignore Backfacing:* When this feature is activated you can select sub-objects facing the current viewport.

- *Ignore Visible Edges:* This feature is used when you are working with the Polygon sub-object mode option. Its purpose when activated is to ignore the visible edges of your selection. Planar Thresh sets the threshold value.

- *Show Normals:* This option turns on normals in your viewports, and the Scale option determines the size of their visibility. A normal indicates which direction a face or vertex is oriented.

- *Remove Isolated Vertices:* This will delete any vertices that are not associated with any polygons in the mesh.

- *Hide/Unhide All:* These features allow you to hide any of your selected sub-objects. This feature works just like the hide and unhide options for hiding objects.

- *Copy/Paste:* These options under the Named Selections listing copy and paste a named selection to and from the copy buffer.

BOOLEAN FUNCTIONS

Boolean functions (or operations, as they are often called) allow you to create compound objects through combining, subtracting, intersecting, or cutting pieces from two mesh objects. There are two ways to access these Boolean functions, as indicated in Figure 2-13. No matter which way you select this tool you must first have an object selected in one of your viewports. The first way is by clicking on Create in the Main menu and then expanding Compound, which contains the Boolean tool. The second way this tool can be accessed is by selecting the Geometry button under the Create tab located to the right of your screen. Once you have this

active, you then need to select Compound Objects from the drop-down menu and click on the Boolean button. The following outlines the operations that can be performed on the objects. Another term you will hear associated with Booleans is *operand*. An operand is simply the variable applied to your selected objects when performing an operation. If you consider creating equations in algebra, in which you use variables, this is very similar. For example, you might use the variables *A* and *B* to represent the two objects you are going to apply the Boolean to.

figure | 2-13 |

Accessing the
Boolean functions.

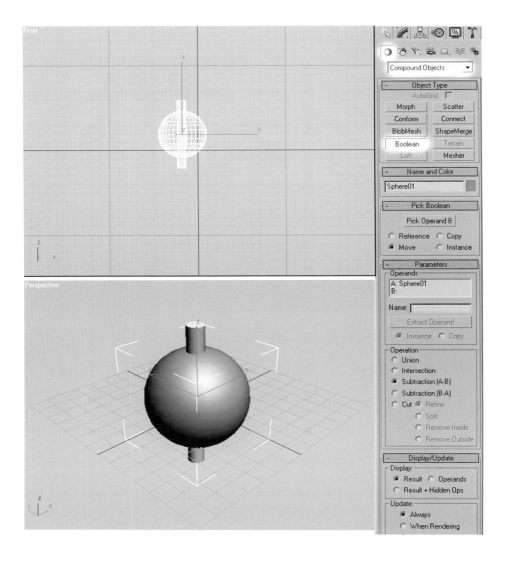

- *Union:* This feature will combine two objects into one single object and remove the areas that overlap or intersect.

- *Intersection:* This option will create an object that retains only the overlapping areas of both objects.

- *Subtraction [A-B] & [B-A]:* Through subtraction you can remove one object and any overlapping areas of your objects. In this process, selecting *A-B* subtracts B from A, and selecting *B-A* reverses this order of subtraction.

- *Cut:* This feature will cut operand *A* with operand *B*. This works like the Slice modifier, which allows you to slice through a mesh. You will note that there are four cut options: Refine, Split, Remove Inside, and Remove Outside. Refine will add new vertices and edges to operand *A* where it is intersected by operand *B*. Split will split your object into two pieces. Remove Inside and Remove Outside delete all faces from operand *A* that are inside or outside, respectively, operand *B*.

Figure 2-14 shows examples of the various types of Boolean operations.

Now that you have some information on Booleans, the following information will tell you how to create them. The first step is to have one of your objects selected, and then you must select the radio button next to the operation you wish to work with. Once you have those elements selected, you must then select the radio button for one of the clone types: Reference, Move, Copy, or Instance. You then click on the Pick Operand B button and once it is highlighted click on the second object in your viewport you wish to perform a Boolean operation on. One last thing that you should know about Booleans before we begin is that they are sometimes unstable and may cause undesired results in certain situations. This is why we recommend that you save the project you are working on before attempting to use them, so that you have a backup just in case your objects become damaged. You will note that we tell you to save a lot, and this is for a very good reason. It is far easier to take a few extra seconds to save your document than it is to rebuild your files.

figure | 2-14

Fig. 2–14. Boolean operations.

When working with Boolean functions, the options for which are shown in Figure 2-15, we have found that Booleans sometimes can be fairly unstable when applying multiple Booleans to the same objects. If this happens to you, one way to fix this is to try converting the object to an editable mesh before each Boolean. This may help reduce undesirable results.

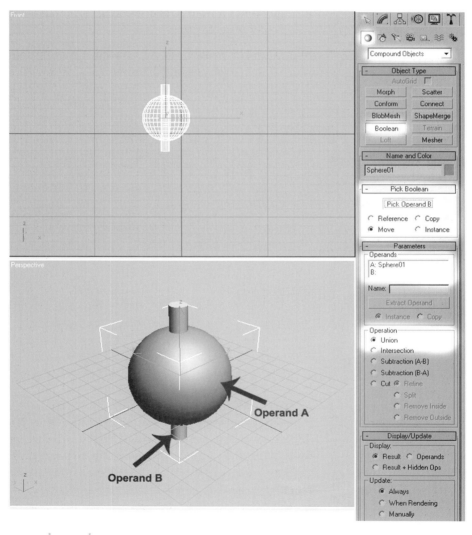

figure | 2-15

Options for creating a Boolean.

Working with Booleans

Now that you have a little better understanding of what Boolean functions are, we have created a small exercise to help you put this information to use by creating a few Booleans in the following.

1. Reset 3ds max so that we have the default settings for this exercise.

2. Create a sphere in your Perspective viewport with a radius of 40.

3. Next to the sphere, create a tube with Radius 1 set to 4.0 and Radius 2 set to 7.0. Set Height to 200.

4. Using your Select and Move tool, position the tube so that it runs through the center of the sphere, as shown in Figure 2-16.

figure | 2-16 |

Tube running through center of sphere.

5. Click on the sphere to make it active, and then click on your Boolean tool in the Compound Objects menu.

6. Select Union as the operation, select Instance in the Pick Boolean rollout, and then click on the Pick Operand B button.

7. Click on the tube to complete your Boolean, and then using the Select and Move tool move the new object along the X axis.

Note that the original tube still remains. This is because in a union, with the Instance option selected your original object is copied and not discarded. The result of this step is shown in Figure 2-17.

figure | 2-17 |

Result of Boolean operation in step 7.

8. Now let's be a little daring, to show you what a subtraction does. Rotate the original tube, and position it so that it intersects the horizontal center of the sphere in the new Boolean object.

9. Click on the sphere to highlight the object, and then click on the Boolean button again to access the Boolean operations.

10. This time, select Subtraction [A-B] as your operation, and select Move (instead of Instance) in the Pick Boolean rollout.

11. Click on the Pick Operand B button and select the horizontal tube.

12. Rotate your object and you will notice that there is a hole through your sphere where your tube used to be.

13. On your own, experiment with the remaining Boolean functions for more practice.

USING TRANSFORMATION TOOLS

Once you create an object you may find that you need to move it around in your scene, adjust its rotation, or scale its size. This is similar to how you would adjust a graphic or a photograph in image manipulation software, except that your tools are found on the main toolbar instead of hidden under a menu structure. You were introduced to these tools briefly in Chapter 1, but now we would like to show you how to use them effectively when working with objects.

Select and Move Tool

Select and Move

The Select and Move tool allows you to move one or more objects around so that you can place them anywhere you choose within your scene. You can access this tool by clicking on the icon on your main toolbar. Once you have the tool activated, you can move the object by clicking on the object in the viewport in which you wish to move it and then clicking and dragging the object along one or more of the axes. If you know the exact coordinates of the location you wish to move your object to, you can also type the values in the X, Y, and Z input boxes on the bottom toolbar.

NOTE: An important tip to remember when moving your objects around in a scene is to make sure they are properly located in all viewports. Although the object you have moved is in the perfect place in the front viewport, it may be off in one of the others.

Selecting and Moving Objects

Now that you know what the Select and Move tool does, we feel that before you move any further it would be helpful to take a few moments to practice putting this tool to work. In this exercise you will be creating a box you can use to learn how to move objects in your viewport. We know that it sounds very simple, and you may wonder why we have written a separate tutorial for it in that we just told you how to do it in the previous section, but we feel the hands-on practice can only help in the long run. This way, you are not thrown into the action and expected to move things without fully understanding how to do so.

1. Our first task is to reset the 3ds max workspace by clicking on File > Reset from the main menu. This will make sure we are

both looking at the same elements on the screen. You may be prompted to save your scene if you were previously working on something. In response, select Yes to save or No if you do not wish to save. You will then be prompted if you really want to reset. Click on Yes to reset the scene.

2. Click on the Box button in the Object Type rollout and create a box in the Perspective viewport by clicking your left-mouse button and dragging to define the Length and Width of the box. Then move your mouse forward to define the Height of the object. Note: The size of the box does not matter, so choose any sizes you wish.

3. Left click on the Select and Move tool from the main toolbar, and click on the box in the Front viewport.

4. You will see two arrows labeled with an X and a Y superimposed on the box, as shown in Figure 2-18. Click on the arrow labeled with the Y and move the box up or down with your mouse button. This allows you to move the box along the Y axis. If you click and hold the left-mouse button on the arrow labeled with the X and move your mouse left or right you can move the object along the X axis.

figure | **2-18** |

The Move Transform gizmo.

Select and Rotate

Select and Rotate

The Select and Rotate tool allows you to rotate your object in a number of different directions. You can access this tool by clicking on the icon on your main toolbar. This tool works a little differently than some of the tools you may be used to. Once you select an object, you will notice that the Rotate gizmo is activated in the viewport. This gizmo is used to rotate the object along one of the axis lines. You will notice that it is represented in the shape of a 3D sphere surrounded by an outer circle. In the center of this sphere you see the letters X, Y, and Z. The three colored lines represented by these letters represent the X, Y, and Z axes and help you determine which axis you are rotating your object on. If you move your mouse on top of one of these lines you will notice that the letter of the axis associated with the color you are on highlights as well. Another way to rotate the object is to click between any of the axis lines, which will allow you to rotate the object in multiple directions. The outer contour circle is known as the screen handle, which is used to rotate the object in the plane parallel to the viewport.

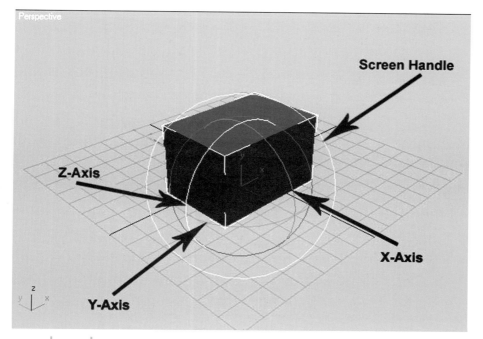

figure | 2-19 |

Rotate Transform gizmo.

Selecting and Rotating Objects

When designing a 3D scene you will find that objects may need to be rotated in order to accurately place them in your scene. I know you're probably thinking why can't I just make the object the way I want it? Well, in most cases you can, but sometimes it may be difficult to design an object at a particular angle. You may also design something one way and realize that it's not exactly how it is supposed to be and need to rotate the object. In this exercise you will be rotating various objects in 3D space.

1. Once again we will start by resetting our scene by clicking on File > Reset. Click on Yes to save changes or No if you do not wish to save. When prompted if you really want to reset, click on Yes.

2. This time, to help you become more familiar with creating different objects, click on the Cylinder button in the Object Type rollout under the Create panel. Click the left-mouse button in the Perspective viewport and drag your mouse to the right to define a Radius of 5 for the cylinder. Then move your mouse forward to define a Height of 100. If you have trouble getting these perfect, once you create the cylinder you can simply type the number *5* in the Radius field under the Parameters rollout, the number *100* in the Height field, and press the Enter key.

3. Now we need a cylinder to work with to continue our exercise. Click in the Front viewport and then click the Maximize Viewport toggle button to maximize this view.

4. Now we want to rotate your object 90 degrees in a clockwise direction. Click on the Select and Rotate tool, and then click on the outer gray circle and drag your object to the right until the Y transform field says 90, or close to it. If you do not get it exactly right, just type in *90* in the Y transform field. Yes, you could have just typed in 90 in this field to begin with but we wanted to show you how to rotate the object with your mouse because in some cases you may not know the exact amount you need to rotate the object.

5. In the previous steps you learned how to rotate an object along the Y axis. We would like to take you one step further now and show you how to manipulate an object in a 3D viewport. To rotate the object along the X and Z axes it will be better for you to work in the Perspective viewport. Click on the Maximize

Viewport toggle button to return to the standard four-viewport look for the interface and then click on the cylinder in the Perspective viewport to make it active.

6. You will notice that there is now a 3D sphere of lines inside of the gray circle you used in the Front viewport. The red circle represents the X axis, the green represents the Y axis, and the blue represents the Z axis. The circles will turn yellow when you roll over them. This helps you see which one is currently active. Click on the red circle and drag the mouse toward you until the X transform field says 90, or close to it.

7. Do the same thing with the Z axis. You will notice that using this axis will rotate your object in a manner very similar to the initial X rotation. Note that you can rotate the object along the Y axis in this viewport.

Select and Scale

Select and Scale

The Select and Scale tool provides you with three options for resizing your objects. You can access this tool by clicking on the icon on your main toolbar. The three different scale modes can be accessed by clicking and holding on the Select and Scale button, which will result in a drop-down menu. It does not matter if you select the Uniform Scale rollout button or the Non-uniform Scale rollout button because you can use the Scale gizmo to perform either function no matter which button is checked. We will show you how to do this in material to follow. The third option, the Select and Squash tool, allows you to stretch an object or flatten it. We will discuss these options in more detail in the next few paragraphs and then provide a small exercise to help you get oriented with scaling.

Select and Uniform Scale will allow you to scale the objects equally along their axes. Using Select and Nonuniform scale allows you to scale the object without maintaining its proportions, which can result in objects becoming deformed. What we mean by this is that if you are scaling an object using Select and Non-uniform scale you can adjust the length or width individually, each independent of the other. The final scale tool is the Select and Squash tool. This tool functions in the same manner as its name. It allows you to squash an object so that it becomes distorted while maintaining a constant volume.

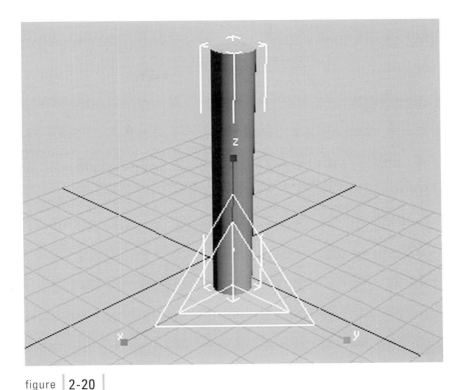

figure | 2-20 |

Transform gizmo of the scale tools.

The Transform gizmo, shown in Figure 2-20, for the scale tools looks a little different from the one we used to rotate our objects. This gizmo looks like a shaded pyramid within a triangle. One thing you will notice when working with this tool is that depending on what section of these triangles you are on your cursor will change to a different style. To perform the actual scaling of the object you need to first decide the orientation of the scale. That is, you can restrict the scaling of an object to an individual axis, or scale an object along multiple axes. To uniformly scale an object that will either enlarge or shrink the object you must place your cursor in the center of the triangle and then click and drag your mouse forward to enlarge, or toward you to shrink, the object. Restricting your scale to affect only one or two axes is called a nonuniform scale. This can be accomplished by moving your mouse over the axis you wish to scale and then clicking and dragging your mouse in the direction you wish to scale the object. You can also scale an object along two axes at one time by moving your

cursor along one of the diagonal edges of the gizmo between those two axes and then clicking and dragging your mouse in the direction you wish to scale the object.

Selecting, Scaling, and Squashing Objects

In the following exercise you will practice selecting, scaling, and squashing objects.

1. Reset Max, and then in the Perspective viewport create a cone with a Radius 1 setting of 25, a Radius 2 setting of 0, and a Height setting of 60.

2. Click on the Select and Uniform Scale button from the main toolbar and then click on your cone in the Perspective viewport.

3. Move your cursor into the center triangle of the Scale gizmo and then click and drag your mouse forward to enlarge the cone. As you can see, you have just uniformly scaled your objects, which have maintained the proportions of your cone. Figure 2-21 shows an example of the difference between a uniform scaling and nonuniform scaling.

figure | 2-21

Transform gizmo of the scale tools.

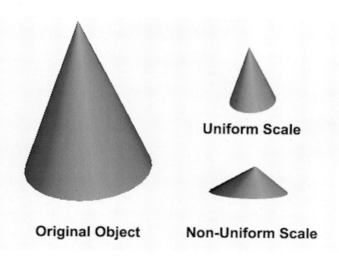

Uniform Scale

Original Object **Non-Uniform Scale**

4. Click on the Z axis and move your mouse toward you to scale the height of the cone. (As you can see, this time you have used a nonuniform scale and have distorted your object.)

5. Click and hold on the Select and Uniform Scale button and then choose Select and Squash.

6. Click on the Z axis once again and move your mouse button toward you to squash the object. (Note that it shrinks the object but makes the edge along the base stretch outward, distorting the object.)

7. Good work, you can either practice scaling other objects if you want to explore these tools further or move on to the next section.

MODIFIERS

When working in 3D modeling you may not always be able to achieve the results you want by using the transform tools or through standard modeling techniques. Sometimes you may need a little help to change the shape of the models you are designing. This is where modifiers come in handy. They allow you to make changes to the shape of your object, to apply mapping coordinates to an object, and perform a few other important functions. The Modifier List is located in the Modify panel next to the Create panel we have been working with. One thing you will notice is that if you click on the Modifier List drop-down it will be empty unless you have an object selected in one of your viewports. Another thing you should know is that depending on what type of object you have selected 3ds max only shows the modifiers that are available for that particular object. We will not be covering all of the modifiers because the list is quite extensive. we are going to give you a basic introduction to the bend modifier and show you how to adjust its settings.

Three Classifications of Modifiers

When looking at your modifier list in 3dDs max 7 you will notice that the modifiers are categorized into three types represented by the options Selection modifiers, World-Space modifiers, and Object-Space modifiers. Selection modifiers are the first of these three groups in the modifier list. They are used to select sub-object sections of your object for applying other modifiers to those particular areas that are selected. So, if you only wanted to use a particular modifier on only a few faces you would want to use Selection

modifiers to select those areas before adding the type of modifier you want. World-space modifiers affect an object based on the object's World space coordinates. Object-space modifiers are used to manipulate individual objects on your screen. If you had a tube selected and added a bend modifier, it would be applied to the selected tube only.

Join the Mod Squad by Modifying Objects

In the following you will practice modifying an object.

1. Reset your scene and create a tube in your Perspective viewport with a Radius 1 setting of 4, a Radius 2 setting of 2, and a Height setting of 100.

2. Zoom your view out so you can see the entire tube, and maximize the Perspective viewport by clicking on the Maximize Viewport toggle button.

3. Select the tube and click on the Modify tab, and then select the Modifier List drop-down.

4. Select the Bend modifier. Make sure the Bend Axis is set to Z and set the Angle to 90. (Note that the object bends from its base.) The tube with the bend modifier applied is shown in Figure 2-22.

5. You can change the direction by clicking and holding the Up arrow in the Direction field to select a positive direction, or the Down arrow to move it in the negative direction. (Either is fine; we just want to show you this feature.)

6. Now let's say you do not want the object to bend from its base and would rather have the bend start in the middle of the tube. Click on the + (plus) next to the Bend modifier in the modifier stack to expand the rollout.

7. Click on the Center option and then click on the Select and Move tool in the main toolbar.

8. Click on the Z axis and move the center point upward so that the bottom of the yellow outline is in the middle of the tube. (Note that the object will bend on either side of its center point now.)

9. Good work. It will take some practice getting used to various modifiers and our suggestion is to create a number of objects

and play around with the settings until you get a good feel for what each modifier can do for you. We will be exploring more modifiers in some of the projects we will be creating throughout this book.

figure | **2-22**

Tube with bend modifier applied.

DETAILED QUAD MENUS

The Quad menus are shortcut menus that allow you to select certain commands without having to jump back and forth around your screen to choose them. To access the Quad menus, perform a right click with your mouse anywhere in the viewport except on the viewport's name. A nice feature of the Quad menus is that once you become more accustomed to some of the tools and features of max you can change these options by clicking on Customize in the main menu and then clicking on Customize User Interface. In this menu you will see a tab at the top that says Quads. This is where you can change any of the features of the Quad menus by adjusting the appropriate settings you wish to change. However, don't go changing any of these features just yet. We want to make sure you have the same menus we do, so that you do not get confused.

The material that follows discusses some of these features in a little more detail and shows you how the Quad menus change depending on what types of objects you have selected in your scene (i.e., what properties are selected). That is, the Quad menus will show the features (such as cameras, lights, mesh objects, or other types of elements) selected in your scene. To use these tools, the first thing you need is an object selected in your viewport.

Display Menu Quad

In the Quad menus the first menu you see is the Display menu. This menu contains elements for isolating a selection, freezing a selection, and hiding objects in your viewport. Figure 2-23 shows the quad menu for creating a mesh primitive. The Display menu commands are outlined in the following.

- *Isolate Selection:* This feature allows you to isolate selected objects so that you can make any transformations to them without having any of your other objects in the way. Once you are finished with isolation mode, you then need to click on the Exit Isolation Mode button in the pop-up window.

- *Freeze Selection and Unfreeze All:* Freeze Selection allows you to freeze the selected object so that it cannot be selected while you are working with other objects in your scene. You can freeze any number of objects in your scene, and then when you are done simply click on the Unfreeze All command to unfreeze all of the objects in your scene.

- *Hide and Unhide options:* These features allow you to hide objects from view so that they do not distract you while working with the other objects you need to adjust. These commands include Unhide by Name (which allows you to specify the object's name you wish to unhide) and Unhide All, which will unhide all hidden objects. Alternatively, you can unhide the selected item.

Transform Menu Quad

In this quad menu you will see all of the transform tools, such as the Move, Rotate, and Scale. You can also clone objects, adjust the properties of the object, access the Curve Editor, establish wire parameters, or convert the object for sub-object editing. The commands in this menu are outlined in the following.

figure | 2-23

Quad menu for a mesh primitive.

- *Move:* This button is a shortcut for activating the Select and Move tool on the main toolbar.

- *Rotate:* This button is used to quickly access the Select and Rotate tool without having to go to the top of the screen and click on it.

- *Scale:* This button is the shortcut for activating the Scale tool from the main toolbar.

- *Clone:* This option allows you to duplicate the selected object. It works the same way as selecting Clone from the Edit menu.

- *Properties:* The Properties feature brings up a list of properties associated with the selected object. It provides you with features for adjusting the object's display properties, rendering control, and other lighting and effects.

- *Curve Editor:* This feature opens the Track View in Curve Editor mode and allows you to edit the function curves of the object. This feature adjusts the curves of your animation, rotation, and a few other features.

- *Wire Parameters:* Wire parameters allow you to link animation and object parameters from one object to another. This option allows an animator to set up constraints outside the track view.

- *Convert To:* This feature allows you to convert your object to an editable mesh, editable poly, editable patch, or NURBS. These elements convert an object so that you can work with the object in sub-object mode. (These elements were covered in the "Working at the Sub-Object Level" section at the beginning of the chapter.)

Tool Quadrants

Tool quadrant options are located on the left side of the Quad menu (see Figure 2-24). They are simply called Tools 1 and Tools 2. They only appear when you have certain objects in your scene (such as lights or cameras) or if you have converted an object to one of the editable sub-object modes. We are not going to break these down individually because depending on the type of object you have selected they will be different. Once you know more about cameras and lights we suggest that you explore these options in the quad. Regarding the sub-object selection commands, they are just a quick way to access the same sub-objects available in the stack view, as well as to access several tools located in the Modify panel. These features include View Align, Attach, Face, Edge, and so on. Most of these features are covered in other sections of the book.

figure | 2-24 |

Quad menu rollout for an object that has the Tool quadrants available.

BOX MODELING AND MESH MODELING

Box modeling is commonly referred to in the industry as mesh modeling, which is performed by manipulating sub-objects of a basic mesh object. This is one of the most common methods of 3D object creation and is usually the first approach new 3D artists use to create their objects. Mesh modeling is really good because no matter what software you use it will allow you to get comfortable with the various transform and sub-object tools. Most 3D software applications, whether high-end or off-the-shelf retail software, provide some capabilities for editing sub-objects. In addition to enabling you to manipulate the mesh itself, mesh modeling allows you to generate sub-objects and vertices from scratch in addition to the base object. The following exercise gives you the chance to explore box and mesh modeling while creating a fun model based on a tasty treat.

Hey, Ice Cream Man, Build Me a Popsicle!

1. Begin by resetting 3ds max.

2. In your Perspective view, create a plane that has a Length setting of 100 and a Width setting of 100.

3. Making sure that the plane is selected, right click in the active viewport and freeze the selection.

figure | 2-25 |

Cylinder with the appropriate settings.

4. In your Perspective viewport, create a cylinder using the Keyboard Entry rollout. Set the Radius to 2 and the Height to 0.5, and then click on the Create button.

5. With the cylinder selected, activate the Modify panel and in the Parameters rollout set the number of Sides to 25, turn on the Slice On feature, set the Slice From to 0 and the Slice To to 180, and check Generate Mapping Coordinates just to get in the habit of doing this in case you wish to apply materials to it at a later time. Figure 2-25 shows the cylinder and the applicable settings.

6. With the cylinder selected, activate the Top viewport by right clicking on it, and turn on the Select and Move transform. Right click on the Select and Move tool to open the Move Transform type-in dialog box.

7. In the Absolute World column, give the cylinder the following coordinates: $X = 0$, $Y = -15$, and $Z = 25$. Once this step is complete, close the Move Transform type-in dialog box.

8. With the cylinder selected, right click in the modifier stack and select Convert To > Editable Mesh. (You can use the quad menus to achieve the same conversion.)

9. Activate the Polygon sub-object mode and in the Perspective viewport use the Arc Rotate tool to rotate your view so that you can see the flat side of the cylinder. Activate the Select Object tool and click on the flat side as shown in Fig-02-26 and then using the control key click on the other polygon next to it to select them both. (We do not want the top or bottom of the cylinder selected but the large flat side.) Figure 2-26 shows the applicable polygons.

figure | 2-26 |

Appropriate polygons selected in the Perspective viewport.

10. Under the Edit Geometry rollout, enter a value of *22* next to the Extrude button.

11. This concludes the construction of the stick portion of our tutorial. Turn off Polygon mode, rename the cylinder *stick*, and give it a beige color from the color swatches.

12. Now we need to construct a popsicle. The first step is to select Capsule (which can be found under the Object Type rollout after selecting Geometry > Extended Primitives from the drop-down list in the Create panel) and create the capsule in the Front viewport with a Radius of 5 and a Height of 40, with 6 Sides. Make sure Smooth is checked and Generate Mapping Coordinates is checked.

13. With the capsule selected in any viewport, right click on the Select and Move tool and set the Absolute World coordinates to (0,0,0).

14. With the capsule still selected, apply an Edit Mesh modifier, and with the Vertex sub-object mode selected select the very bottom vertex, as shown in Figure 2-27.

15. Switch to the top viewport, and in the Soft Selection rollout under the edit mesh settings check the Use Soft Selection box and set Falloff to 10. Using the Select and Move tool, move the vertex selection along the Y axis until a dent is formed at the back of the capsule. Once this is done, uncheck the Use Soft Selection box.

16. Click and drag a selection box around all of the vertices on the other end of the capsule and using the Scale tool with the Percentage Snap on scale the vertices down 40 percent.

17. If you want to make the popsicle longer, move the vertices along the Y axis to extend it. Turn off vertex mode and then move the popsicle down on the stick more to hide some of the stick.

18. Name the capsule *popsicle* and select the color of your choice. Select both objects and group them by selecting Group > Group from the menu bar.

19. In the Front viewport, move the grouped object upward so that the popsicle rests on the plane. Congratulations, you have created your first mesh model!

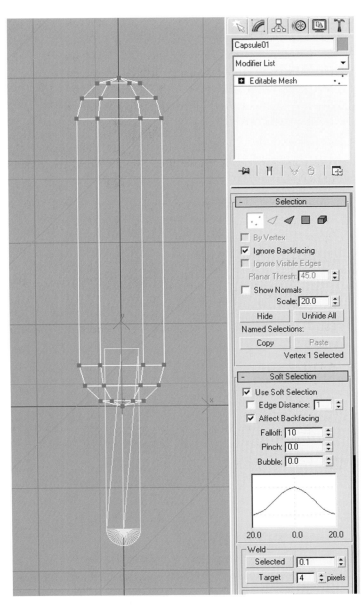

figure | 2-27 |

Bottom vertex selected.

SUMMARY

In this chapter you learned how to create 3D models using a variety of techniques. You learned how to convert an object into an editable mesh, how to manipulate an object at sub-object level, and how to create compound objects using Boolean functions. This is the ground floor and base for modeling much more complex items. We also explored how to add a modifier to bend the orientation of your object. All of these techniques are the groundwork for better things to come.

in review

1. What are the five sub-object levels for an editable mesh when editing an object in sub-object mode?

2. Name each of the scale tools and describe what the differences among them are.

3. How do you access the Quad menus in a 3ds max viewport?

4. Name the three classifications of modifiers.

5. What is the Ignore Backfacing option used for?

6. Name three of the items found in the Transform Quad menu and describe them.

7. How do you convert an object into an editable mesh?

8. What is the Isolate Selection function used for in the Quad menu?

9. What do the colored lines or colored circles represent when using a Transform gizmo?

10. Describe how you would subtract a section from an object using Boolean operations.

⤴ EXPLORING ON YOUR OWN

1. Using the knowledge you have received from the section on Booleans, let's take a bite out of that tasty popsicle you created in the box-modeling exercise. Create another object, such as a cylinder, and cut the cylinder out of the end of the popsicle object to achieve that type of effect.

2. Create some standard primitives and apply some modifiers to them so that you get a feel for using them to manipulate objects.

3. Explore the sub-object levels of various objects by manipulating their vertices, faces, polygons, and edges so that you become comfortable editing at this level.

ADVENTURES IN DESIGN

CUSTOMIZING YOUR WORKSPACE

So far, you have been introduced to the 3ds max 7 interface and the myriad of tools contained in it. In Chapter 1, you got the grand tour of the various toolbars, panel sets, and viewport controls, as well as some of the various viewport shading modes. Chapter 2 started you on polygonal modeling, where you were enlightened in the art of subobject manipulation. As you progressed through the exercises in the chapter, you began utilizing many of the different modeling tools at your disposal, as well as the viewport navigation controls that not only allow you to move around your scenes but aid you in your productivity. The faster you can get around the faster you can work.

One of the big reasons 3ds max has been a tour de force in the industry is its ability to be extremely customizable. It allows an artist to configure the interface to look, feel, and behave exactly how he or she wants it to, which is extremely important to professionals (and students) looking to find a more efficient way to work. The key to being an effective 3D artist (in addition to having a killer imagination) is productivity and efficiency. The more efficiently you can work the more work you can produce, which equates to a happy and satisfied client, art director, or animation supervisor. If you ever have the chance to visit a design firm or production studio and pay close attention to how the artists are working and using their workstations, you will notice that the designers who can "bang out the work" rely heavily on keyboard command shortcuts, which greatly increase the speed at which they can produce finished pieces. In software such as Photoshop, for instance, shortcuts make the artist more productive.

The same holds true with 3ds max. In addition to utilizing keyboard shortcuts, you also have the option of transforming the interface into a working environment that best suits your working style. For instance, by default, the interface has an overall light gray color with nice colorful icons and buttons. We have the option, however, to give the interface and the various interface elements any color we choose. We can alter the window color, the viewport color, the icon pictures, and the viewport layout, and even create custom keyboard shortcuts and quad menus. Because of this, a 3D artist can set up 3ds max to look like an entirely different piece of software altogether. Of course, it usually takes some time to figure out exactly how you prefer to arrange your tools and view your interface. Figures A-1 through A-3 show some possible interface customizations that can be achieved.

Figure A-1. Discreet Dark interface scheme with custom viewport layout.

Figure A-2. Discreet Light interface scheme with custom viewport layout.

Figure A-3. Modular-ToolbarsUI interface scheme with floating command panels..

Pick Your Poision: Utilizing an Interface Scheme

There are many things you can do to "mix things up" within the 3ds max environment. One way, which is probably the easiest way to customize 3ds max, is to import a preexisting interface scheme (referred to as a UI scheme). A scheme has all of the various colors, menus, and tool icons already set up and altered to form a coherent workspace. These schemes primarily affect the interface colors. To load a custom UI scheme, select Customize > Load Custom UI Scheme. An Open dialog window will appear, which will display the available pre-made schemes. Simply select the one you wish to use and then click on OK. The new scheme will load and you are ready to go! If you wish to revert to the factory default scheme, just load the DefaultUI scheme and your interface will return to the standard 3ds max "look."

Staying Afloat

3ds max also allows you to "un-dock" your various toolbars and panels and use them as floating palettes, much like you would in Photoshop or Illustrator. If you move your mouse to

the far edge of a panel or toolbar, you will see what looks like two little pieces of paper next to your mouse pointer. When you see this icon, right click to open a context menu that gives you the choice to dock or float a toolbar or panel, opt whether to hide or unhide interface elements, or to open the Customize User Interface window.

One advantage to this is that you can maximize the area your viewports use, which will give you more elbow room to work with. Even with the larger real estate you get with the floating toolbars and panels (see Figure A-4), some of you might not

like those convenient though sometimes annoying panels hovering above your workspace. 3ds max allows you to hide all panels and toolbars by utilizing Expert mode (Alt + X), which will hide everything but your viewports. This will give you the largest viewable work area possible. While in Expert mode (see Figure A-5), you can utilize your nifty keyboard shortcuts you set up when you customized your interface (or you could use the default key commands). To get those tools back, simply press Alt + X again and you will be returned to normal mode. This will also work when your toolbars are docked.

Figure A-4. 3ds max with floating palettes.

Figure A-5. 3ds max operating in Expert mode.

Customizing Your Ride

Okay, you've read how easy it is to customize your 3D environment. Now it's time to get in there and try out some interfaces. Feel free to deviate from the following exercise and make your own customizations. The point is to streamline your workflow and increase your speed and efficiency. Have fun!

1. Open 3ds max. The first thing we'll do is change our viewport layout. Go to Configure > Viewport Configuration. In the Viewport

Configuration window, select the Layout tab and select a viewport layout of your liking.

2. Select Customize > Customize User Interface. In the dialog window (see Figure A-6), select the Colors tab. On the top left-hand side of the window, under the Elements category, make sure that Viewports is selected from the drop-down list (this should already be active by default). From the scroll pane below the drop-down list, select Viewport Background and then click on the top color swatch on the right and

set the RGB values to R = 90, G = 90, and B = 90. Close the color mixer and click on the Apply Colors Now button to accept the color change while keeping the Customize User Interface window open.

3. Below the Elements category, in the Scheme category, make sure Custom Colors is selected from the drop-down list (again, this should be the default). In the scroll pane below, select Background and then click on the bottom color swatch to the right. Set the RGB values to R = 102, G = 47, and B = 47 to set the overall interface color to a mid-burgundy. Again, click on the Apply Colors Now button.

4. A bit farther down, below the Background option, select the Text option and set the RGB options to R = 183, G = 183, and B = 183. Apply the color and click on the X button in the upper right of the dialog window to close it.

5. Well, it might not be the prettiest looking interface, but at least it gives you the idea of how to go about customizing your workspace. You should note that you can save the schemes you come up with, as well as load them at your convenience.

We really only scratched the surface when it comes to customization of the 3ds max interface, but if you take the time to play a bit with some of the different customization options you will be able to seriously streamline your workflow and really speed up your efficiency.

Figure A-6. Customize User Interface dialog window.

CREATE.

| spline modeling |

3

 charting your course

In the previous chapter we introduced you to 3D modeling using standard 3D primitives found in 3ds max. We showed you how to manipulate the objects at their sub-object levels in order to form more complex creations. We also discussed how you can use modifiers as another way of manipulating an object's appearance. Although those methods are extremely useful, for many modeling situations there will be times when you will need to use other techniques. You will often find that there are many ways to create your models, and as you start to dig into 3ds max 7 a little further it will become much easier for you to determine which method to use.

One alternative method is to use 2D splines and shapes, and then transform them into 3D objects, as discussed in this chapter. This is known as spline modeling. Once you begin working with this style of modeling you will begin to see that it is very similar to designing line art with a 2D graphics application such as Adobe Illustrator. One of the major differences is that instead of being limited to leaving your graphics as a flat 2D design you have the ability to convert them into 3D works of art.

 goals

- **Introduction to 2D shapes and splines**
- **Use lines to draw custom shapes**
- **Work with spline tools and at the spline sub-object level**
- **Explore principles of lofting and lathing**
- **Import files from Adobe Illustrator**

INTRODUCTION TO 2D SHAPES

Shapes are used for a number of situations within 3ds max. Shapes allow you to work with geometry at a 2D level in order to set up the groundwork or structure for a 3D model. Through a combination of techniques we will be discussing in this chapter you will learn how to combine various types of shapes in order to have more control over drawing items you want to create from scratch (instead of having to work with and manipulate existing 3D standard primitives). As you will see when we begin 2D modeling, working with shapes is a little bit different than the operations associated with previous modeling exercises, and may take a little getting used to at first.

When creating a shape in 3ds max you will notice that they appear differently in your viewports than standard 3D primitives. Shapes are made up of vertices, which provide you with an outline of the object, but they do not have any faces or polygons. They will appear as 2D objects in your viewport. To access the various shapes in 3ds max, click on the Create icon and then click on the second tab in from the left (named Shapes). Take a look at Figure 3-1 if you need help finding this panel. Once you have selected the Shapes button, you will notice in the drop-down list below it that there are two options for creating shapes. The first option, which is active by default, is Splines. Splines are a group of vertices and connecting segments used to produce straight or curved lines. If you click on the Down arrow you will see a second method for creating shapes, called NURBS Curves. The term *NURBS* stands for nonuniform rational basis spline. NURBS modeling is used primarily for organic object modeling. This is a complex type of modeling that should be reserved for when you have a strong grasp of the other modeling techniques we are discussing in this book. We wanted to point them out so that you could choose to explore them on your own if you wish.

figure | 3-1 |

Shapes panel.

There are a number of Spline object-type options in 3ds max for creating basic shape types, including Line Spline, Rectangle Spline, and Circle Spline (to name a few of the more commonly used options). When creating your shapes in a viewport, you perform this task the same as when you created the standard primitives used in Chapter 2. Before we begin creating our shapes, we would first like to point out that by default shapes will not render in 3ds max. What this means is that when you render your scenes they will not show up in the final output.

There are two ways to make shapes visible when you render your scene. One way is to convert the shape into a 3D object using a technique such as lofting or extruding the shape via the extrude modifier in the modifiers list. For right now we do not want to explore this option, because we will be working with these methods later in the chapter, when we learn how to convert shapes into 3D objects. We feel that it is better to learn the techniques for controlling the properties of shapes before we turn them into anything 3D.

Creating Shapes

In this exercise we will show you how to create a few of the shapes found in the Shapes panel. Once you create these shapes, we will show you the difference between a shape that is renderable and one that does not have this option turned on.

1. Begin a new 3ds max scene, and then click in the Front viewport to make it active.

2. Let's make our viewport a little cleaner and easier to see by pressing the G key to turn off the viewport grid and then clicking on the Maximize Viewport toggle button to maximize your Front viewport.

3. Click on the Shapes button, select Circle from the Object Type rollout, and draw a circle in your viewport as shown in Figure 3-2.

4. Create a large rectangle to the right of the circle.

5. Click on the Select and Move tool from the main toolbar and select the circle. While holding down the Ctrl key, click on the rectangle to select both items.

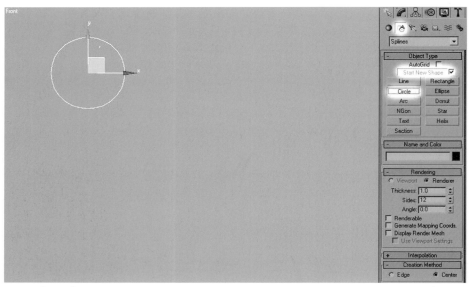

figure | 3-2 |

Circle drawn in viewport.

figure | 3-3 |

Shapes correctly
positioned in view-
port.

6. Clone these two items by holding down the Shift key, clicking
 on the Y axis on your transform gizmo, and dragging it down-
 ward to create a copy of both shapes. In the Clone Options box
 that appears, select Copy, make sure the Number of Copies is
 set to 1 (as it should be by default), and then click on OK.
 Figure 3-3 shows an example of what you should have to this
 point.

7. Now we need to make sure that our objects are renderable. To do this, click on the top left circle in your viewport, and then click on the Modify tab (which you should remember from previous exercises is located next to the Create tab).

8. In the lower right part of the panel you will see a rollout named Rendering. If it is not open, click on the name to open it and then click in the box next to the word *Renderable* , shown in Figure 3-4.

9. Repeat step 8, but this time make sure you select the rectangle that is on the top right.

figure | **3-4**

Making a shape renderable.

10. To show you the difference, we are going to leave the bottom two shapes alone, which do not have the Renderable option checked. Click on the Quick Render (Production) button, which is the teapot button on the far right in the top right-hand corner of your screen. This will render your scene, which will only show the top two shapes. This is because they were checked as Renderable, and the bottom two were not.

The exercise you just completed should provide you with some knowledge for creating 2D shapes in your 3ds max viewport. As you learned from this example, the Renderable option must be turned on for the shapes to appear in your final rendering. This is true of all 2D shapes you will create in Max. Feel free to try creating a few more of the shapes and take a minute to explore how they look in each of your viewports.

Working with Lines

Lines are slightly different than working with regular shapes. This is one of the reasons we did not include them in the previous example and dedicated a separate section in this chapter to creating lines. You probably know from geometry or drawing classes that lines are created when setting a point in motion to create a second point in space. Using the Line tool, you can create straight lines by clicking in your viewport, moving your mouse to set the point in motion, and then clicking again to define the second point. This will create a line in the direction you move your mouse between the two points.

TIP: If you hold down the Shift key while creating a line the line will be constrained perfectly straight and parallel to the World X, Y and Z axes.

Now that you know how to create a straight line, we would also like to point out that you can create curved lines. This is achieved in a very similar manner as using the Pen tool found in many software applications. To create a curved line, you simply click to create the first point, and then click to create the second point (but this time as you click the second point you drag the mouse toward you or away from you).

Designing Line Types

The next exercise is set up to give you a little bit of practice drawing standard and curved lines in your viewport. This is a basic tutorial you can build from in order to draw more complex line types and shapes.

1. Begin a new 3ds max scene, and then click in the Front viewport.

2. To see your splines more clearly for this exercise, press the G key to hide the viewport grid.

3. Now that you have a clean viewport, select the Create tab, click on the Shapes button, and then click on Line from the list of Spline Object Types.

4. To begin your line, click anywhere in your viewport and then move your mouse in any direction to add some length to your line. Then click once again to complete the line.

5. Note that if you move your mouse around you will begin creating a new line segment from the end point of the first line segment. This allows you to create custom shapes that can be more complex. To stop your line at any point, right click.

6. Click on the Line button once again and click a short distance below the first line to begin a second line. Move the mouse to the right to begin creating a horizontal line, but when you click the second point this time hold your left-mouse button down and move the mouse down and to the right in order to create a curved line segment.

7. Let go of the mouse button and then right click your mouse to stop the curved line. Another option when working with lines is to draw a shape and then close the spline to form a custom shape.

8. Click on the Line tool once again and somewhere in your empty space draw a small triangle. When you click on the start point to close the triangle, a dialog box will appear asking you whether to close your spline. Click on Yes.

9. Figure 3-5 shows a completed example of this exercise. You can save this exercise if you wish, but it will not be used again in this book.

figure | 3-5

Completed exercise.

As mentioned previously, this was just a small practice exercise in order to get you oriented with creating some basic lines. We encourage you to elaborate on the items created here in order to create more complex and custom shapes. Through practice you will be able to enhance your skills and start to visualize how you can connect these different styles of modeling to model more efficiently. Once you start to get a feel for the best way of creating

objects your productivity will increase and your modeling will become much easier.

SPLINE SUB-OBJECTS

Working with spline sub-objects is fairly similar to working at the sub-object levels of a 3D mesh (Chapter 2). Once you create your shape you can convert the shape to an editable spline by right clicking on the shape with your mouse and then selecting Convert To > Convert to Editable Spline. If you look below your modifiers list, where it says Editable Spline, you will see that it has the same little symbol for expanding the sub-object sections when we used the editable mesh properties for modifying a mesh. You can edit a spline in three different modes: vertex, segment, and spline (outlined in the following). If you look below this window in 3ds max 7, in the selection rollout you will see that you can choose these options in this section as well. You can also use the Edit Spline modifier to allow you access to sub-object levels of a spline.

- *Vertex:* Selecting a vertex will allow you to move or manipulate the individual vertices that make up your 2D spline.

- *Segment:* Selecting a segment will select the area between two adjacent vertices.

- *Spline:* Selecting by spline will allow you to click on the entire spline. This is useful for when you need to select the individual splines within a compound shape.

Customizing Splines and Shapes

As you just learned, when creating splines you have the ability to manipulate them by converting your shapes into editable splines or using the Edit Spline modifier. This will allow you to adjust the spline using one of the three spline sub-object modes described in the preceding list. These methods work in the same manner as manipulating the sub-object levels of a 3D mesh, so you should already have a good grasp on this information. When working with splines you also have the ability to create custom shapes by combining multiple splines into one shape. Now that you understand how they work, let's put your skills to use in a small exercise.

1. Begin a new 3ds max scene and in the Front viewport draw a rectangle with a Length setting of 50 and a Width setting of 60.

2. Now we need to uncheck the Start New Shape checkbox in the Object Type rollout. This will allow us to add more shapes to the current shape without separating them into two different shapes.

3. Click on the Circle tool and draw a circle next to your rectangle that has a radius of 20. Once you create the circle you will notice that if you move either of the shapes the two shapes move together. The two noncontiguous splines are shown in Figure 3-6.

figure | 3-6

Viewport with the two noncontiguous splines within a single shape.

4. Go to the Modify panel and click on the Spline sub-object button in the Selection rollout, and then click on the outline of the circle and move it so that it is centered within the rectangle.

5. Click on the Vertex sub-object button and select both of the vertices at the top of the rectangle. You will see a series of colored squares appear. The red squares are for manipulating the selected vertices, and the green squares can be used to adjust the curves of your line between the vertices.

6. Select the green colored square icon on the left at the top of your shape and move it upward, which will create a curve. Now do the same thing to the square icon on the top right so that it is in the position shown in Figure 3-7.

7. Select the Segment sub-object button and then click on the bottom line of your rectangle and move it downward. As you

figure | 3-7 |

Custom shape with
curved top and
handles visible.

see, using segment sub-object mode will allow you to move
the segment between two vertices.

8. Save this file as *Ch3_customshape.max*, because we will be
 working with it again in just a few minutes.

MAKING SPLINES 3D (BEVEL AND EXTRUDE MODIFIERS)

Working with 2D shapes to build models is often a good technique
for setting up the base of your models. Often you will find that you
need to make some modifications to these shapes, because when
working with 3D applications your ultimate goal is to create 3D
renderable graphics. In this section we will be discussing how to
apply Bevel and Extrude modifiers to add some thickness to your
2D shapes, as well as to apply beveling to the shapes edges.

Beveling a Shape

To practice beveling a shape, try the following exercise.

1. Begin a new 3ds max scene, and then click in the Top view-
 port.

2. In the Top viewport create a rectangle that has a Length setting
 of 35 and a Width setting of 100.

3. Select the rectangle you just created, and then in the Modifier
 List (found in the Modify tab) apply a Bevel modifier to your
 object. If you look at your Perspective viewport you will notice

that adding this modifier has filled in your shape, making it solid. The shape will now appear renderable, as shown in Figure 3-8.

4. In the Bevel Values rollout, enter the number *20* in the Start Outline field. The start outline sets how far the distance of the outline is offset from the original shape.

figure | 3-8

Renderable shape.

5. In Level 1 set Height to 13 and Outline to 11. Level 1 allows you to determine or control the distance above the start level by defining the Height, and the Outline value determines how far to offset level 1 from your start outline.

6. Click in the checkbox to enable Level 2 and set Height to 8.0 and Outline to -0.0.

7. Your final result should look like the beveled shape shown in Figure 3-9.

As you can see, beveling can be used to enhance the edges and structure of your 2D shapes and transform them into 3D objects. You can use the Bevel modifier to create 3D beveled buttons for

figure | 3-9

Completed beveled shape.

multimedia and other user interfaces. We would also like to provide you with another example of how you can use the Bevel modifier on text to enhance its appearance in 3ds max 7. We encourage you to explore beveling further with various shapes to become more comfortable with this technique. One way to relate this back to the graphic design industry is to associate this technique with the Bevel and Emboss filter of Adobe Photoshop. We use this filter a lot when creating buttons and adding special effects to our text. You will find that you can produce many of these same effects in the 3D world.

Working with the Extrude Modifier

As previously mentioned, extruding shapes allows you to transform a 2D shape into a 3D object. One of the reasons this is a very useful technique is that you have the ability to design customized shapes and are not limited to using standard primitives. You will find that this method is very simple and is an effective technique for creating 3D objects. In the following exercise you will work with the Extrude modifier.

1. Begin a new 3ds max scene and click in your Top viewport.

2. Draw a circle, a rectangle, an *n*-gon, and a square in the Front viewport. The size of these does not matter for this exercise. (Note that holding down the Ctrl key will restrict the rectangle to be a square.)

3. Now that you have your objects, it's time to extrude them. Click on the circle and then in the Modify tab select the Extrude modifier.

4. In the Parameters rollout, set Amount to 50 and then press Enter. You will notice that your shape has now extruded 50 units.

5. Click on the other three shapes and repeat step 4 to extrude each of them 50 units.

Now that you have learned how to extrude shapes, you can have a little fun creating new 3D objects from your 2D splines. This Extrude modifier will work on your custom shapes like the one we created in the spline sub-object exercise. Open the *Ch3_customshape.max* file you saved a few minutes ago. Make sure you exit the Segment level first, and then apply an Extrude modifier to it

and set Amount to 20. If you did not save this exercise, you can open it from the *Ch3* files on the companion CD-ROM. As you can see, extruding the shape produces a result like that shown in Figure 3-10. The center circle you placed within the rectangle is hollow. This happens because when we unchecked the Start New Shape option before we created the circle it allowed us to combine the circle with the rectangle as one shape. The area between the rectangle and the circle is what 3ds max understands.

Perspective

figure | 3-10

Completed view of the extruded multi-spline shape.

LATHE MODIFIER

As mentioned previously, throughout this book we will be introducing you to various modifiers as needed for our exercises. Remember that modifiers allow you to make alterations to the structure and properties of your objects. The Lathe modifier is used to rotate a spline or NURBS curve around an axis to create a 3D object. You can specify a value for this rotation in the range of zero to 360 degrees. When working with the Lathe modifier, it is

figure | 3-11 |

Rough outlined shape to be lathed.

figure | 3-12 |

View of shape with point to be selected.

best to create an open 2D shape. In the following exercise you will work with the Lathe modifier.

1. Begin a new 3ds max scene, click in the Front viewport to make it active, and then maximize this viewport.

2. Select the Line tool, click on the Snap toggle, and select the 2D Snap option from the flyout.

3. Create a shape similar to that shown in Figure 3-11. As you can see, in the example we created the rough outline on purpose so that you did not think you had to make the shape perfect. We can manipulate the sub-object levels of the line to make our design more precise.

4. Turn off the 2D Snap toggle, click on your shape if it's not only selected, and then select the Modify tab so that we can access the sub-object levels of your shape. Using the Vertex sub-object level, select the point shown in Figure 3-12.

5. Move this point so that the line is a little bit straighter than it was before, and then click on the second vertex to the left of this one. Because

this point was curved, you will notice that you have what is called a Bezier handle. This can be used to manipulate the shape of the curve.

6. Manipulate this vertex so that it produces a smoother curve, heading toward point 3 above the vertex. Select point 3 and move it so that the curve between point 2 and point 3 looks like that shown in Figure 3-13.

figure | 3-13

Example of modified shape.

figure | 3-14

Final shape manip-
ulation to be lathed.

7. Now let's smooth the curve between points 3 and 4. Click on point 4 to the left of your third vertex at the top, and then select Smooth under the Tools 1 area of the Quad menu.

8. Using the same techniques as those in the previous steps for manipulating our points, manipulate each of the remaining points until you have a shape you feel comfortable with. Figure 3-14 shows an example of the final shape we created to use for our lathe.

9. Now you are ready to lathe your shape. Turn off sub-object mode and go up to the Modifier List and select Lathe.

10. Make sure your Degrees setting is set to 360.0, and then click on the button that says Max in the Align area to complete the exercise. The completed candlestick is shown in Figure 3-15.

figure | 3-15 |

Final candlestick.

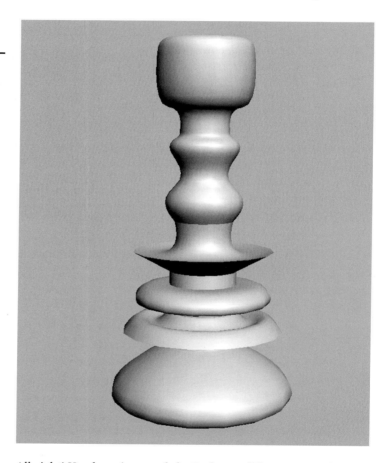

All right! You have just used the Lathe modifier on your shape to create a very cool-looking candlestick. Let's talk about some of the items within the Lathe modifier's rollout that you just came across. Figure 3–16 shows you the parameters for the Lathe modifier that we will be discussing. These settings control the way the Lathe modifier reacts to your object, as well as how the object will function in different situations. We wanted you to see that the items we chose for the previous exercise were picked for a reason and not just random figures. We feel it is best to inform you of how to use

UTSA Libraries
www.lib.utsa.edu

**To avoid fines return
your books
by the due date.**

50¢ per day, per book

Higher fines apply for:
*Reserve Books
Multimedia Materials*

For more information:
http://lib.utsa.edu/Services/
Circulation/fineschedule

**Need to keep your books
or videos longer?**
Use our
Online Renewal Service:

http://lib.utsa.edu/Services/
Circulation/renew

JPL Hours
Open continuously
(24 Hrs) Sunday 1p.m
through Friday 9 p.m.
Saturday
9 a.m. – 9 p.m.

For more information:
http://lib.utsa.edu/About/Hours

UTSA Libraries
www.lib.utsa.edu

**Need a group study room
for an exam or project?**

http://lib.utsa.edu/Services/
General/study
OR
Call us at (210) 458-4574

**Need a computer for
papers or presentations?**
Visit the *Library Electronic
Classroom (LEC)* UTSA's
only 24 hour computer lab.

**Can't find books or
journal articles you need
at the UTSA Libraries?**
Use our
Interlibrary Loan Service:

Fill an online form:
http://lib.utsa.edu/Services/Ill
OR
Call us (210) 458-5501

Important Numbers:
Circulation Desk
1604: (210) 458-4574
Downtown:
(210) 458-2440

Reference Desk
1604: (210) 458-4573
Downtown:
(210) 458-2446

Multimedia Center
(210) 458-5503

each of these settings, outlined in the following, whereby you can explore lathing more on your own to create some unique 3D designs.

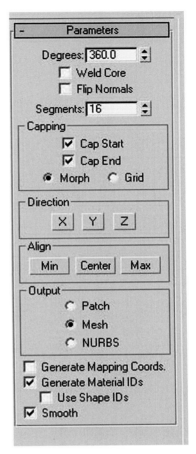

- *Degrees:* Used to determine how many degrees your object will be rotated around its axis. The values can range from 0 to 360 degrees.

- *Weld Core:* Used to break down your mesh by joining vertices that appear on the axis of revolution.

- *Flip Normals:* If your object was turned inside out because of the way you rotated it or the direction of your original vertices, this feature will help you flip the shape to fix this problem.

- *Segments:* Determines how many interpolated segments are created in your newly created surface between the beginning and end points.

- *Cap Start:* This is the start of your lathed object when you are using a Degrees setting value that is less than 360.

- *Cap End:* Will cap the end of your object when you are using a Degrees setting value less than 360.

figure | 3-16 |

Lathe modifier parameter options.

- *Morph:* Arranges cap faces in a repeatable pattern used to create morph targets.

- *Grid* – is used to position faces in a square grid that is trimmed at its boundaries.

- *X-Y-Z Direction:* Specifies the direction the lathe will occur from the object's pivot point.

- *Min-Center-Max Align:* Used to set the axis of revolution to the minimum, center, and maximum extents of the shape.

- *Output:* These choices will determine how the structure of your object is created and what options you have for manipulating its levels. Patch, Mesh, and NURBS will create an object that can be manipulated as a patch, editable mesh, or NURBS object.

● *Generate Mapping Coords/Material IDs:* These choices allow you to create mapping coordinates for your object or to set up Material IDs that multiobject and sub-object materials can be applied to.

THE BASICS OF LOFTING

We have discussed various methods of creating objects using standard 2D shapes, as well as how to use the Line tool to draw custom shapes. Another method for creating 3D objects when modeling with shapes is called lofting. To create a lofted object you must first create a path. This path will be the path your loft object conforms to. You then need to draw another spline to use as the cross sections of your object. When you combine the path with your second shape, it will third solid object. The following exercise shows you how to construct a lofted 3D object.

1. Begin a new 3ds max scene, click in the Front viewport, and press the G key to turn off the viewport grid.

2. Using your Line tool in the Front viewport, draw a path similar to that shown in Figure 3-17.

3. Now that you have created the path for your object, we need to choose the shape we will be using to create our cross sections. Select the Circle tool and draw a circle that has a radius of 25. You can input the radius setting in the Parameters rollout, shown in Figure 3-18.

figure | 3-17

Example of the path from step 2.

4. Once you have both your path and your shape it is time to loft your object. We are going to start by selecting our path. Using the Select Object tool, click on the path to select it.

5. Now that we have our object selected, to loft the shape you need to click on the Geometry button found in the Create panel. Once you click on the Geometry button, click on the drop-down menu below it and select Compound Objects from the list.

6. Click on Loft under the Object Type rollout, and in the Creation Method rollout make sure Instance is selected. Click on the Get Shape button, and then select the circle in your viewport.

7. You will see that the circle has been lofted along the path and is now a 3D shape. Switch to your Perspective viewport so that you can see the transformation in 3D. Figure 3-19 shows the completed loft.

figure | 3-18 |

Parameters rollout for Radius setting input.

figure | 3-19 |

Completed loft object.

SPLINE CAGES (USING SPLINES AS A FRAMEWORK)

Using spline cages is a form of polygonal modeling that falls somewhere between mesh and NURBS modeling. Using them allows you to create organic forms without having to know how to manipulate NURBS objects. These are good for beginners just starting out because they will help you get acquainted with the concept of working with cross sections and surfaces that are generated for them.

To build an object with this method, you would first create the basic shape of the object with splines. Instead of using actual tools, the rest of the process is done through the use of two modifiers: CrossSection and Surface.

Building a Golf Tee

In the following exercise you will work with spline cages.

1. Open the *Ch3_golftee.max* file from the *Ch3* folder on the companion CD-ROM. As you can see, we provided you with the shapes already set up so that you can focus on what surface tools allow you to do rather than spending a lot of time trying to line up your circles properly.

2. We need to connect these circles into one shape so that we can apply the CrossSection modifier to build our framework for the surface. In your Perspective viewport, click on the circle at the very top and convert it to an editable spline.

3. In the Geometry rollout, click on the button that says Attach, and then click each of the circles beneath the top one. This will merge all circles into a multi-spline shape.

4. In the Modifier List, click on the CrossSection modifier to join the shapes to construct your framework. As you will see in Figure 3-20, our spline framework has now taken shape.

5. Apply the Surface modifier to your object and watch how Max applies the surface to your framework. The completed golf tee is shown in Figure 3-21.

figure | 3-20 |

figure | 3-21 |

Spline framework after CrossSection modifier applied.

Completed golf tee with Surface modifier applied.

IMPORTING ADOBE ILLUSTRATOR FILES

One of the great things about 3ds max is that it supports many different file types from a variety of outside software applications. One application we have found to be a great source for creating 2D shapes and designs is Adobe Illustrator. Even though you can produce the same types of items using a number of elements in 3ds max (such as combining shapes and creating custom shapes with splines or curves), we feel that bringing this to your attention will provide you with another alternative if you feel more comfortable working with graphic design applications. To begin using this method there are some important things to remember in order to make sure your designs can be successfully converted into 3D objects in max. The key to designing line-art drawings in Adobe Illustrator is to make sure you are using closed shapes and lines that contain no fills. You need to make sure your shapes have a stroke color set, which will allow you to use the Extrude modifier of 3ds max to convert the shape into a 3D object. These shapes can

also be converted into editable splines to allow further manipulation in Max. For now, let's discuss some of the basics for working with shapes in Adobe Illustrator.

Let's explore this method a little further in the following exercise and create a simple graphic in Adobe Illustrator that we will import into 3ds max. This will help you get a good grip on the process we are describing. Take a break from 3ds max for a moment and jump over to Adobe Illustrator. To further demonstrate how versatile you can be with this process, we will export our illustration as an AutoCAD file. If you do not have Illustrator, don't worry; we will provide you with the file you will need to import into 3ds max for the second part of this exercise.

1. In Adobe Illustrator, create two rectangles and position them as shown in Figure 3-22. One thing to take note of is that the negative space between the two rectangles will be the area extruded once the Extrude modifier is applied.

figure | **3-22** |

Position of rectangles in our Illustrator document.

Negative Space

2. Let's add some text to this so that you can see how it works with 3ds max. Make sure your stoke color is set to Black and the fill is set to None. Using the Text tool in Adobe Illustrator, select Arial as your font and set Font Size to 100 pt. Type *Extrude* into the center of your two rectangles.

3. In Adobe Illustrator, select File > Export. In the File name field, type *illtemplate*; make sure *Save as type* is set to AutoCAD Drawing; and click on Save.

4. In the next dialog box, make sure to check Outline Text at the bottom of the box, and then select OK to accept the default options to complete your save.

5. Open 3ds max 7, click on your Front viewport so that it is active, and then select File > Import from the main menu. Select the *illtemplate.dwg* file that you saved from Adobe Illustrator and then click on Open.

6. You will now receive a small dialog box labeled AutoCAD DWG/DXF Import Options. Simply click on OK.

7. Select both the rectangular shape and the text, and then apply an Extrude modifier to it with the amount of 50.

Good work. You have transformed 2D shapes from a vector-based application into 3D objects. We have found that the DWG format is very reliable and is an excellent file type for importing files into 3ds max. Version 7 allows for file linking which provides an even more streamlined workflow.

SUMMARY

In this chapter you learned how to create 3D objects from basic 2D shapes. We discussed the creation of objects using lofting and lathing techniques, worked with spline sub-object levels, and used spline tools to give you better control for creating your models. You also learned how to use the Bevel and Extrude modifiers to manipulate your shapes. Another useful item you learned was how to use Adobe Illustrator to create 2D line art used to create a 3D model. You will find that in 3D modeling you will often use outside applications to enhance the power of 3ds max.

in review

1. Describe how to loft an object.

2. Name three spline object types in 3ds max 7.

3. What does the Lathe modifier do when applied to a 2D shape?

4. Describe a scenario in which you would want to apply the Bevel modifier.

5. What file format works well when importing Adobe Illustrator drawings into 3ds max?

6. Describe the steps needed to make a shape renderable.

7. Describe the process of Lathing an object.

8. In lathing, what do the Min, Center, and Max options do?

9. How do you convert a shape into an editable spline?

10. What are spline cages used for?

◢ EXPLORING ON YOUR OWN

1. Experiment with the techniques covered in this chapter, using some of the shapes we did not cover in order to see how they react in certain situations.

2. Begin by using Adobe Illustrator to create a line-art design such as a logo or a signage project, and then import the file into 3ds max to turn the design into a 3D model.

3. Using the shape tools in 3ds max, design a 2D interface for a multimedia project or web site, and then apply modifiers such as Extrude and Bevel to give the interface a 3D appearance.

IMAGINE.

| patch modeling |

4

 charting your course

So far you have been introduced to various modeling techniques in 3ds max 7. These techniques include primitive modeling, box modeling, and spline modeling. Now that you have a few of these methods under your belt, we would like to teach you yet another way to create your 3D models. This technique is called Bezier patch modeling.

Patch modeling is a technique used for organic modeling such as character creation. In this chapter you will learn the basics of working with Bezier patch modeling so that you can expand your skills in 3ds max 7. We will explore various properties of patches, teaching you how to construct and manipulate patches. The chapter also explores patch properties so that you can have more control over your models.

 goals

- Introduction to the basics of patch modeling
- Explore patch types and their functions
- Work with patches at the spline sub-object level
- Subdivide and attach multiple patches

INTRODUCTION TO PATCH MODELING

For those of you familiar with using a gradient mesh in programs such as Adobe Illustrator, you will find that patch modeling has a similar feel. There are a few methods for creating patches we will introduce you to in this chapter. The first method we will be discussing involves the creation of patch grids. The second method for creating a patch is by converting any object to an editable patch. Patches are useful for organic modeling. We will be looking at ways of modifying and manipulating patches throughout this chapter.

Working with Patch Grids

To create a patch grid you must select Patch Grids from the drop-down list in the Create > Geometry panel. You will notice that you have two types of patches available in the Object Type rollout. These method options are Quad Patch and Tri Patch. A quad patch is a flat grid consisting of a series of rectangles. The major difference between these two types of patches it that tri patches are made up of triangular patches instead of the rectangular ones found in a quad patch. An important thing to remember when working with tri patches is that they will always contain 72 triangular faces no matter how large or small your patch grid is. These faces will grow when you increase the size of a patch or shrink if you decrease its size.

Creating a Quad Patch

In this section we are going to show you how to create a quad patch, as well as inform you of the menu options available in the Parameters rollout for creating the patch and how they affect your patch. Let's begin by creating a simple quad patch. In the following exercise you will be simply creating a patch so that you can follow along with the information that we will be discussing.

1. Select the Create button and select Geometry.

2. In the drop-down list select Patch Grids, and then click on Quad Patch. In your Top viewport, click and drag to create a patch. Don't worry about the size for now, because we will set that in just a minute.

3. Set the Length and Width options for the patch in the Parameters rollout to 50.

4. Set the number of Length and Width segments to 4.

5. You should now have a quad patch that looks like that shown in Figure 4-1.

6. Save this file as *Ch_04_01.max* and keep this file open because we will be reviewing it in the next section.

figure | **4-1**

Quad patch.

Now that we have created our basic quad patch, let's take a look at options in the Parameters rollout. The Length and Width options determine the size of our patch, as they do for standard primitives and basic shapes. The Segment Length and Segment Width determine the number of control vertices our patch contains. Control vertices are used to manipulate the curves in our objects. You will notice that at this point you do not have much control over your patch and it looks simply like a standard grid. This is because patch grids must be converted into an editable patch before you can manipulate them at their sub-object levels. We will discuss this technique in just a few minutes. You can close this file for now. We will come back to it later in this chapter.

Working with a Tri Patch

In the previous section we showed you how to create a quad patch, but before we move on and do more with it we want to make sure you are aware of how to create a tri patch. These steps are almost identical to creating the quad patch, so you may wonder why we are showing you this. The point is to highlight their differences, such as how they appear in your viewport. In the following exercise you will create a simple tri patch.

1. Select the Create button and select Geometry.

2. In the drop-down list, select Patch Grids and Tri Patch. Create a tri patch in the Top viewport by clicking and dragging out the patch. Do not worry about the size for now.

3. Click on the patch, select the Modify panel, and set the Length and Width options of the patch in the Parameters rollout to 50.

4. You should now have a tri patch that looks like that shown in Figure 4-2.

5. Save this file as *Ch_04_02.max* and keep this file open because we will be reviewing it in the next section.

Now you that you have had the opportunity to create both basic patch grid types, you can see that there are no length or width segments available in a tri patch. You can also see from the two examples just created that a quad patch consists of rectangular patches and a tri patch consists of triangular patches. If you did not follow along and create the previous examples, Figure 4-3 shows an example of the two patch types side by side in the Top viewport.

figure | 4-2

Creating a tri patch.

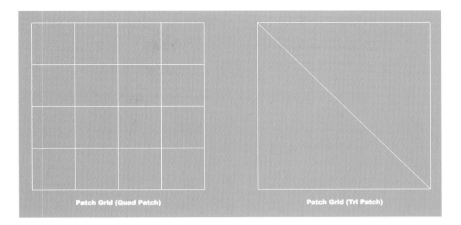

Patch Grid (Quad Patch) Patch Grid (Tri Patch)

SUB-OBJECTS OF AN EDITABLE PATCH

In this section we are going to take a look at the sub-objects of a quad patch and a tri patch. These sub-object levels are the same for both types of patches. We will be using the quad patch file created in the quad patch exercise to discuss these levels. Open the *Ch_04_01.max* file you saved in the quad patch exercise. If you did not save it or did not create the example, you can find this file in the *Ch4* folder on the companion CD-ROM. Now that you have your file open, we need to convert your quad patch to an editable patch so that we can take a look at the sub-object levels and further manipulate it. To do this, select the quad patch in your viewport, right click on the patch, and then select Convert To > Convert to Editable Patch, as shown in Figure 4-4.

figure | 4-3

Quad patch versus tri patch.

figure | 4-4

Converting to an editable patch.

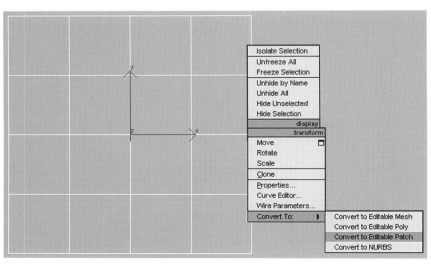

Types of Sub-Object Levels

Now that you have converted your quad patch into an editable patch you will see a number of sub-object selections available in the Selection rollout. We are going to take a few minutes to introduce you to each of these sub-object modes and to tell you how to use each of them. There are five sub-object levels you can use to make selections to your object. These sub-object mode options are Vertex, Handle, Edge, Patch, and Element. The following outlines these sub-object levels and explains their functionality.

● *Vertex:* The Vertex sub-object level, shown in Figure 4-5, is very similar to working with the Vertex sub-object level of the other modeling techniques we discussed in previous chapters. One of the big differences is that you can manipulate its handles to adjust the curve of the selected vertex.

figure | **4-5** |

Selected vertex with control handles.

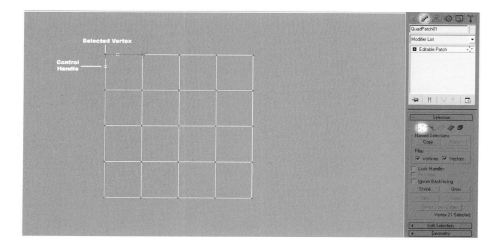

● *Handle:* Allows you to select and manipulate a control handle for each vertex without selecting the actual vertex. As you can see in Figure 4-6, each of the small squares are handles that can be used to modify the patch.

● *Edge:* An edge, shown in Figure 4-7, is a boundary line between two vertices of the patch object. You can modify edges through a technique known as subdividing in order to add more patches to your existing patch grid.

● *Patch:* This option selects an entire patch. It is very similar to selecting in the polygon sub-object mode of 3D primitives.

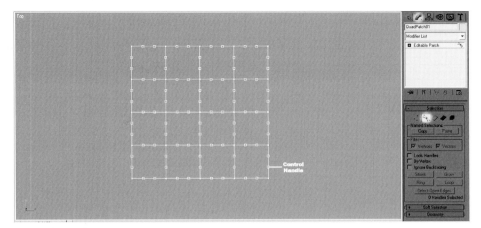

figure | 4-6

Control handles of the patch in sub-object mode.

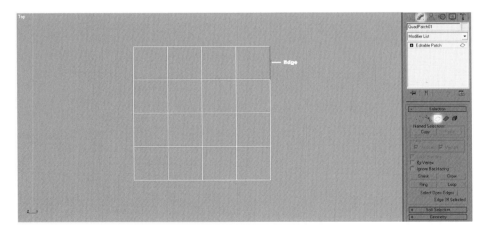

figure | 4-7

Selected edge in sub-object mode.

Selecting with the Patch sub-object level (see Figure 4-8) allows you to delete, detach, or subdivide your patch.

● *Element:* This option allows you to select the entire element of the patch, as shown in Figure 4-9. It is very similar to using the Element option for modifying sub-object levels of a 3D object.

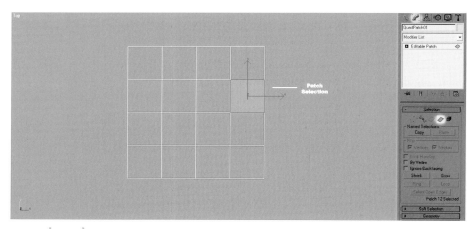

figure **4-8**

Selected patch in sub-object mode.

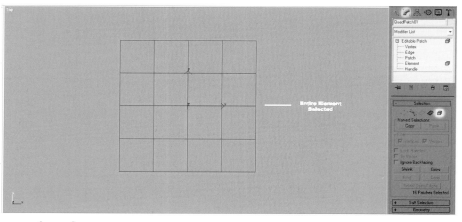

figure **4-9**

Selected element in sub-object mode.

SUBDIVIDING PATCHES

When working with patches you will see an area in the Geometry rollout named Subdivision. This mode allows you to break up your patch selections into multiple patches. In the following exercise we will take a look at how this option works. Open and follow along with the *Ch_04_02.max* file, which is the tri patch you created earlier in this chapter.

1. Convert the tri patch into an editable patch so that we can begin editing this patch using its sub-object levels.

2. Select the Patch sub-object button and click on one of the two triangular patches of your patch grid.

3. Click on the Subdivide button to divide your patch.

4. As you just saw, this has now subdivided the selected patch area to create four new triangular patches with new control handles.

5. Go up to the Edit menu and click on Undo Patch Subdivide, so that we can show you what the Propagate feature does when it is turned on.

6. Click in the box next to the word *Propagate* in order to activate this option, and then click on the Subdivide button once again.

7. Figure 4-10 shows an example of both of these subdivisions deselected side by side in the Top viewport.

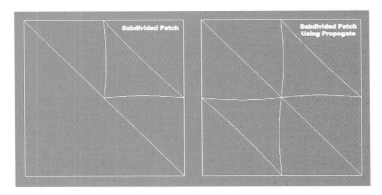

figure | **4-10**

Side-by-side examples of subdivided patch.

Good work. You do not need to save this example. As you can see, the Propagate option subdivides all surrounding patches and not just the one that was selected. This can be useful for when you need to create more control handles to manipulate your patch further.

PATCH TOPOLOGY

In the Topology area of the Geometry rollout you will see a number of buttons for functions such as adding, attaching, deleting,

and detaching patches when working at the sub-object levels. In this section we will take a look at these features and discuss how they can be used to manipulate a patch. The first two items we will discuss are the Add Tri and Add Quad options. These two buttons are used to add a tri patch or a quad patch to the selected edge of an existing patch. To use them, remember that your patch grid must first be converted to an editable patch. Once your object is converted, you need to select the edge where you wish to add the new patch. So, you would simply select that edge and then click on the Add Tri or Add Quad button to add the patch type you want. Figure 4-11 shows an example of the process we just discussed for adding a patch to an existing patch. You can use this method to add a patch to any edge of an existing patch, but be careful not to add more than you need or you may end up with a patch that is too complex and misbehaves when you try to modify it.

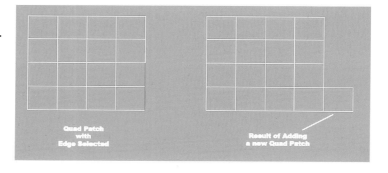

figure | 4-11

Adding a quad patch to an existing patch.

The next two items you will see in the Geometry rollout under Topology are the Create and Detach buttons. Create provides you with a free-form drawing method for creating a tri patch or quad patch in order to add patches to an existing object, which is very similar to working with the Pen tool of graphic design applications to create new points when drawing shapes. If you take a look at Figure 4-12, you will see an example of a patch added onto an existing quad patch using the Create feature. This is very useful when you need a specific shape for your new patch. You can click on the Create button to activate its functionality, and then click on a vertex in the Patch sub-object level and draw either a tri patch or a quad patch connected to that vertex. If you want to draw a tri patch you need to click to create a starting point (which would be on the first vertex), move your mouse where you wish to make the second point, click a third time to define your third point, and

right click to finish your tri patch. If you wanted to create a quad patch you would do the same thing except that you would add a fourth point to the patch you create instead of just three.

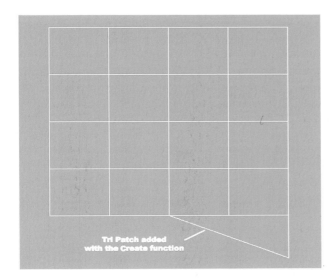

figure | 4-12 |

Adding a tri patch using the Create option.

Another useful feature you will find in this menu is the Detach function. To use this you must first select a patch using the Patch sub-object mode, and then click on the Detach button. This will remove the selected patch, or multiple patches, from the existing patch grid, as indicated in Figure 4-13. The detached patches now become a separate patch, and you will receive a message box that asks you to rename your new patch.

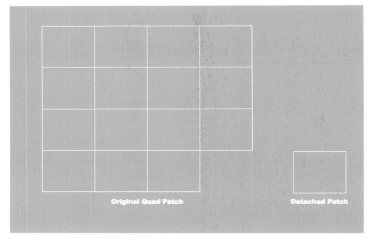

figure | 4-13 |

Detached section of a quad patch.

The final options you will find in this section of the rollout are Reorient, Copy, Delete, Hide, and Unhide All. When you activate the Reorient option, Max will reorient an attached patch to align its local coordinate system with the creation local coordinate system of the selected patch. Copy will make a copy of a detached patch as a separate item, which would be kind of like cloning a patch without changing the original patch. The Delete button will delete a selected patch or multiple selected patches. The Hide option will hide your selected patch in the viewport, and Unhide All will make them all reappear again.

Below this section you will see a new section named Weld, as well as one named Extrude & Bevel. The Selected and Target buttons will allow you to combine two or more vertices, leaving you with a single vertex. The final section we will discuss is the Extrude & Bevel section. As you remember from working with splines, you can extrude an object to give it depth in 3D space. This is also true for working with patches. You can extrude sections of a patch to give it some depth. The extrude and bevel options allow you to extrude your patch and bevel the edges of the patch. We are not going to spend a lot of time going through each of these because you should be somewhat familiar with the options, which are very similar as those you used to modify splines.

CONSTRUCTING A TABLECLOTH

Now that you have more knowledge of working with patches we would like to put the techniques and information you learned to good use. In this exercise we will construct a simple table and then create a tablecloth using a quad patch to cover the top of our modeled table. The first thing we will need to do is model the table. Instead of giving you the file we feel that it would provide you with more practice with various modeling techniques to create it yourself. We will model a generic table out of standard primitives, and then the tablecloth will be created using a patch grid.

1. Reset 3ds max. Begin by creating a box in your Perspective viewport that has a Length setting of 60, Width setting of 150, and Height setting of 2.5. This will serve as the main body of the table. Set the object color to a brown color.

2. Now that you have the tabletop, we need to create some legs to hold the table up. Create a new box that has a Length setting

of 4, a Width setting of 4, and a Height setting of 36. Set this color to the same color you picked for the table.

3. We want to add a little more definition to the table leg. To do this, convert the table leg into an editable poly.

4. Select the vertex sub-object mode and select all of the vertices on the bottom of your table leg box. Use the Select and Uniform Scale tool and uniformly shrink the bottom vertices so that they are slightly smaller than the top vertices. This will pull the bottom of your table leg closer together near the bottom of it.

5. Turn off the sub-object mode. Position the table leg in your Top and Front viewports so that it is the left leg on the side of the table closest to you. Figure 4-14 shows the table leg positioned in the correct place on the table.

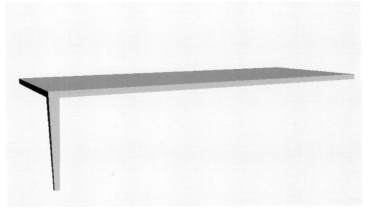

figure | **4-14**

Table with leg in the correct position.

6. Clone the table leg and place a leg at each corner of the table so that you have a total of four legs on your table. Select all of the pieces of your table and group them by selecting Group under the Group menu. Name the group *Table.*

7. Save your model as *Ch_04_03.max* before we continue.

Good work modeling the table, but you may wonder why we didn't add more details to the table such as braces underneath it. The reason is that we are going to add a tablecloth that will cover this area of the table. One good practice to remember is to make sure you do not create more than you need when building your models. Think of this as the same thing a magician uses when they perform slight-of-hand magic. When modeling you do not have to create

fine details for areas that are not visible in the final scene. The finished table model is shown in Figure 4-15. Now let's continue our exercise and add a tablecloth on top of our table using a patch grid.

figure | 4-15 |

Completed table model.

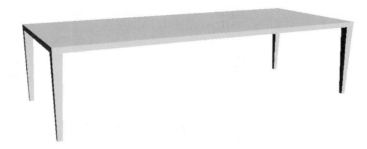

1. Maximize your Top viewport and create a quad patch that is slightly larger and wider than the surface area of your table. The Length should be set to 64, and the Width should be set to 155.

2. Position this patch so that it extends equally around each side of the table, as shown in Figure 4-16, and then move the patch grid above the table.

figure | 4-16 |

Table with patch grid in the correct position

Quad Patch Position

3. In your Front viewport, create a new quad patch that has a Length setting of 10 and a Width setting of 155. Make sure you convert this patch into an editable patch, and then move it so that it is aligned with the first patch and the top of the table.

4. Make sure this new patch is still selected, click on the Attach button, and click on the first patch you created on top of the table.

5. Select the Handle sub-object mode and modify the bottom handles of the patch by adjusting the curves until you have a wavy shape you are satisfied with. Make sure you use the Select and Move tool for this. Figure 4-17 shows the result of adjusting the handles to create a wavy cloth on the side of the table.

6. Select the Edge sub-object button, click on the bottom edge of the patch on the side of the table, and click Add Quad to add a patch to the existing one.

figure | **4-17**

Manipulated patch from step 5.

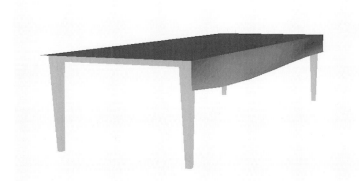

7. Manipulate the control handles of the new quad patch to create more wrinkles in the patch, as shown in Figure 4-18.

8. On your own, draw new quad patches and align them in the proper viewports to finish the cloth on all sides of the table. Remember to adjust the length and width of your patches on the two smaller ends of the table.

figure | **4-18**

Patch with added wrinkles.

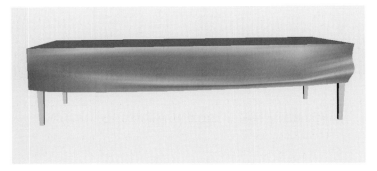

9. Save your file as *Ch_04_04.max.*

SUMMARY

In this chapter you learned how to model objects through the use of patch grids, and how to convert objects into an editable patch so that they can be further manipulated. You learned the difference between a tri patch and a quad patch, and how to stitch and subdivide your patches for more complexity. Although it may seem that you could use other techniques in order to model items, patch modeling offers a wide variety of features for organic modeling. This chapter was a basic introduction to this technique, so we encourage you to explore this further and try to model more complex items through the use of patch modeling.

in review

1. What are patches and how are they used?

2. Discuss the differences between a tri patch and a quad patch.

3. How do you combine multiple patches?

4. What is the Propagate option used for when subdividing a patch?

5. Before you can edit the sub-object levels of a patch on a patch grid, what must be done to the patch grid?

6. The patches of a tri patch are made up of what shape?

↗ EXPLORING ON YOUR OWN

1. Take a few moments to explore using the extrude and bevel options found in the Extrude & Bevel section of the Geometry rollout to create an organic object using patches.

2. Practice using the subdivide and attach options with both the tri patch and quad patch to create more complex patches.

3. Model a simple object such as a flower, curtain, or flag using the techniques you have learned throughout this chapter.

Design

5

 charting your course

Okay, so it might not be just like painting a room in your house or a ceramic figurine, but it's not an analogy that is too far off the mark. Now that you have a little 3D sculpting experience under your belt, you may be wondering when we get to make it look all pretty and pristine. Well, ladies and gentlemen, the time has come. It's now time for you to walk into the wonderful realm of materials! This chapter will introduce you to 3ds max's Material Editor and will guide you through the process of creating stunning surface materials for your 3D models.

This is an area of 3D design you should really work and practice hard at. Seventy-five percent of 3D imagery relies heavily on the surface qualities of the objects and the environments in the scene to make it as believable as possible. The truth of the matter is, the materials used in a scene and how well they are used can either make a piece fantastic or absolutely horrid. Excellent texturing and lighting in a 3D scene can really improve the overall quality of the piece. Even if you aren't the best at modeling, good textures on your objects can smooth out a lot of the rough edges and actually improve the look of your meshes. Knowing a little bit about color theory will help you a bunch when working with these surface textures, as you will have a better understanding of the relationships of light color and object color. If color theory isn't your forte then we will make sure that we explain many of these relationships as we work through this chapter together.

 goals

- Explore what materials and texture maps are
- Examine the important relationship between object color and lighting
- Set up a standard material using pre-made textures
- Create custom material from imported images
- Use Photoshop to create custom material
- Examine mapping coordinates and why they are needed
- Correctly apply mapping coordinates to a 3D form
- Apply your first material to an object

KNOWING YOUR COLOR IN THE PIXEL WORLD

Before we just jump on into painting your models, it is important that we sit and reflect for a moment on what makes the objects around us look the way they do. Color is the most obvious trait that all objects share. In our reality, the color we see is a result of light bouncing off an object and reflecting a particular color to our eyes. This is called reflected color for obvious reasons. Let's take an apple for example. We perceive the apple as red because the fruit absorbs all of the colors within the spectrum of the white light that is hitting it except (you guessed it) red, as indicated in Figure 5-1.

figure | 5-1

The apple reflects the color red to our eyes while it absorbs all of the other colors within the light spectrum.

Although reflected color works great in the world of fine arts, it does not work well at all within the digital realm. When working on a computer, the color you see represented on the monitor is a result from the color of the light shining through the pixels on the screen. Video, television, computers, and virtually all computer displays utilize a form of color known as additive color, sometimes known as transmitted color. As indicated in Figure 5-2, by "transmitting" red, blue, and green (RGB) or a combination of those colors from the monitor we are able to achieve virtually any color imaginable. When these colors are combined equally, the result is white light. Because we work within a virtual workspace, the additive color model will be the set of rules we will live by.

Additive Color using the RGB Color Model

figure | 5-2 |

A screen pixel can transmit red, blue, or green light. Combinations of these colors can produce a tremendous variety of other hues. RGB light transmitted together will produce white light.

When building our surface textures, we will consider how color is affected by light on an almost constant basis. By paying attention to the lighting in our scenes, we will be able to more effectively paint our objects.

BITMAP VERSUS PROCEDURAL MATERIALS

In the graphic design arena, there are two major image types you come in contact with: raster and vector. Let's review for those of you who might not be familiar with these terms. As indicated in Figure 5-3, raster images (sometimes referred to as bitmap images)

consist of many dots (known as pixels) that when arranged together form the overall image you see. Raster graphics are generally photographic in nature, containing complex color information such as subtle gradients and hues. File formats commonly associated with this image type include Windows BMP, GIF, JPEG, PNG, and TIF.

Raster Imaging

Note the pixels that make up the overall image.

figure | 5-3 |

Raster images consist of tiny pixels that form the image as a whole. When scaled up, raster graphics distort and becomes pixelated, resulting in an absolutely horrible image. Usually these types of images need to be scanned at a high resolution to be used in print materials.

Vector images work a little bit differently. Unlike their raster counterparts, vector images are tremendously powerful due to their immense scalability. These graphics are calculated mathematically and are produced by a series of vector points and curves. They are resolution independent, which make them a superb choice for print design as they can be scaled billboard-sized or scaled down for use on business cards. In addition, the resulting file size is usually much smaller than raster images, depending on the complexity of the image and the total number of vectors used. Normally, illustrations, clip art, line art, and artwork that utilizes simple to moderately complex color fills are best suited for vector graphics. Although it is possible to generate complex color changes with vectors, it would dramatically increase the file size of the image, pointing which case you might be better off using a raster image. Figure 5-4 shows an example of a vector image.

In 3ds max, we have two different material types that mimic very closely the rasters and vectors in graphic design. We have materials known as bitmap textures, and we have procedural textures. Bitmap textures, as you might gather, are created using bitmap (raster) images. These images can be TIF, PNG, BMP, GIF, JPG, or even AVI and QuickTime movie files. These are very versatile materials due to the huge number of file types that can be imported into the Material Editor. One thing you need to be careful of, however, is the resolution of the files you are importing into your texture.

Theoretically, 72-dpi-resolution images should work fine in most 3D projects, and often they do. Some people tend to prefer using a bit higher resolution on texture files (especially for ultra-high detail renderings and animations). Although this is not required, it can serve as extra security, just to make sure. When creating our own texture images for our 3D creations, we usually build them at 1024 x 1024 pixels at a resolution of 100 to 150 ppi (pixels per inch). Depending on what type of material is being built, we will usually make the texture capable of being tiled. For example, if creating a material for a brick wall it is imperative that the bricks match up correctly if the image needs to be tiled or repeated over the 3D object. If it's not, you are going to get a pretty funky little wall as an end result, with very visible seams showing on the wall surface.

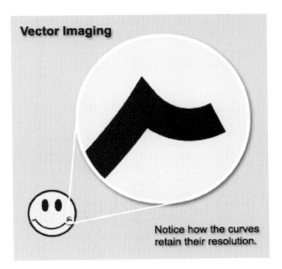

Vector Imaging

Notice how the curves retain their resolution.

figure | **5-4** |

Vector images have no sizing constraints, allowing you to resize the graphic without losing image quality. Pixelation is not present due to the fact that these images are calculated mathematically.

Bitmap Versus Procedural Textures

It is important to note that bitmap textures operate on a file-path system, meaning that if you assign a TIF image as part of a material 3ds max will create a file path to the location where that image resides. If the image file is moved, the material will not display correctly in your scene. This is very similar to how QuarkXpress uses linked images within a print layout. It's always a good idea to create a separate folder for all of your texture images to reside in. This folder should reside in the same directory as your 3d max scene file. By getting in this habit, you can ensure that your project will be nice, neat, and tidy.

Procedural textures are great because they rely solely on the parameters within 3ds max. This has some advantages over bitmap textures in that there is no need to track the file path of images because procedurals are vector in nature. This is a huge help when collaborating on a project and saving materials to a library file. In addition, because the material is vector-like in nature there are no resolution constraints for you to have to worry about.

Procedural textures are 3ds max's equivalent of vector-based images. These types of materials are calculated mathematically like their 2D counterparts, but with one notable exception: they also have depth. You could really consider them true 3D materials. Unlike bitmap textures, if you apply a procedural texture to an object and cut away a portion of that object the inner surface will have the same material as the exterior surface of the object. Because procedurals utilize vectors, these types of materials can be infinitely scaled with no loss of quality. Procedural textures are also great because you can easily save the end material result within a material library without having to worry about including necessary bitmap textures and file paths. This makes distance collaboration much less cumbersome. A lot of new users find procedural materials difficult to work with at first, and they can be a bit confusing. Our biggest advice, as with most features of the software, is to fiddle and play, click on things, and experiment as much as you can. You can read as many books, articles, and tutorials as you want, and although those are invaluable nothing can replace good old-fashioned hands-on experimentation. We will be working with procedural textures more throughout this chapter to get your feet wet. Figure 5-5 shows an example of a bitmap texture, and Figure 5-6 shows an example of the use of procedural materials.

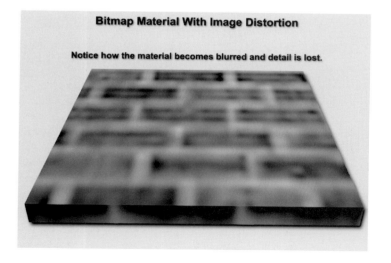

figure | 5-5 |

Bitmap textures utilize raster graphics that could get distorted if placed on a large enough object.

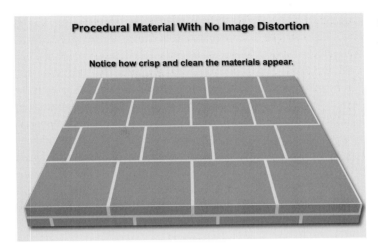

figure | 5-6 |

Procedural materials are 3D textures that have volume and depth and can theoretically be scaled infinitely small or large without losing quality.

SAY HELLO TO THE 3DS MAX MATERIAL EDITOR

We now get to make those cool 3D objects look pretty, and with some practice, realistic! Like much of the Max interface, the Material Editor of 3ds max can be a bit daunting at first. This is mainly due to the shear volume of settings that can be applied to a particular texture, most of which relate a whole heck of a lot with light. Once you can grasp how light and surface textures interact with each other, it will become much easier to utilize the various texture maps within the Material Editor. After getting a grip on this, along with a few of the key tools on the Material Editor, you will notice that the Material Editor as a whole will seem to get a little less big and become much more manageable.

Let's take a moment and look at the Material Editor and break down some of the major components of its interface that you will be working with. Figure 5-7 shows you the default layout of the Material Editor tools and menus.

- *Material Editor menus:* These menu systems give you access to various tools associated with how you view the textures you are building. Note that these settings have no bearing on how the actual material will look, but how you view the material within the editor.

- *Sample slots:* The material editor's sample slots are basically your "preview windows" for each texture you create. Think of

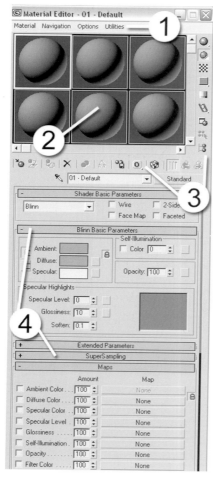

figure 5-7

The 3ds Max 7 Material Editor. This is basically your paint palate, where you can "mix" your surfaces for the 3D objects in your project.

them as little thumbnail versions of your texture that can be previewed on a variety of object types. By default, materials are previewed on spheres, but cylinders and boxes can also be used as a sample object. If you want to see what your "texture-in-progress" looks like on a specific object in your scene, you can define a custom object for your sample slot. Custom sample objects will be covered in more depth later in the chapter. The Material Editor displays six sample slots at one time by default. However, you can actually work on a total of 24 materials at once. The number of slots displayed can be changed in the Material Editor Options dialog box.

- *Toolbars:* The toolbars for the Material Editor can be found along the right side and just below the sample slots. These various tools correspond to the same options that can be found in the menu systems, although some tools are not available in the menus, such as the Video Color Check and the Sample type. Again, these tools don't affect the way the actual material will look in your scene; they merely affect the way you preview the material. We will explain the tools from this toolbar as we need them.

- *Rollouts:* These rollout submenus access the myriad of parameters associated with each material you build. The parameters that appear in these rollouts will change depending on what aspect of the texture you are currently working on.

Just like the main interface of 3ds max, once you break down the various parts of the interface the Material Editor starts to get a bit smaller. At this point you might be chomping at the bit to begin building some really cool textures for your objects. Before we dive into that, it's crucial that you have an understanding of what shaders are. The following section discusses shaders in detail, at

which point you will then be ready to start mixing some pixels! Hold on to your seats!

Shader Shenanigans

Shaders are mathematically calculated algorithms that tell 3ds max how light interacts with an object's surface. Basically, this just means that the shader tells the software how the highlights look on a particular material. Max 7 has eight shaders that can be utilized to produce different highlight effects. The particular shader you use will largely depend on the type of surface you are trying to simulate. Let's take a closer look at the available shader-type options within the Material Editor.

- *Anisotropic:* The highlights with this option are elliptical in nature (i.e., the anisotropy setting controls how elliptical the highlight is or isn't) and share many of the same parameters as the Blinn and Phong shaders. The highlights produced follow the contours of the object the surface is applied to. Within the Basic Parameters of the shader, the amount the highlight is elongated can be controlled. This is a perfect choice for hair, brushed metal, or glass.

- *Blinn:* The Blinn shader is the max 7 default shader for all materials. It calculates circular highlights that have a nice soft appearance. Use this shader for such materials as plastics.

- *Metal:* This shader should be pretty self-evident as far as what it's good for. The Metal shader simulates the lustrous qualities of metal. When used, it generally produces very dark colors and extremely high-intensity highlights. This is really good for metallic objects (go figure).

- *Multi-Layer:* The Multi-Layer shader is exactly the same as the Anisotropic, creating elongated, elliptical highlights on the surface of the object, except instead of just one highlight a second highlight is layered on top of the second. The second runs parallel to the first highlight, although the Orientation value allows you to change the direction the highlight travels along the surface. The fabulous thing about the Multi-Layer is that each highlight can be manipulated independently of any other. Each can have a different Color setting and Anisotropy setting, giving your material some truly unique effects. This is a perfect choice for highly polished curved surfaces.

- *Oren-Nayar-Blinn:* Commonly referred to as an ONB shader, the Oren-Nayar-Blinn produces very soft and subtle circular highlights that are really great for surfaces of low shininess, such as cloth, carpet, and certain types of wood.

- *Phong:* This shader is very similar to the Blinn shader, except that it produces more irregular and harsher circular highlights. This is also a good choice for shiny objects such as plastic.

- *Strauss:* The Strauss shader works much the same way as the Metal option, except that it is usually easier to set up than the Metal shader.

- *Translucent:* A relatively new shader to the Material Editor (it was first incorporated in release 5), this will allow light to pass through an opaque object. Not to be confused with a transparent material, the Translucent shader cannot be "seen through" but will let certain amounts of light through the surface. A good example of this would be frosted glass. You can see silhouettes through the glass, but details cannot be made out. The light that passes through the object can be transferred to objects placed behind the translucent material.

These shaders are invaluable to the creation of realistic textures, and are the first step in creating custom materials of your own. It should be noted here that these shaders are only available to you when producing a Standard material type. 3ds max actually gives you a number of different types of materials. Standard materials are the default and are the most commonly used type. Other types include Blend and Composite materials, which allow you to mix multiple materials; the Ink 'n Paint material, which allows you to simulate traditional cel animation styles; and the Multi/Sub-Object material, which allows you to set up numerous materials in one slot and apply them to one object. These are just a few of the different material types available to you. To use these other material types, simply click on the button located directly to the right of the material name and select the material type from the Material/Map browser, which we will take a closer look at soon.

Once the foundation of the material has been set up, you can produce more complex surfaces by using the various map channels that can be found under the Maps rollout. These channels can manipulate many different aspects of a surface texture, including bumpiness, opacity, and reflection (just to name a few). These map

channels and more are discussed in detail in the following section. Figure 5-8 shows the various material shaders.

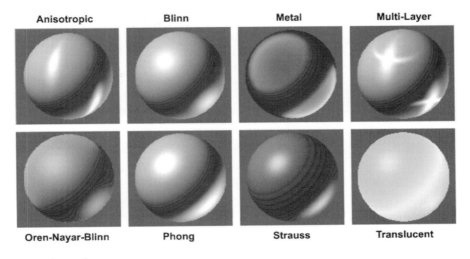

| Anisotropic | Blinn | Metal | Multi-Layer |

| Oren-Nayar-Blinn | Phong | Strauss | Translucent |

figure | 5-8 |

The eight 3ds max material shaders.

The Rainbow of Color Maps

Materials are one aspect of 3D design you should try to spend some time working with, in that 90 percent of a highly photorealistic rendering is because of good lighting and texturing. As you work with the Material Editor, you will notice that the textures you build are created in a series of layers. These different layers can be blended a variety of ways to achieve the end result, although you should note that this will be a bit different than working with Photoshop layers.

NOTE: Many times, a 3D artist may be working within a production team and be handed a 3D mesh object that looks, well, less than perfect. Depending on the deadlines the team has to work with, there may not be enough time to go back and remodel the mesh. Luckily, with some really awesome material mapping, some good photo-quality textures, and well-placed lighting, the artist can cover up a lot of the imperfections on the sub-par objects.

Like much of computer-related hardware and software, many features within 3ds max and other animation software operate via

Maps		
	Amount	Map
Ambient Color ...	100	None
Diffuse Color	100	None
Specular Color ..	100	None
Specular Level .	100	None
Glossiness	100	None
Self-Illumination .	100	None
Opacity........	100	None
Filter Color	100	None
Bump	30	None
Reflection	100	None
Refraction	100	None
Displacement ..	100	None

figure | 5-9

The material map channels allow you to import bitmap and
procedural elements into your texture.

what is known as a hierarchical structure. Basically, this means that operations within the software are prioritized and arranged in a logical order calculated by the computer in order of importance. You can almost think of it as a chain-of-command structure the computer follows. Max uses terminology centered on the hierarchy of a family. This hierarchy is created on the basis of dependence. One aspect of a material may depend on another aspect, which in turn may depend on yet another. Operations and functions with a high priority are labeled parent objects, whereas less important operations are called children. This can be a very confusing concept for newbies because parent objects can be children to even more important operations known as ancestors. This hierarchy concept can be better demonstrated as we start to construct our own materials, so let's take another deep breath and discuss color maps and map channels, which will help you further understand the concept of parent and child operations. Figure 5-9 shows the material map channels found under the Maps rollout.

The channels found under the Maps rollout deal directly with the appearance of the final material. Many of the channels relate very closely to lighting terminology many photographers and videographers use in the industry. To understand how these maps work, you need to appreciate how they interact with light in addition to how they work within the material. We will only be describing the most commonly used map channels and those that deal directly with light. It should be noted here that the maps available to you will depend on the particular shader you use. Okay, now that you know where to find these map channels let's take a closer look at them.

● *Ambient Color:* This channel controls the color of a surface when it sits in a shadow. In addition to importing a bitmap or

procedural texture in this map slot, the ambient color can also be given a solid color within the Basic Parameters rollout of the current shader.

- *Diffuse Color:* This channel relates to the color of a surface when it is in full direct light. This can also be assigned a color within the Basic Parameters rollout. The primary image used in a bitmap texture is always loaded in the Diffuse Color map channel. For instance, if you want to create a brick wall material using a photo of some bricks, you need to load the photo in the Diffuse Color channel in order for the material to look like bricks.

- *Specular Color:* This channel affects the highlight color of a surface. The highlight is where the light is reflected perpendicular to the viewer's eye. The intensity of the highlight is controlled by the Specular Level spinners.

- *Glossiness:* The intensity and size of the highlight are controlled by the Glossiness channel. The size of the highlight can be controlled by the Glossiness spinners. The Glossiness map allows you to determine where the glossiness can appear on the surface.

- *Self-Illumination:* When you want to create the illusion of an object casting light in your scene, this channel will give a surface the appearance of a lit object. It is important to note that when an object has 100 percent self-illumination applied to it the object will not receive light or shadows from lights set up in the scene. The self-illumination is controlled by the Self-Illumination spinner, and you can use the Self-Illumination map to determine where the self-illumination will be applied.

- *Opacity:* To adjust where an object will appear opaque or transparent, utilize this channel. When a black-and-white image is loaded into the Opacity slot, white areas of the graphic are opaque and black areas are transparent. Shades of gray provide variation of transparency, with lighter grays appearing more opaque than darker grays.

- *Filter Color:* This is the resulting color of light after it passes through a transparent or translucent surface. A good analogy is stained-glass windows. Once light passes through the window, it changes color to the color of the glass it passed through.

- *Bump: This* is an often-used channel for simulating surface texture by calculating high and low areas of the surface. Like the Opacity map, the Bump map can use a grayscale image. White

areas are high areas on the object and black represents low relief on the surface. Shades of gray will depict an intermediate level between low and high relief.

● *Reflection:* When creating highly polished surfaces such as metal and polished wood, it is a good idea to add reflection to the material. You can use Raytrace or Reflect/Refract maps to reflect elements of the scene in the surface. In the event there are no other objects in the scene to create a nice reflection, a bitmap can be imported into the reflection channel to fake realistic reflections.

● *Refraction:* This channel simulates the bending of light as it passes through a transparent object and/or distorts the reflections on an object's surface.

● *Displacement:* Very similar to the Bump channel, the Displacement map creates depth in a surface texture by physically subdividing (or tessellating) the mesh of the object. The object is then modified to reflect the depth illustrated by the grayscale image that is loaded into the Displacement channel. Note, however, that this tends to really increase the polygon count of your scene, which will start to dramatically bog down your processors and increase the rendering time of your scene.

We know that is seems like a ton to take in at once, but once you work with these various map channels creating beautiful and realistic materials for your scenes will get easier and easier. So now that we've jammed all of this mumbo jumbo into your head, why don't we now start creating some materials before you forget everything!

Accessing the Material Library

3ds max comes shipped with pre-made materials that can be used for a variety of surface types. These materials are compiled in a material library file, which is an archive of textures that can be transferred to disk if needed. The libraries are a great way of keeping your textures organized, and organization is the key to an efficient production. Accessing the default material library is done by opening the Material/Map browser, shown in Figure 5-10. This browser allows you, the artist, to not only select which type of material you want to create but which material library you want to browse from. In material to follow, you will use the Material/Map browser to construct a custom texture.

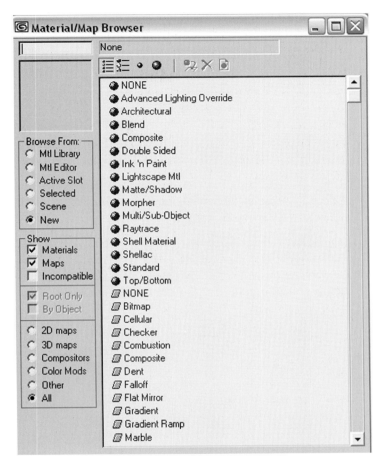

figure | 5-10 |

The Material/Map browser provides access to material types and material libraries.

> ▶ **Material Libraries**
>
> Material libraries can be a tremendously powerful way of organizing your textures. As you progress and utilize 3ds max in your projects, you will most likely notice that you gradually accumulate a large number of textures. A helpful tip that can save time and keep you from hours of searching for that great material you once created is to categorize your materials into material types. You can place all of your woods, fabrics, metals, and other like surfaces together in their own libraries. This makes it infinitely easier to find what you need.

Importing Custom Sample Objects

Before we start to play around with material libraries and custom texture creation, let's take a short moment to explore how to use a custom object for your Material Editor sample slots. It's a very easy process that can be done in no time.

1. Start with a fresh Max scene and create a teapot in the Top viewport. The size of the teapot doesn't really matter.

2. Save the scene as *teapot.max*.

3. Go ahead and reset your scene (File > Reset). Open the Material Editor and select Options > Options to open the Material Editor options window.

4. Under the section labeled Custom Sample Object, click on the None button next to where it says *File Name*. Browse for your *teapot.max* file and click on Open. Hit OK to close the Material Editor Options dialog and save the settings.

5. Select an empty sample slot and click and hold on the very top-right Sample Type tool, shown in Figure 5-11. You will see the standard sphere, cylinder, and box objects, but now you will see a box with a question mark on it. By choosing this, it will place your custom object within the sample window. If you click and drag your middle mouse wheel, you can arc rotate around your custom object.

That's it! Piece of cake.

figure | 5-11

Sample Type tool.

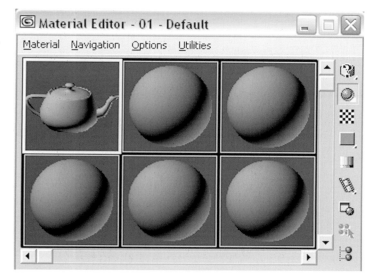

Importing a Material from the Material Library

Let's try bringing in some ready-made materials into the Material Editor. This is by far the easiest way to get a material for an object. It requires no skill whatsoever, which is always a good thing every now and then.

1. Open the Material Editor by either clicking on the Material Editor button on the main toolbar or by pressing the M key.

2. Select an empty sample slot within the Material Editor.

3. In the Material Editor menus, select Material > Get Material to open the Material/Map browser.

4. On the left side of the browser, under Browse From, select Mtl Library.

5. Where it says *Show*, uncheck the box next to Maps. This will allow you to hide the image maps used to create these materials. It will make it less confusing if you just see the final result, shown in Figure 5-12.

6. On the right of the browser, above the material list, click on the fourth icon from the left, shown in Figure 5-13. This will allow us to see large thumbnail previews of each texture.

7. To place a texture into the Material Editor for use, you can either double click on a thumbnail preview or drag the thumbnail preview over an empty sample slot and release the mouse button.

figure | 5-12

Result of step 5.

figure | 5-13

Icon for accessing thumbnail previews.

Once the material is in the sample slot, it can then be applied to objects within your scene. These default materials are good to use when starting out, because you can dissect them to see how they were put together. Often, reverse engineering is a great way to learn some of the nuances of texture creation. In fact, the same process can be applied to many other aspects of 3D design. Many of the 3D resource web sites on the Internet have great tutorials you can try out, many of which have links to sample files that can be downloaded and picked apart along with the tutorial text. We find this to be one of the most comprehensive ways of learning this difficult trade.

Importing Graphics for a Material

So far you have read about the various types of materials that can be created, as well as the various types of graphics that can be loaded into the Material Editor when creating a custom material. We can now start importing images into the various material map slots. By importing images into these various channels, you will be well on your way to creating your own custom materials from scratch. You will be able to produce your own image maps within the graphics editor of your choice, such as Adobe Photoshop or Painter. Once made, they are ready for use within 3ds max. This is an easy procedure to follow, and the process will also expose you to the hierarchical structure within the Material Editor.

When importing any type of image into one of the map slots, whether it be a raster image created in Photoshop or a procedural map, you will be given access to the parameters relevant to that specific map type. These parameters will change depending on the map type you use. For instance, the settings available for a Noise procedural map will be different from a Falloff procedural map. It is important to keep this in mind while you work with your materials. It's easy to get lost as you add more and more maps to your final material. You should also note that it is possible to import maps within other maps. Depending on the type of texture you are working with, you might be given options to import additional textures within those map parameters. This creates a "layering" effect within the material that begins to form the hierarchy of the material. Let's import some maps into a new sample slot and see how this hierarchy stuff works.

Importing Maps into Color Channels

In the following you will practice importing a map into a color channel.

1. Open the Material Editor, if you haven't already, and select an empty sample slot.

2. Expand the Maps rollout and click on the None button next to the Diffuse Color map slot, shown in Figure 5-14. This will open the Material/Map browser, which will allow you to select the map you wish to import.

figure | **5-14**

Diffuse Color map slot.

3. At this point, we can see the various types of procedural materials we could implement. However, because we wish to utilize a raster image for this exercise select Bitmap at the top of the material list. This will open a Select Bitmap Image File window, which will allow you to browse for a specific file.

4. In the Select Bitmap Image File window, go to Ch 5 > Maps on the companion CD-ROM and select the *sandy. jpg* file in the *Maps* folder. Immediately, the image is loaded into the Material Editor and can be seen in your sample slot, as shown in Figure 5-15. Note that the Maps rollout has disappeared and has been replaced with bitmap parameters relevant to the JPEG graphic you

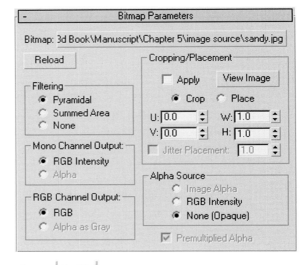

figure | **5-15**

Loaded image.

just imported. Don't worry, your map channels are still there, you just can't see them because you have moved down an entire level within the material's hierarchy. Within these settings, adjustments can be made to the orientation and output of the image, as well as to how many times the image is repeated on an object.

Importing raster images is just that easy! In fact, you can use animation or video files as a material by importing them the same way you did the *sandy.jpg* file. Now let's continue with this sandy material by importing a procedural material into the Bump map channel. This will allow us to create the illusion of peaks and valleys within the sand.

1. To return to your Maps rollout, we need to get out of the bitmap parameters of the Diffuse Color slot. Click on the Go to Parent button on the Material Editor toolbar, shown in Figure 5-16.

figure | 5-16

Go to Parent button on Material Editor.

2. Now we are in the parent of the material and we can see the various map slots. Click on the None button next to the Bump map channel. This will open the Material/Map Browser window.

3. Out of the material type list, select Noise and then click on OK.

4. At this point, the noise parameters are available to us. We are going to leave the Coordinates option set to the default values, so there's no need to mess with them. Down in the Noise Parameters rollout, shown in Figure 5-17, set the following:

 Noise Type = Regular
 Size = 22.75

5. Click on the Go to Parent button to return to the Maps rollout.

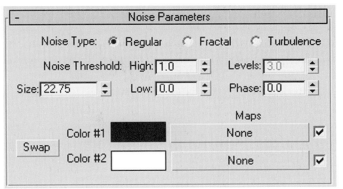

figure | 5-17 |

Noise Parameters settings.

6. Next to the Bump channel, change the value to 65. This increases the amount the noise map is being applied to the overall sand material. Figure 5-18 shows the result of the exercise.

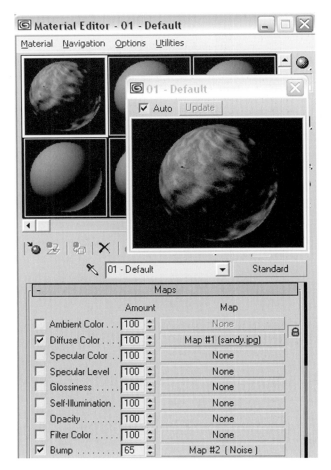

figure | 5-18 |

Finished sand material with the imported JPEG and Noise maps..

Ta-da! You just built a material by merely loading different types of maps into the Material Editor. Essentially, that's all there is to this stuff. Of course, it can get much more complex, depending on the complexity of the material you want to build, but the process is the same. The important thing to remember is that each time you bring in another type of texture map (whether it be a procedural map or a bitmap image) you create a child texture to the overall material, meaning that you will need to click on that Go to Parent button to return to the previous set of parameters. It is this hierarchical structure that gives us that "layering" effect within material. Traditional art often operates on much the same principle. When creating a painting you might start with a base color or foundation color as the basis for the painting. Gradually, more colors are applied additively to achieve the finished piece of art. 3ds max is not the only 3D software application that follows this additive approach to materials. Maya, another high-end animation package, and many mid-range applications also tend to utilize the "layering effect" when it comes to constructing materials.

Creating Your First Material from Scratch

Well, it's the moment you have been waiting for. Let's put those graphic design skills to work and create a cool brushed metal material from scratch! To start the process, we are going to begin work in Photoshop to create the images that will later be imported into the 3ds max Material Editor. The following exercise walks you through the steps necessary to generate a seamless texture that can be tiled. By making it capable of being tiled, we can ensure that we will not see any seams on the surface if the material needs to be repeated on the object.

NOTE: In most cases, you will want your bitmap textures to be capable of being tiled because your final material will most likely need to be tiled on whatever object it is applied to. The scale of the 3D object and the image size of your bitmap generally will dictate how much tiling needs to be done to the material.

Ideally, we like to use relatively large-format, high-resolution images for custom-made material maps. We like to make our images 800 x 800 pixels or larger at a resolution of 100 dpi. This helps to ensure that the materials look good for the final rendering. Using 72-dpi images is also fine, because a lot of the time 3D work is seen on some sort of screen or monitor. In the case of us graph-

ic designer types, we will encounter times when our 3D work will need to be reproduced in print. You might be thinking that a 100-dpi texture will not look good as a print. However, the physical resolution of the material is not related to the physical resolution of the final rendered image. In other words, we are able to use 100-dpi textures in our scene and render our final image at 300-dpi. We'll talk more about rendering for print later in the book. You're probably pretty eager to create your first custom material from scratch, so let's not delay any longer!

Forging Brushed Metal from Scratch

In the following exercise you will create a custom material.

1. In Photoshop, go to File > New to open the New window. Create a new document that is 800 pixels wide and 800 pixels high, with a resolution of 100 pixels/inch. Make sure it has a white background color and uses the RGB Color Mode setting.

2. Now we are going to add some noise by going to Filter > Noise > Add Noise. Set the noise parameters, as shown in Figure 5-19, as follows:

 Amount = 400%
 Distribution = Gaussian
 Monochromatic = Checked

3. You should see something that resembles a snowy television screen. Now we are going to blur the noise so that it resembles brushed metal. Select Filter > Blur > Motion Blur and set the parameters as follows:

 Angle = 0o
 Distance = 75 pixels

4. Alright, now we can start to see the surface of brushed metal take form. As we can see, the motion blur we just applied did not quite make it to the left and right edges of the image, so we will

figure | **5-19**

Noise parameters.

need to crop it so that we only see the blurred areas of the noise. Select the Crop tool and hold the Shift key down to constrain the aspect ratio. Click and drag a box within the area of the image that is the most blurred (make sure you're still holding down that Shift key), as shown in Figure 5-20. Get it as big as you can without including any of the sharp sides. When you are satisfied with your crop area, press Enter to accept the cropping.

figure | **5-20** |

Cropping an image.

5. After the cropping, our image is obviously no longer 800 x 800 pixels in size. We need to correct that now by going to Image > Image Size and changing the Width and Height settings back to 800 pixels. We won't get much distortion on the image from sizing up because we only increased the size a little bit, not to mention that it would be pretty difficult to see pixels among the streaks in the image.

figure | **5-21** |

Applying a hue.

6. Create a new folder (place it anywhere you like) and name it *Brushed Blue*. Save your Photoshop file to this new folder as *brushed_blue.psd*.

7. Let's make this metal a little more interesting by giving a bluish hue to it, as indicated in Figure 5-21. Make sure your image is in RGB Color mode and not Grayscale. Create a new layer above the *Background* layer. Activate the Paint Bucket tool and choose a medium blue (R-51 G-102 B-255) for the foreground color. Fill the empty layer, change the layer's blending mode to Soft Light, and adjust the layer opacity to 50%.

| figure 1 |

Dennis F. Alba. Sports Car. Quezon City, Philippines. OSTUDIO/ *www.ostudio.com*. The body of the car as well as the interior elements were modeled by modifying a simple box with an editable poly modifier. The objects were then given smoothing by applying NURMS subdivisions to them. Accessories were modeled with editable spline and lathe objects.

PATRICK BEAULIEU
CHARACTER ANIMATOR

| figure 2 |

Takar's Room. Patrick Beaulieu/ *www.squeezestudio.com.* The objects found in this room were created with a variety of techniques, ranging from editable poly and subdivision surfaces to lathe and loft objects. Careful texturing was done to help add realism. A combination of bitmap and procedural materials were used.

| figure 3 |

Wazo and Charley the Bear. Patrick Beaulieu/www.squeezestudio.com. These relatively cartoonish characters were created by extruding edges over an image template to create a mesh framework. Polygon surfaces were then created to skin the model. Standard lights were used to light the characters, and fur and feathers were added by using the Shag-Fur plug-in by Digimation.

PATRICK BEAULIEU
CHARACTER ANIMATOR

| figure 4 |

The Real Face.
Daniel Berroteran.
The model was made
using a combination
of spline modeling and
subdivision polygonal
modeling. Modeling
was kept simple,
since the focus of the
piece was on lighting
and color. A skylight
and Light Tracer were
used for global illumi-
nation. Some stan-
dard lights were used
to add specular high-
lights to the scene.
The final scene was
rendered with the
Default Scanline
Renderer.

| figure 5 |

Old Hallway. Daniel Berroteran. The modeling process was very simple polygonal modeling with subdivision surfaces. All 3D objects in the scene are unwrapped and painted in Adobe Photoshop, using 3ds max´s Render to Texture tool. For lighting, standard lights were used with very low decay values, to give a first lighting pass, and then mental ray was used in conjunction with standard and area lights for the final lighting setup.

Trichius Fasciatus
MysticMan Productions 2004

| figure 6 |

Trichius Fasciatus. MysticMan Productions /
www.mysticmanproductions.com.
Subdivision surfaces were used for the
modeling of the main objects in the scene.
The hair effects were created with the
third-party plug-in Ornatrix from Ephere
Productions. Bitmap materials were created
in Adobe Photoshop, using photographic
reference for accuracy and detail. The final
render was produced with mental ray.

Acanthoscurria juruenicola
MysticMan Productions 2004

| figure 7 |

Acanthoscurria juruenicola. MysticMan Productions / *www.mysticmanproductions.com.* This piece was produced the same way as *Trichius Fasciatus,* with subdivision surfaces being used for the modeling and the Ornatrix plug-in for the hair effect. Bitmap materials were again created in Adobe Photoshop, using photographic reference for accuracy and detail. The final render was produced with mental ray.

| figure 8 |

The Incredible Power of Myopia. José María Andrés M. / webmaster @alzhem.com. This rather simple image was easy to create, by manipulating primitives with the editable poly tools and smoothing. The cactus thorns and porcupine spikes were made by cloning the thorns and spikes with the Scatter tool, which allows an object to be dispersed on a designated object. The lighting was done by using a skylight and single key light combination to achieve the global illumination and sunlight effect. The third-party VRay rendering system was used to achieve the final render.

| figure 9 |

Heptapus From Now On. José Maria Andrés M / *webmaster@alzhem. com.* Models in this scene were primarily made with the editable poly tools and NURMS smoothing. Only simple procedural materials were used for the textures in the scene. The lighting was done by using a skylight and single key light combination to achieve the global illumination and sunlight effect. The final composition was made in Photoshop, combining two separate renders (one for wet areas and one for dry). Again, the third-party VRay rendering system was used for the renders.

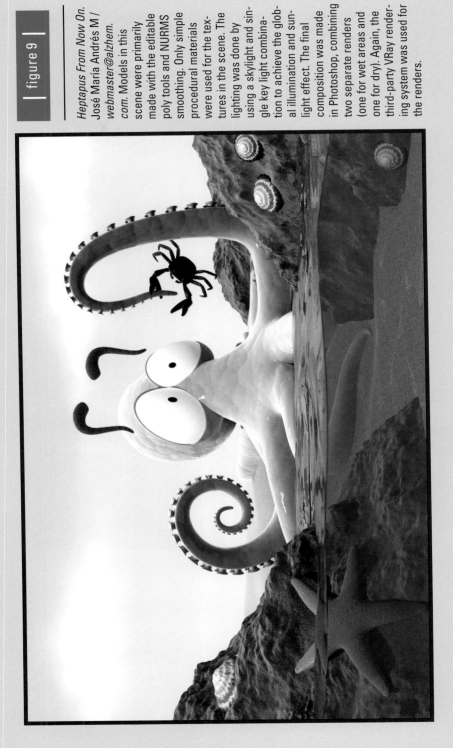

| figure 10 |

Mayan Inspired Statue. Aaron Arlof. This statue was modeled off of a concept sketch, one polygon at a time, using the editable poly and other surface tools like subdivision surfaces. The statue was created in pieces; the head, body, wings, and pedastal were created separately and then welded together later. Standard lighting was used, and final touchup work was done in Adobe Photoshop.

| figure 11 |

Seahorse. Mariska Vos, MA / *www.mariska3D.com.* Here is a fantastic example of how effective lighting can dramatically enhance a relatively simple scene. The use of translucency plays a key role in producing realism within a scene such as this. The fairly simplistic materials allow the viewer to focus on the ambience of the overall image.

Forever. Steven Till. The jewelry in this piece was modeled using standard box modeling techniques, beginning with a sphere (with an edit poly modifier applied) for the heart objects and modified torus objects for the chain. Standard lighting rigs were used to light the necklace. The textured model was then rendered and composited in Adobe Photoshop to achieve the final composition.

figure 12

THE FINEST MERLOT KISSED WITH THE FLAVOR OF FRUIT

figure 13

Wine Label. Steven Till. This Photoshop composite features two 3D fruit objects that were created using lathed splines. The lathed objects were then given a noise modifier to "bump them up" a bit to add some realism. Procedural materials were used for the surface textures, and standard lighting was used to illuminate the scene.

WWW.LSUDESIGN.COM

UMBERTO LA SORDA

| figure 14 |

Escape. Umberto La Sorda / *info@lsudesign.com* / *ww.lsudesign.com*. The glass, fish bowl, and fish bowl water were created off of lathed splines. The splashing water was created with the aid of a plug-in, but then manipulated by hand to achieve the desired results. The fish were box modeled and then smoothed, with a photorealistic texture applied to them. Bone objects were added in order to pose and manipulate each fish's body position. An HDRI was used to illuminate the scene.

| figure 15 |

Admiring Edison. Simon Osbaldeston, *Simplepsy.com,* *"Man"* from *Lowpolygon3D.com.*
The main set of this scene was created with box primitives with textures and bump
mapping added for detail. Subdivision modeling was done for the bench. The lightbulbs
were initially created by lathing a spline, and then an edit poly was applied to add fur-
ther detail. Translucent shaders were used to achieve the frosted glass on the bulbs.
Metals in the scene were created with the mental ray Lume Metal shader with reflec-
tion blur added. Depth of field was applied to the camera to provide added realism to
the scene.

| figure 16 |

Smithfield Street Bridge. Matt Rathman, Student, Art Institute of Pittsburgh / *matt@rathmans.com.* Box modeling and splines were used quite extensively for this piece, using simple boxes with two-sided materials with alpha channels for the bridge supports. Lofts were utilized to create the barbell-shaped support spans. One standard light was used to simulate sunlight, with an HDRI skylight for the fill light.

You might be wondering why we are using a separate layer for the colorization of the metal instead of simply applying a Hue and Saturation adjustment or by using the Variations function to color the noise. Later we will be creating a black-and-white image that will be used in the Bump channel of our material, so by placing the color into a separate layer it will be much easier to generate this bump image if the noise and the color are already separated. At this point, we now have a piece of brushed blue metal. So far, it's looking great. However, it's difficult to tell if this texture will cause any seams to be visible if the image is tiled, so we need to ensure that this texture can be tiled. To accomplish this, we will be using Photoshop's Offset filter. Continue with the following steps.

1. Make sure your *Background* layer is selected and select Filter > Other > Offset from the menu. In the Offset dialog window, change the values to the following:

 Horizontal = 400 pixels right
 Vertical = 400 pixels down
 Undefined Areas = Wrap Around

2. You should now be able to see a big vertical seam within the noise. To correct this, we'll use Photoshop's Healing Brush tool (if you are using a version of Photoshop prior to version 7 or CS, you can use the Clone tool to achieve the same result). Activate the Healing Brush tool and set up the brush in the Options bar as follows:

 Brush Diameter = 87 pixels
 Brush Hardness = 23%
 Mode = Replace
 Source = Sampled

3. Hold down the Alt key and click anywhere on the noise streaks (make sure you don't click on one of the seams). This will take a sample of the noise. Release the Alt key and then begin painting over any visible seams until no seams remain, as indicated in Figure 5-22. Once all seams have been vanquished, it's finally time to export our first image map for our material.

4. Save your Photoshop file.

5. In Photoshop, select File > Save for Web. In the Save for Web dialog window, shown in Figure 5-23, set Preset to PNG-8 128 Dithered. You might want to use PNG, TIFF, or TGA files for materials because they utilize a lossless compression scheme

figure | 5-22

Eliminating seams.

and tend to retain detail a little better than JPEG or other lossy formats, although there is nothing wrong with using JPEG files for your materials.

6. Click on the Save button and save the image as *brushed_ blue.png* in the *Brushed Blue* folder you created earlier.

Although we now have the image that will be going into the Diffuse Color channel of our material, we still need to make a black-and-white version to be used as the bump map that will give our metal a little roughness. Note that we have not applied any lighting effects to the image to simulate shininess for the metal. The actual metallic properties of the material will be handled within the Material Editor by using...that's right, shaders. Okay, time to generate our bump map.

1. Let's start by turning off the visibility of our blue color layer.

2. Duplicate the *Background* layer so that we can retain the original noise.

3. Select the *Background* layer copy and then select Image > Adjustments > Levels and set the following parameter:

Input Levels = 0, 0.20, 177

figure | 5-23

Save for Web dialog window.

4. The result is a high-contrast black-and-white version of our blurred noise. The white areas will appear raised, and the black areas will seem deeper, on our finished surface. Perform a Save for Web function again and save the high-contrast image as *brushed_blue_bump.png* (you can use the same settings as before).

5. Save your Photoshop file.

We are on a roll! We hope you're having as much fun as we are. Now that the two main aspects of the material have been created in Photoshop and are ready to be imported into 3ds max, the next step will be to set up the shader that will simulate the metallic qualities of the finished texture. Because this will be metal, we will use either a Metal or a Strauss shader. If you remember our discussion on the various material shaders, those two are the most appropriate to use to simulate the luster of metallic surfaces. In addition to choosing the shader, we also need to make adjustments to the Specular Level and Glossiness settings for the material, which control the size and brightness of the highlights of the final material.

1. In 3ds max, make sure the Material Editor is open (M key) and activate an empty sample slot.

2. Under the Shader drop-down list, select the Metal shader option and set Specular Highlights to the following settings:

 Specular Level = 75
 Glossiness = 70

3. Open the Maps rollout below the Shader's Basic Parameters option. In the Diffuse Color channel, click on the None button to open the Material/Map browser. Select New in the Browse From area, select Bitmap, and open the *brush_blue.png* image you exported from Photoshop (or the *Brushed Metal* file from the *Ch 5* folder on the companion CD-ROM). We now see the bitmap parameters for the imported image and can see the image within our sample slot.

4. Under the Coordinates rollout above the Bitmap Parameters option, set the U and V tiling values to 2. This will repeat the brushed metal pattern twice when this material is applied to an object.

5. Click on the Go to Parent button to return to the Maps rollout. In the Bump channel, open the Material/Map browser by

clicking on the None button, and opt to use a new bitmap. Load the *brushed_blue_bump.png* file into the channel and change the U and V tiling settings to 2 to match the tiling of the diffuse map. Now the grooves from the bump will match the size of the grooves in the diffuse image.

6. Click on the Go to Parent button in the Material Editor to return to the root of the main metal material.

7. Next to the Bump channel, change the setting from the default 30 to 5. This will reduce the roughness of the overall material.

Congratulations! You have just produced your first finished material from scratch. Even better, you were able to utilize skills you already utilize in your everyday design lives. Figure 5-24 shows what the finished texture should look like. Building realistic materials for your 3D scenes is a process that takes some practice to master, just like modeling objects. The more you can work with the Material Editor, the better you will get.

figure | 5-24

Finished metal material.

Now that you have had some exposure to creating materials, the next step is to apply these textures to the objects in your scene. Before you can apply a material to a 3D mesh, the object must first have mapping coordinates associated with it. These coordinates are critical for correctly orienting the material to the object. In the following section we will be taking a look at the various ways of mapping a texture, as well as the different mapping types.

CHARTING A DESTINATION FOR YOUR MATERIALS

As stated previously, to apply a material to a 3D object within a scene the material must first contain something known as mapping

coordinates. These coordinates can be considered "rules" or "guides" 3ds max follows when it calculates what the textured objects look like during the final rendering of the scene. These coordinates are essential for the correct placement of 2D textures that have been used in the final material (images loaded into specific map channels, such as the brushed metal we made). They also ensure that the material will be displayed correctly on the object. The type of mapping you use will largely depend on the type of object that will receive the coordinates. As we discuss the various mapping types, you will begin to see appropriate choices in the mapping style you use.

The coordinates utilize an axis format (see Figure 5-25) similar to the 3D axis planes that objects in a 3D scene use. Instead of calling them X, Y, or Z, we call them U, V, and W. The U axis represents the horizontal direction, the V shows the vertical direction, and the W depicts depth of the material as it travels through the object. The W axis is used as a rotational axis and is mostly used with procedural materials, so we won't spend a whole bunch of time on it, although it is important that you are aware of its presence.

Planar **Spherical** **Cylindrical**

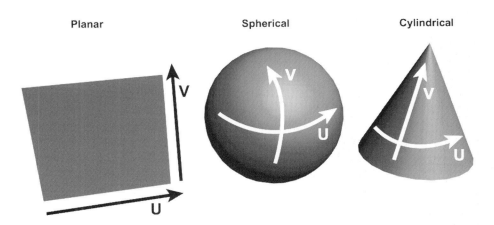

There are two ways coordinates can be applied to a 3D object. The first and simplest method is performed during the creation of a primitive object such as a sphere or box. Within the basic parameters of the object, there is a checkbox labeled *Generate Mapping Coordinates*. This will automatically place appropriate coordinates onto the object. Although this is an easy way to do it, you are severely limited in how the texture is aligned onto the object. With this method, any tiling that needs to be made must be done within

figure | **5-25**

The UV coordinate axes.

figure | 5-26 |

Basic UVW Map modifier
parameters.

the material itself in the Material Editor. The inherent
problem with this, however, is that you are forced to use
that material's tiling values when assigning it to other
objects in the scene. It is not uncommon for a scene to
require one material to appear several times in a scene
but have different tiling on the various objects that hold
that material.

The second method is the preferred way of assigning
coordinates to an object. It incorporates the use of the
illustrious UVW Map modifier found in the Modifier
List. By using this modifier, you will gain much more
control over the placement and orientation of the bitmap
material onto the object. Figure 5-26 shows you some of
the parameters associated with the UVW Map modifier.

The first thing you need to consider when mapping an
object is the type of object you are working with. The
modifier allows you to apply one of a number of differ-
ent coordinates that relate to a specific type of shape.
Sometimes, you may wish to experiment with these coor-
dinate types to achieve different effects with your materi-
als. In addition, once coordinates have been applied the
object will have a mapping gizmo placed on it. This
gizmo allows you to move, rotate, and scale the mapping
to best suit the object. Just fiddle with the gizmo and the
mapping type a little to see which one looks the best for
your given situation. The coordinate-type options are
described in the following.

● *Planar:* This coordinate type is primarily used for flat
surfaces such as walls, floors, and mirrors. It is ideal
for the Plane primitive because the Plane is a 2D
object. You need to be careful when using planar
mapping on boxes and cubes, however. When planar
mapping is used on these objects, "banding" will
occur. We'll talk more about banding later.

● *Cylindrical:* This coordinate type is perfect for objects
such as pipes, wine bottles, candlesticks, columns, or
any other object that resembles a cylinder.

● *Spherical:* Use this coordinate type for anything
round in nature. Keep in mind that this type will
cause the bitmap texture to "pinch" at the poles of

the object. You may also see some distortion or stretching with this mapping type.

- *Shrink Wrap:* This is a rather unusual coordinate type that is good for organic forms, or irregularly shaped objects. The Shrink Wrap gizmo is the same as the Spherical gizmo.

- *Box:* The box coordinates are ideal for blocky objects that contain large, flat surfaces.

- *Face:* Face mapping will assign the given material to each face on the object. This can be especially useful for texturing patterns (an insect's eye, for example).

- *XYZ to UVW:* This specific coordinate type is primarily used for procedural textures. It translates the XYZ coordinates of an object into the UVW equivalents, which will make it easier for the procedural textures to relate to. These coordinate types are shown in Figure 5-27.

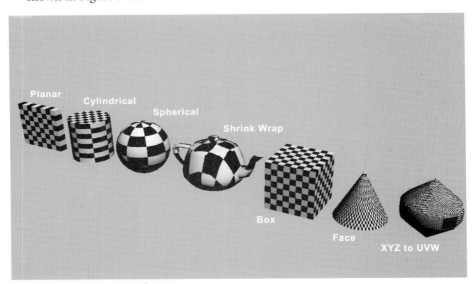

The actual process of assigning mapping coordinates to an object is a piece of cake. The difficult thing is to make sure everything lines up the way it should. When texturing your scenes, you should always keep in mind the scale of the objects as they relate to other objects in the scene. Far too often we see new users create a material and apply it to an object without considering the scale of the material. We have seen brick walls in which each brick appears to be bigger than a grown human! By tiling the material, the bricks

figure | **5-27**

The seven mapping coordinate types.

can be scaled down to an appropriate size that we are used to seeing. Evoking a sense of scale with your materials will help in achieving a believable render, no matter if it's intended to be a photorealistic piece or a cartoon-like rendering.

DON'T GO THERE

A material appearing within a scene with incorrect scaling is a sure sign of an amateur. Very rarely will you use a material with no tiling. Most of the time, tiling can be used in conjunction with scaling via the mapping gizmo to resize the material in the scene. Because texturing and lighting are key aspects of a great render, it is to your benefit that you check all aspects of your materials, including the scaling.

One thing that will help you when mapping your textures to your objects is to remember that the UVW Map modifier provides you with an object (gizmo) that aids you in the placement of the texture. This gizmo acts as a sub-object for the UVW Map modifier and is accessed through the modifier stack. The gizmo can be scaled, moved, rotated, and manipulated any way you like, in that sometimes the default placement of the texture is not aligned properly right off the bat and may need some tweaking. An example of this is shown in Figure 5-28. While playing with the gizmo, you will notice that the placement of the material will move and adjust. However, the tiling will not be affected. This makes it possible to physically scale the material without tiling the bitmap or actually editing the bitmap image in Photoshop.

figure | 5-28

Effect on material when the UVW Map gizmo is modified.

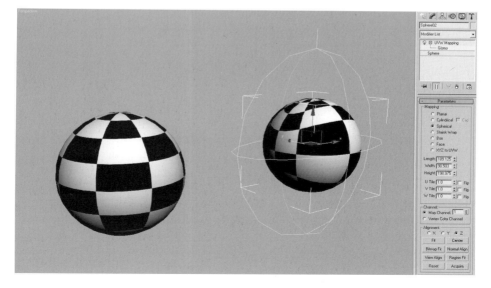

At this point we have discussed the various mapping types associated with standard texturing situations. You will no doubt encounter times as a 3D illustrator when you need to apply mapping coordinates to a more complex object that doesn't conform to standard shapes such as spheres, boxes, or cylinders. Character meshes, vehicles, and very organic objects tend to be extremely complex in terms of texturing, and advanced measures need to be taken to effectively and correctly apply a material to these types of objects. One method that is extremely effective is to use what is called an Unwrap UVW modifier, which takes the object's mesh and flattens it. Once the mesh is "rolled out," it can be taken into Photoshop. You can then paint the material directly onto the mesh image and later export the new material as an image file that can be imported back into 3ds max. Once the new material is back in the Material Editor, it can be applied to the 3D object.

This technique, although widely used in the industry, is a bit beyond the scope of this book. Even though we won't be unwrapping meshes, we can still explore how to apply mapping coordinates to complex forms. Loft objects are a great example of a type of object that doesn't conform to the standard coordinate types included within the UVW Map modifier. Lofts, by their nature, allow us to automatically apply mapping coordinates to a mesh during the creation process. The next section explores loft-mapping coordinates in detail. An example of the use of the UVW Map modifier is shown in Figure 5-29.

figure | 5-29

3D mesh object after applying the Unwrap UVW modifier. The resulting image can be painted on in Photoshop or another image-editing application.

Mapping Coordinates to Loft Objects

Now that we have a grip on standard material mapping, another thing you need to know is how to apply mapping coordinates to loft objects. At first glance, you might think that it is possible to apply Cylindrical or Box mapping, possibly even Shrink Wrap coordinates to your loft, depending on the shape of the spline used. Although this may work to some degree on simple lofts, this method is rather ineffective when attempting to loft very complex lofts. The problem arises from the curves that appear along the path of the object. For instance, let's say you wish to apply a material that resembles ceramic tile onto a loft object that resembles a tube or a cylinder, but the loft follows some curves. Traditional mapping techniques can't negotiate those curves correctly, which makes the end result look a bit funny. With conventional mapping, your material will most likely get distorted, pinched, incorrectly tiled (especially near the bends), or will be just plain silly-looking. To correct this, the wonderful programmers at Discreet allow you to assign "loft-specific" mapping to any loft object.

Here's how it all works out. Lofts still utilize a U and a V coordinate system, much like their UVW counterparts, as shown in Figure 5-30. The U axis runs around the circumference of the loft object, whereas the V axis runs along the loft's path. You should keep in mind that the V axis is not necessarily a straight line. If the path you used contained Bezier curves or hard angles, the V coordinates will reflect that. It is because of this V axis that we are able to control how the material will tile along the "length" of the loft.

figure | **5-30**

The UV coordinate axes that affect loft mapping.

To adjust and manipulate the UV coordinates on a loft, simply go to the loft parameters in the Modify panel. Beneath the Surface

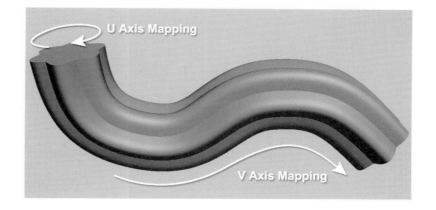

Parameters rollout you assign mapping coordinates by checking the checkbox next to the Apply Mapping option. Just under that option you will see two value spinners that correspond to how the material is tiled along the loft. The Length Repeat value is used to adjust tiling along the V axis, and the Width Repeat is utilized to manipulate tiling across the U axis. While working with these values you may notice that the material looks "squished" in some areas and stretched out in other places. This occurs because by default the material is repeated along the loft object according to how the object's "path steps" are distributed. The closer the vertices are together the more compressed or squished the material will appear. The farther apart the vertices are the more stretched the material will look. Sometimes this effect is not at all a bad thing and may indeed be just the thing that makes your loft object look great. However, in case you don't want this to happen 3ds max has a nifty feature that will correct the phenomenon. Directly beneath the Repeat values is a checkbox labeled Normalize. When Normalize is checked, the vertex distribution of the material's tiling is overridden and the texture will be distributed evenly along the loft, as indicated in Figure 5-31. When Normalize is unchecked, the vertex distribution will determine how the texture is tiled along the object, as indicated in Figure 5-32.

figure | 5-31

Tiling a material on a loft object with the Normalize option turned on.

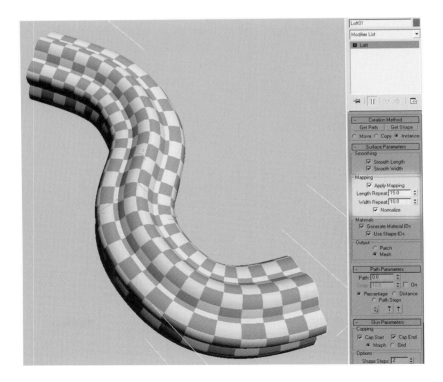

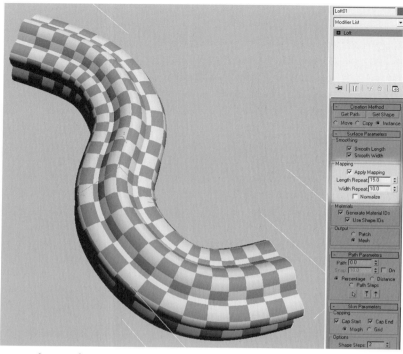

figure | 5-32 |

Tiling a material on a loft object using vertex distribution. The Normalize feature is turned off.

MATERIAL IDS AND MULTI/SUB-OBJECT MATERIALS

If you decide that this 3D stuff is pretty cool and that you might want to make a career out of it, you will almost certainly encounter a situation in which you need to apply multiple textures to a single mesh object. Up until now, our texture painting has focused on getting one fantastic material on one terrific object. Now we need to dive just a little deeper into the art of object texturing and discuss material ID numbers and multi/sub-object materials, which will empower you to use any number of materials on a single object.

Let's put you in the shoes of a texture artist who is working with other 3D artists at an animation house. You get handed a finished mesh of an F-16 fighter jet from Joe Shmoe, one of the modelers

with whom you work. The jet is one complete object; there are no individual parts whatsoever (this is not uncommon). In order to apply materials to the jet you will need to make various selections of faces and assign each group a material ID number. For instance, the canopy of the cockpit would constitute a group, so you would assign a glass material to that group of faces. You might then group much of the fuselage of the plane together and apply a flat gray metal texture to it. You would repeat this process until every surface of the model has an ID number assigned. Then you can begin to build the multi/sub-object material the plane will use. This material consists of several submaterials that act just like a normal empty material slot. Each of these submaterials corresponds to a particular material ID number, and when the multi/sub-object material is applied to the mesh the various submaterials will automatically be placed onto the corresponding surfaces of the model that hold the same material ID number.

figure 5-33

Objects are automatically given material ID numbers. You can assign customized IDs to selected surfaces of an object using sub-object editing.

When objects are created, they are automatically given material IDs, as indicated in Figure 5-33. If we look at a basic box, each surface of the object is assigned a different ID number. The box has a total of six surfaces and thus holds six different IDs. Let's say you wanted to create a die for a casino scene you are building. You could use a box as the base object and construct the different sur-

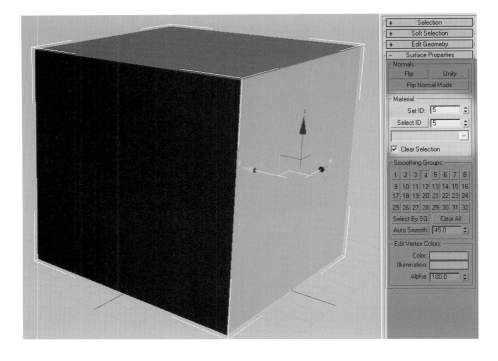

faces of each die using a multi/sub-object material. There would be a total of six submaterials, each depicting a number on the die. Each of these submaterials correlates to a surface on the cube and when the material is applied to the object you now have a nifty set of dice you can gamble with in your virtual casino.

> ## Are Multi/Sub-Object Materials Evil ?

Although multi/sub-object materials are interesting and can be useful, most professional 3D designers tend to stay away from using them, in that it initially takes a rather long time to go through the process of selecting faces, assigning the ID numbers, and setting up the material. This process could slow down the artist quite a bit, so what they do a lot of the time is detach parts of an object and create individual materials and mapping coordinates for each piece of the object. Once the separate materials are all placed on the object parts, the various pieces are linked and/or grouped. If the model needs to remain a single mesh object, the parts can be reattached to form a single object. The former pieces become Element sub-objects of the overall mesh and the materials will inevitably result in a multi/sub-object material.

How about we try building a simple multi/sub-object material so that we can get a better feel for this process? It would be fitting for us to make that pair of dice, and who knows, maybe even win a little something at the craps table.

Gambling with Material IDs

In the following exercise you will work with material IDs.

1. Start by building a chamfered box in your Top view port with the following parameters. Use the Keyboard Entry rollout. Note that you can access the Chamfer Box within the Extended Primitives.

 Length = 20
 Width = 20
 Height = 20
 Fillet = 1

2. Under the Parameters rollout, set the following:

 Fillet Segments = 5

3. Name the object *die 01.* This will be the first die in our set.

4. Apply an Edit Mesh modifier to the box and activate the Polygon sub-object.

5. Begin selecting each main surface polygon of the box and assign each a different material ID. Make sure you don't select any polygons that make up any of the chamfer surfaces. Figure 5-34 shows what you should see at this point. Figure 5-35 shows the Edit Mesh material ID parameters.

figure **5-34**

Chamfered box with Edit Mesh modifier applied and polygons selected.

figure **5-35**

Edit Mesh material ID parameters.

6. Once all six main sides of the box have been designated with unique IDs, select all six of those surfaces. Invert the selection to select the chamfered sides, as shown in Figure 5-36. Give this selection an ID number of 7.

figure | **5-36**

Chamfered box with the polygon selection inverted.

7. At this point, we can start mixing our material that will spice up this box. Turn off the sub-object mode, open the Material Editor, select a sample slot and rename it *Red Dice*. Next to the material name, click on the Material Type button to open the Material/Map browser.

8. From the browser list, select Multi/Sub-Object. When prompted, you can discard the old material. You should now see a list of submaterial slots in the material parameters.

9. Click on the Set Number button to change the number of sub-materials to 7.

10. Name each submaterial accordingly. For instance, you can name them *one*, *two*, and so on to correspond to the number that will appear on the die. For the seventh material, you could name that *chamfer*.

11. To save time, we will set up the material for the first submaterial, clone it to the other six submaterials, and then merely swap the imported bitmap textures to the appropriate image. Each submaterial will utilize three imported bitmaps: one for the color and pattern of the texture, one for the opacity of the surface, and one for the bump channel that will simulate the dimples of the number dots. Click on the button next to the first submaterial slot. You will now see what looks like a Standard material slot. We will use the Blinn shader for this. Under Shader Basic Parameters, check 2-Sided. Under Blinn Basic Parameters set the following:

 Specular Level = 165
 Glossiness = 60

12. Under the Maps rollout, click on the button in the Diffuse Color channel. Select Bitmap from the Material/Map browser. From the *Ch 5* folder on the companion CD-ROM, import *redDice_one.png* from the *Dice* folder.

13. In the Opacity channel, import the *redDice_one_opacity.png* image.

14. For the Bump channel, import the *redDice_one_bump.png* image and set Bump Amount to 140.

15. One thing you might want to do is activate the Show Map in Viewport button, which will allow you to see the texture in the viewport while you work. Click on the Diffuse channel to go down a level and select the Show Map in Viewport button. Once done, you can click on the Go to Parent button to return to the root of this particular submaterial. You might want to do this as you go along building all of your submaterials. This will prevent you from having to drill down several levels within your material to do this.

16. Save your work. You can save your Max scene as *Red_Dice. max.*

17. Now we must clone the first submaterial so that we can use it as a template for the other submaterials.

18. Click on the Go to Parent button to return to the submaterial list. Click and drag the material button next to the first submaterial down to an empty submaterial slot within the *Red Dice* material. When prompted, make the duplicate material a Copy clone. Repeat this process until all subtextures have the cloned material in them.

19. Now it's time to customize the remaining six submaterials. You will need to go into each one and update the bitmap graphics for the Diffuse Color, Opacity, and Bump channels. To do this, click on the channel you wish to change. Under the Bitmap Parameters rollout you will see a long button with a file path to the currently loaded bitmapped image. By clicking on that button, you can browse for a different image. Replace the bitmaps until all submaterials in your overall texture have all of the correct maps in the correct channels, as indicated in Figure 5-37.

figure | 5-37

Replace each channel's bitmap with new bitmaps that correspond to the surfaces of the die.

20. Once you have replaced all of the bitmaps in each submaterial channel, it's almost time to see what this texture looks like on our chamfer box. Go through each of your submaterials and make sure that the Show Map in Viewport button is turned on. This allows you to see a preview of your material in the workspace.

21. The last submaterial that needs to be made is the "chamfer" material. Basically, all you need to do is clone one of the other submaterials into the last material slot (Mat ID #7) and remove the maps from all map channels by dragging an empty "None" channel to the Diffuse and Bump channels. This will reset them to the original "None" mode. In the Opacity channel, swap the current map with the *chamfer_opacity.png* file.

22. Back to the box. Make sure the chamfer box is selected and apply a UVW Map modifier to it. Change the mapping type to Box and we're good to go!

23. Click and drag your *Red Dice* sample slot and release on the die object. You should now see a rough representation of your die in the viewport, as shown in Figure 5-38.

24. Clone the box and use your transform tools to offset the second die. Now we have a pair of dice! Find an interesting view of the dice and render your view, such as that shown in Figure 5-39.

figure | 5-38 |

Our multi/sub-object material placed on the chamfer box.

figure | 5-39 |

The finished rendering of the dice after the chamfer box has been cloned.

When applying a UVW Map modifier to an object that will eventually have more modifiers added to it, be sure the UVW Map does not appear at the top of the modifier stack. This will cause the material to be mapped incorrectly. Say, for instance, you create a cylinder you will later bend. After building the cylinder, apply the UVW Map and then the Bend modifier. This will ensure that the material will follow the contour of the object better.

Wow, now that was fun! Hopefully you can start to get an idea as to the power materials hold and how effective they can be when creating a 3D design. You were able to turn a simple box into what seems to be a more complex object solely with materials. By experimenting with different material types and by messing with all of the settings and parameters, you should be able to achieve some pretty incredible things for your own work.

SUMMARY

A ton of information was covered in this chapter regarding 3D surfaces and materials. Together, we walked through the basics of the 3ds max Material Editor and built a variety of material types ranging from simple pre-made materials to more complex materials consisting of multiple submaterials. This step of 3D illustration is one of the most crucial steps within the production pipeline, and although it will take some practice to get proficient with the Material Editor the end result of all the practice will definitely pay off and will reflect in more professional-level renderings.

in review

1. Explain the additive (transmitted) color model and why it is relevant to 3D illustration.

2. Describe the differences between bitmap materials and procedural materials.

3. What are some of the common bitmap types that can be imported into the 3ds max Material Editor?

4. Discuss what shaders are and list the eight available shader types that can be used as a foundation for a material.

5. The 3ds max Material Editor operates on a hierarchical structure. Explain how this hierarchy works and why it is important.

6. The Ambient, Diffuse, and Specular color maps are among the most common maps used in 3ds max. Describe how each of these relates to light.

7. Why are mapping coordinates important when applying materials to 3D objects?

8. Describe what the Material/Map browser is.

9. When creating a texture from scratch using Photoshop or other graphics application, is it usually a good idea to create a texture that can be tiled? If so, why?

10. Loft objects generally tend to cause problems when applying mapping coordinates. Describe how one can assign coordinates to a loft object.

↗ EXPLORING ON YOUR OWN

1. Attempt to add reflections in the dice material. Experiment using different reflection maps, such as the Reflect/Refract and Raytrace maps.

2. Try experimenting with different procedural maps and some of the other material types, such as composite, blend, and multi/sub-object materials.

3. Search the Web for 3ds max tutorials pertaining to materials and texturing. Tutorials can be an invaluable wealth of knowledge. If you wish, sign up for some of the 3D forums available on some of these 3D resource sites. There are a lot of talented people out there you could learn from! Some great web sites to visit include:

http://www.3dcafe.com http://www.3dm-mc.com
http://www.pixel2life.com http://www.3dluvr.com
http://www.3dlinks.com http://www.cgtalk.com
http://support.discreet.com

ADVENTURES IN DESIGN

GETTING OUT OF YOUR SKIN

So how do you like materials and textures so far? Texturing is definitely an interesting and extremely rewarding aspect of 3D design. It's one thing to model an object from scratch, but there's definitely a special feeling you get when you create a killer photorealistic material and apply it to that model. It enhances the final rendering so much that it can truly be a magical experience to see your model become more lifelike with a realistic texture.

In Chapter 5 we discussed numerous topics, ranging from bitmap materials to multi/sub-object materials. We also very briefly touched on a concept known as "unwrapping," in which an object's mesh is essentially flattened out. The main purpose for this is to achieve even better mapping coordinates for the 3D model than what the standard UVW Map modifier can provide. By performing an unwrap on the mesh, the artist can further refine the coordinates by visually reorienting portions of the mesh within a neat little editing window (which we will take a look at in material to follow). This process can eliminate areas of the material that might appear to be stretched or distorted. This is especially helpful for irregular objects that really don't conform well to the standard mapping types such as spherical or box mapping.

There is also another reason for unwrapping a mesh object. In addition to fixing mapping coordinates, texture artists also use this technique to aid them in the actual creation of the material. A common practice in the industry is to produce a lot of the object's detail in the material itself, which allows the modeler to create objects that have far fewer polygons than might be needed if the detail were included as part of the object. Can you see where we're going with this yet? Video game graphics use this technique almost religiously, in that the images need to be rendered in real time. By placing all of the minute detail within the material rather than on the actual model, less processing power is required to render the game play. However, don't think that only game developers use this method of texture creation. Hollywood effects houses also rely heavily on custom materials built with the use of unwrapped meshes.

Let's Unwrap the Box!

To unwrap a mesh object, an Unwrap UVW modifier is applied (after a UVW Map modifier is applied) to it. At this point, the mapping coordinates can be adjusted in the Unwrap UVW editing window. Once the mesh

has been flattened out, the artist can export the flattened mesh with a neat (and free) little plug-in called Texporter (which can be downloaded for free from *www.cuneytozdas.com /software/3dsmax*) to save the mesh as an image file, which can then be imported into a paint program such as Photoshop or Painter. At this point, the 3D artist becomes a painter, using photos, brushes, paint, and color to generate a texture for the object, using the mesh image as a guide for precise placement of detail. Okay, this might be a bit confusing, so why don't we try painting a texture for a simple object. We'll go through the process of unwrapping a mesh, exporting it with Texporter, and painting a texture in Photoshop. Before you begin, visit Cuneyt Ozdas' web site and download the Texporter plug-in. It is very easy to install. Simply double click on the

EXE installation file and install Texporter into the root directory of 3ds max. Once the plug-in has been successfully installed, you may continue with the exercise. (Note: In order for the plug-in to take effect, make sure 3ds max is not running during the installation. Once installed, you may then start up the software and the new plug-in will be available.) In the interest of time, and to ease you into working with this technique, we will use a very simple object.

1. Open 3ds max and start with a fresh scene.

2. In the Top viewport, create a box that has a length, width, and height of 50.

3. Apply a UVW Map modifier to the cube and set Mapping to Box.

4. Once the mapping coordinates have been set, apply an Unwrap UVW modifier to the box. You can leave the parameters at their default values.

5. Under the Parameters rollout, click on the large button labeled Edit. You should now see the Edit UVW's editing window, as shown in Figure B-1.

Figure B-1. The Edit UVW's editing window.

6. It is within this window that the mapping coordinates can be edited by moving, scaling, rotating, and mirroring faces, vertices, and edges. You should see a square with a grid behind it. At the present time we are looking at the mesh of the box. However, we can only see one side of the box. Here is where we need to flatten it out. Within the Edit UVW's window, go to Mapping > Flatten Mapping in the menu at the top of the window. This will bring up the Flatten Mapping dialog window, shown in Figure B-2.

Figure B-2. Flatten Mapping dialog window.

7. In the Flatten Mapping dialog window, leave the settings at their default values except for Spacing, which should be set to 0.0. Click on OK. This will unwrap the mesh and flatten it out onto a 2D grid.

8. Let's go ahead and turn off the grid in the Edit UVW's window to make it a little easier to see the flattened mesh. In the Edit UVW window, go to Options > Advanced Options to open the Unwrap Options dialog window.

9. At the top of the Unwrap Options dialog window, under the Colors section, you should see a number of different color swatches. The bottom left-hand swatch is the color for the grid. Directly above this swatch you will notice a checkbox next to Show Grid. Go ahead and uncheck this box. Now the grid disappears and we can better see our mesh in the Edit UVW window.

10. You should now see what looks like a triangular stack of squares, each square representing a surface of the box. (See Figure B-03 for how the flattened mesh corresponds to the 3D object.) At this point we need to export this mesh as an image. Go to the Utilities panel and click on the More button under the Utilities rollout. From the utilities list, select Texporter. Click on OK.

11. Within the Parameter rollout, set the following:
Image Size:
Width = 800 Height = 800
Display:
Edges = Checked
Mark Overlaps = Checked
All other checkboxes should be unchecked.
Colorize By:
Constant = Selected
Set the color swatch to White.
All other radio buttons should be deselected.

12. Once the parameters have been set, activate the Pick Object but-

Figure B-3. The resulting mesh of the box after flattening has been performed. Note the arrangement of the box surfaces.

ton and select the box object in your viewport. You should now see a window pop up with the flattened mesh displayed in white against a black background. You can now save the mesh as an image file by clicking on the small diskette icon in the upper left-hand corner of the Texporter image window, shown in Figure B-4. We saved ours as a TIFF, but you can save yours as whatever you like.

Figure B-4. Texporter settings and image window..

Figure B-5. Final box material.

12. Open your saved mesh image in Photoshop (or your favorite paint software).

13. Okay, we now need to make our mesh lines visible throughout our texturing process. You can duplicate the background layer. Go to Image > Adjustments > Invert to reverse the colors, and set the blending mode to Multiply. Fill the upper right-hand region with black to distinguish the surfaces from the background. By keeping this layer on top of our painting we will be able to see where the edges of the mesh are at all times.

14. You can now delete the original background layer. Create a new alpha channel, setting the object to white and the background to black. Your alpha channel should

look very similar to the top multiply layer, but without the mesh lines.

15. At this point, we imported a couple of different metallic photos, which we will use as the foundation of our texture. Feel free to use any metal you like. Make sure that each photo is on its own layer below the mesh layer.

16. Create a second alpha channel and begin to paint areas within the object to simulate places where the paint or metal has been chipped off. We've found that grunge brushes (which are easy to find online) work great for this.

17. Make a selection of this alpha channel and go back to your Layers palette. Highlight the top

metal layer and then press Delete. This will get rid of the selected areas, revealing the other metal underneath.

18. Now we can add any desired details. For our texture, we used our burn tool to darken areas along each edge of the mesh. This should help enhance the worn effect.

19. Once you have your texture looking how you want it to, we can now save out our new material. Hide the mesh layer to show everything underneath. Save the image as a TIFF file (you can go ahead and flatten the layers). The final box material is shown in Figure B-5.

20. Back to 3ds max! Open the Material Editor and select an empty sample slot. In the Diffuse Map setting, load the TIFF you just saved.

21. Click on the Go To Parent button and activate the Show Map in Viewport button so that you can see this material in the viewport.

22. Apply your new material to the box, as shown in Figure B-6.

Excellent job! You should now have a nicely textured box. You should note that if you change your sample slot object to a box in the Material Editor your texture might look a little funny. However, once you apply the material to the box everything will line up perfectly because we have precise mapping coordinates assigned to the object. Even though this was a simple exercise using the unwrap technique, you can explore this texturing method with more complex objects. If you would like to see how we approached our material, the PSD file can be found on the companion CD-ROM in the *Adventures > AID B* folder. Happy painting!

Figure B-6. Box with the final material applied.

| lights, cameras, render! |

6

 charting your course

Now that you have just finished learning how to paint your objects with really neat surfaces and materials, it is time for you to continue on your journey into the world of digital lighting. In the previous chapter, it was said that 90 percent of a good rendering is in the lighting. This is a very interesting aspect of the 3D illustration process that can really produce photorealism that is quite amazing. This chapter will give you a look at how to create standard lighting setups, as well as more advanced lighting approaches such as radiosity and global illumination.

In addition to talking about light and shadow, you'll also get exposure to virtual cameras, and how to optimize them to match your output method. Rendering techniques will also be discussed, including rendering for print. We know that you will find this chapter helpful; and who knows, you might even like it so much that you'll want to specialize in this aspect of 3D design.

 goals

● **Create a variety of virtual lights**

● **Adjust light parameters to create a variety of lighting scenarios**

● **Apply basic global illumination to a scene**

● **Set up a photometric rig**

● **Use the Light Lister for fast manipulation of light settings**

● **Set up virtual cameras and adjust parameters**

● **Experiment with different output settings for the final scene rendering**

LET THERE BE LIGHT

You have just learned how to apply surface materials to your models, but before you go crazy and texture all your meshes you should know that materials are done after lighting has been set up. In many animation and effects studios, the lighting is set up prior to the texture mapping. The main reason to create the light first is to get a precise idea of how the light will act, behave, and look within a scene. If textures appear on surfaces before the lightning is applied, there is a risk of the material giving a false sense of how the light reacts in the scene. Usually what is done is that each mesh object in the scene is given a white flat matte material, as indicated in Figure 6-1. Void of color or patterns, the objects will more accurately depict how the shadows and highlights appear. This is usually the standard practice in 3D design.

You can see from Figure 6-1 that the matte material acts as a blank canvas for the lighting artist to "paint" the light onto the scene. If there were materials and patterns on the objects in the scene, it

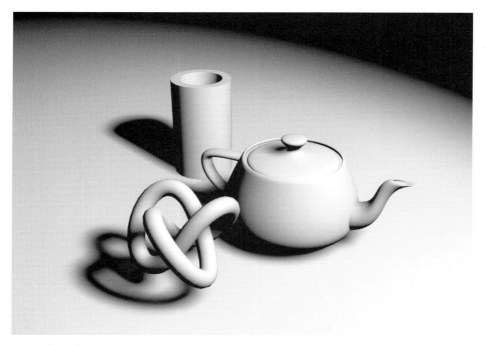

figure | 6-1

With a white matte material applied to all objects in a scene, the lighting artist can get a better idea of how the final lighting rig will look.

would be much more difficult to distinguish the resolution and quality of the shadows and highlights produced by the virtual lights in the lighting rigs. Figure 6-2 shows the same scene with some materials applied to the objects. Note that it is now much more difficult to see what the light is doing in the scene.

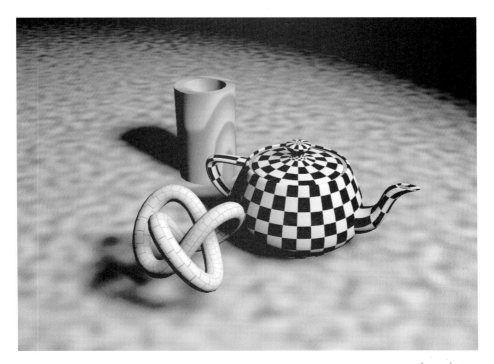

Throughout the course of this chapter, we will walk through the process of setting up some standard lighting rigs using the standard virtual lights available in 3ds max 7, as well as introduce you to some of the advanced lighting utilities included with the software. So, without further ado let's move on.

figure | **6-2**

Materials make it much more difficult for the lighting artist to discern the quality of the lights being used.

SETTING THE STANDARD WITH LIGHTS

Before we jump right into virtual lights, it would be a good idea to take a step back and consider where these 3D lighting techniques are derived from. All 3D applications these days base their lighting systems on traditional lighting methods. Studio photography, videography, and cinematography are all industries that have contributed to how lights are to be handled within a 3D software environment. Even the types of lights included in 3ds max are modeled

after real-world light types. This makes the transition for lighting technicians who want to move from traditional to digital lighting a lot easier.

Some Traditional Lighting Rigs

As stated previously, the art of virtual lighting (and it truly is an art in and of itself) is directly related to traditional studio lighting as well as real-world lighting scenarios. For the most part, the basic approach to setting up a basic light rig is a question of how many lights you want to use. One approach is called one-point lighting, which uses only one light source. A good example of a one-point light would be none other than our nearest star; the sun makes a fine one-point light. Probably the most notable characteristic of this technique is the way the light produces very harsh and dark shadows. This holds true in a portrait studio as well. No matter which angle you use, you will always have large areas of shadow on your subject. Figure 6-3 shows a single light setup in a studio environment. In this particular example, the light is positioned to illuminate only one side of the subject.

figure | 6-3

A one-point light rig.

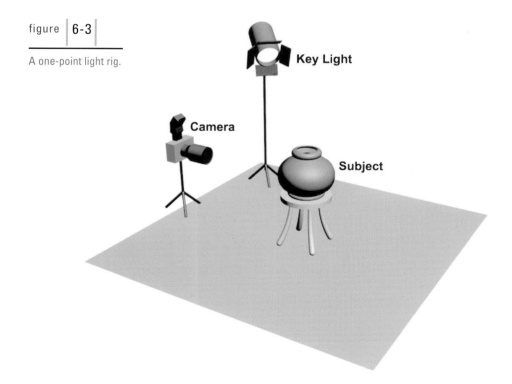

Next we come to the two-point light system. This setup has a main light source called the key light, which is usually directly focused on the subject. The second light has an interesting job. In most cases, the harsh shadows produced by a single light is an undesirable effect, at which point a second light (known as a fill light) can be used. The fill light is usually about 1/3 as bright as the key source. This fill source allows you to brighten up those dark shadows, which lets you see more of the subject. Generally, the key light is positioned at a 45-degree angle pointing down toward the subject and is situated on one side of the camera. The fill light source is usually positioned on the opposite side of the key light on the other side of the camera. Figure 6-4 shows a two-point rig.

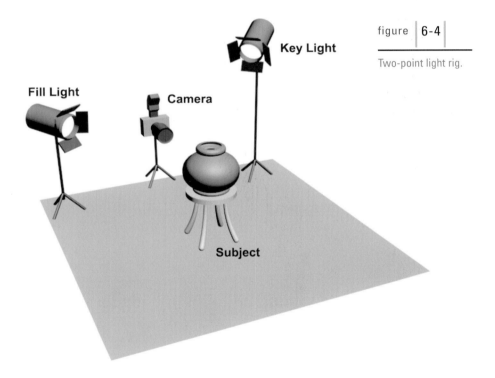

Key Light

Fill Light

Camera

Subject

figure | 6-4

Two-point light rig.

Finally, we come to the three-point lighting setup. Just as the two-point system (built upon the one-light setup), the three-point setup builds upon the two-point rig. Sometimes having light focused on just the front of the subject isn't enough. What can happen, depending on the scene, is that the subject and the background begin to blend, resulting in the subject getting lost in the scene. For instance, if a gentleman is having his portrait taken in a

tuxedo, with a backdrop or environment that is fairly dark, the black tux and the background will start to blend. To alleviate this, a third light called a backlight can be implemented. This is a flexible light that can come in handy. When used in a studio setting, the backlight can be used to add a little razzle-dazzle to a subject, perhaps to show details in hair or fur. For this use, the backlight should be a wee bit brighter than the key light.

Another really cool thing you can do with a backlight, which works quite well on small sets or spaces that have very limited areas, is to direct the light at the background elements. This way, you can dramatically brighten up the background, which not only brings out the subject but creates the illusion of a larger space. One of the most common uses for a backlight is to define the subject within the scene. By aiming the light fully on the subject, you can better accentuate the edges of the subject of your scene. Figure 6-5 shows a scenario using the three-point lighting rig.

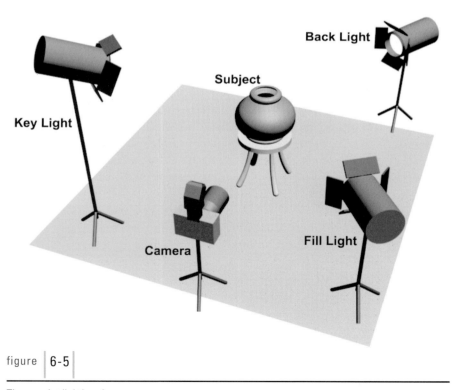

figure | 6-5 |

Three-point lighting rig.

When using some of these basic rigs, try to avoid using the same brightness for all of the lights being used. Doing this can wash out shadows that otherwise would improve the overall impact of the scene. By varying the brightness of each light, you can create a much more dramatic piece.

All of these techniques can be carried over into the realm of 3D when lighting your objects and scenes. The biggest difference between the virtual and the real is that you don't have to worry about breaking your back lugging equipment or tripping over miles of power cables. Actually, there are a few more differences between the two, which we will start discussing in the following sections.

THE 3DS MAX 7 LIGHTING EXTRAVAGANZA!

The arsenal of lights at your disposal can be found within the Create command panel. Below the panel tabs, look for the button with the spotlight icon (shown at right). This will give you access to the virtual lights within the software. 3ds max provides you with two main types of lights: standard and photometric. Standard lights are the run-of-the-mill virtual lights available in 3ds max. They are more often than not the lights you will use in your 3D scenes. Photometric lighting is primarily used to simulate something called radiosity within an environment. Radiosity is basically the "bounced light" that is created from the main light source bouncing off other objects in the scene. Although radiosity can be applied to standard light objects, photometric lights allow for more realism in your pieces. In addition to better radiosity results, photometric lights allow you to utilize real-world light parameters to achieve very real representations. Here's a good example. Pretend for a moment that an architectural firm has approached you to produce a 3D rendering of a remodeling project the firm is designing. In the rendering, they want you to show the exact lighting scheme that will be used when specific types of lights are installed during the remodel. The contractor has told you that they will be using GE 75-watt SoftWhite light bulbs for the incandescent lighting, and 125-watt halogen lights for the track lighting. Photometric lights will give you the ability to input those manufacturers' light properties to attain results that will accurately show what those lights will look like in the completed remodel. We'll talk more

about radiosity and photometric lighting later in the chapter, but for now let's take a closer look at the standard lights in 3ds max.

Standard Light Objects

To see exactly what the light will look like in the final image, 3ds max must first render the scene to calculate which parts of which objects will receive light and which won't. The way max does this is by looking at each object's face normals. Normals are basically which direction each face surface is facing. During the rendering process, Max will look at the angle of these face normals to determine to what degree the lights are hitting the surfaces of each object. The more a face is angled toward a light source the lighter that part of the object will appear.

Here's another interesting tidbit for you regarding virtual lights. They all shine through objects. Yep, that's right, when you create a light in 3ds max that light will shine on and through every object it's directed at. Even if you place a small object behind a much larger one, the smaller of the two will still be lit up. The way to avoid this is to enable shadow casting within the light parameters. With shadows on, objects that are obscured from the light will appear in a shadow and not receive any illumination. Shadows are discussed further in material to follow. For now, however, let's take a look at some different light types. The various light objects can be broken down into three main categories of lights, with three additional lighting types that are used in conjunction with advanced lighting. These categories are outlined in the following.

- *Omni:* The term *omni* in this context stands for *omni-directional*, meaning that the light rays emitted from the object shoot out from all directions. A perfect example of an omni light would be the sun. Even though the sun rays hit only one side of the Earth at any given point, in truth the sun emits light in every direction into space. A standard light bulb could also be considered a type of omni light.

- *Spot:* The spot light object in 3ds max is considered a unidirectional light type, meaning that the light transmitted by the object is shot in only one direction. Light originating from a spot light begins at a focal point (at the origin) and gradually spreads out and disperses as the light travels over distance. This occurrence produces a cone-shaped, or rectangular beam of

light from the spot light object. Perfect examples of spot lights are vehicle headlights, most types of theatrical lighting, and stadium lights.

- *Direct:* A direct light is basically a cousin of the standard spot light. It works in much the same way, with one major exception. A standard spot light emits light in a cone-shaped beam, whereas a direct light transmits light in a straight, cylindrical beam. The reason the light doesn't scatter over distance is due to the fact that the light rays are traveling parallel to one another, rather than originating at the same point and being projected at an angle. A laser beam is a perfect example of a direct light. The beam could theoretically travel an infinite distance, and the light wouldn't disperse to a larger area as it traveled.

- *Skylight:* Skylight objects are meant to simulate daylight in exterior scenes. These types of light typically require some form of advanced lighting calculation such as radiosity or light tracing.

- *mr Area Omni/Spot:* These lights are transmitted from a rectangular or a disc-shaped area rather than an actual light object. These types of lights utilize advanced lighting calculations and can only be used with the "mental ray" rendering engine included with 3ds max 7.

These lighting sources represent the main types of light that can be generated within 3ds max. The spot and direct lights actually have two versions you can utilize in a scene. The spot light object gives you the option of using a target spot or a free spot. A target spot, when made, actually creates two objects: the spot itself and the target object. The target (seen as a small box) is basically the focal point of the light. By moving the target object, it allows you to aim the light in the direction you want it to point. A free spot, when created, will only produce the actual light object. To aim the light, you will have to use the transform tools to move and rotate the light to position it to your liking. Although a target spot is much easier to control and position, there are many instances in which a free spot is most desirable. A great example would be lights that are mounted to moving objects, such as a car, plane, or even on a character.

The free spot will allow you to link the light object to the moving object without having to worry about a second target object getting in the way. You would have to link the target to the main object as well, and even then there's a chance the light would attach to the

object and the target would not, with the result being a light that is spinning wildly as your animated mesh moves about. The direct lights have the same options. When you go to create a direct light, you have the choice of either a target direct or a free direct. Those types of lights work the exact same way as the target and free spots. You should note that you are able to switch between target and spot lights, and vice versa, in the light parameters in the Modifier panel. Figure 6-6 shows you the various standard lights in 3ds max (excluding mr Area lights and the Skylight).

 DON'T GO THERE It is recommended that you stay clear of Skylights, mr Area Omni, and mr Area Spots until you have a basic understanding of virtual lighting basics and have done a little reading on advanced lighting in 3ds max. Light tracing, radiosity, and mental ray are advanced lighting techniques that we will touch on later in the chapter.

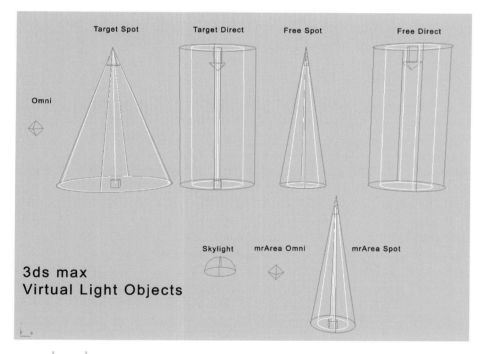

figure | 6-6 |

The various 3ds max light objects.

From looking at Figure 6-6, you probably noticed some funky lines and gizmo objects around some of those light objects. At this point in the game you need to get a feel for the anatomy of a virtual light. Each element of the light translates to real-life lighting terminology and phenomena. Figure 6-7 depicts the anatomy of a normal, run-of-the-mill standard target spot. Keep in mind that just about all of the elements present in every light object (with the exception of the target object, which is not present in free spots, free directs, or omni lights).

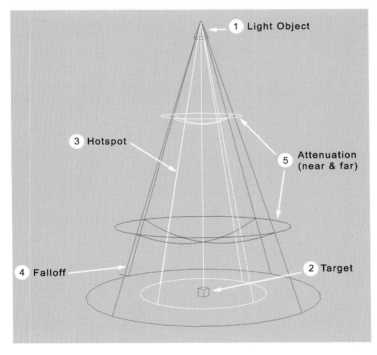

figure | 6-7 |

The "anatomy of a light" in 3ds max.

Have you had a minute to absorb Figure 6-7 and learn some anatomy? In the following we're going to take a closer look at what the deal is for each of those light parts.

- *mr Light object:* This is the origin of the light. The look of this object in your viewport will be determined by the type of light you create. To gain access to the light's many parameters, the light object must be selected.

- *mr Target:* The light's target allows you to aim the light according to your needs. With the light's target selected you cannot adjust light parameters. The light object itself must be selected.

● *mr Hotspot:* The hotspot of the light is depicted as the center cone gizmo emitting from the light. The hotspot of a light is the area where the light is most focused and is brightest, as depicted in Figure 6-8. Objects that sit within the hotspot will appear brighter than those that sit in other regions of the light.

figure | **6-8**

Light hotspot: the area where the light is brightest and most focused.

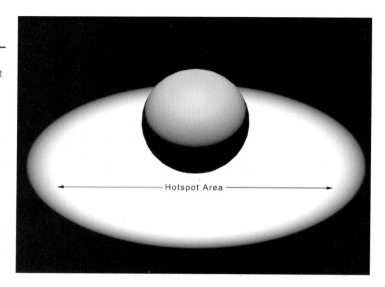

● *mr Falloff:* The falloff appears in the viewport as the outer cone originating from the light object. The falloff of the light is basically the cutoff point between the light and darkness. The area that lies between the hotspot and falloff range could be considered the ambient portion of the light. This region depicts the gradual transition between the brightest part of the light and the darkness outside the falloff range. Objects that sit within the falloff, shown in Figure 6-9, will appear darker than those that sit within the hotspot.

figure | **6-9**

Light falloff: The region within the rays of light that transition between the hotspot and the darkness of the shadow. The larger the falloff the more diffuse the light will be.

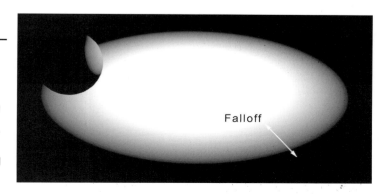

● *mr Attenuation:* In virtual space, light travels forever. To achieve more realistic results with your light rigs, turning on attenuation will help tremendously. Attenuation is the gradual diminishing of light as it travels over distance, as depicted in Figure 6-10. This means that the farther the light goes the dimmer the light will get, until no light exists at all. The attenuation is determined by a near and a far range. The Near Attenuation setting determines when and how the light "fades in" from the light source, and the Far Attenuation settings determine how the light begins to "fade out" to blackness.

figure | **6-10**

Light attenuation tells the light to gradually diminish as it travels over distance.

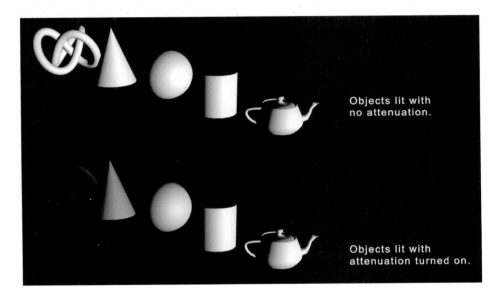

Objects lit with no attenuation.

Objects lit with attenuation turned on.

Lurking in the Shadows

One of the most important thinks to remember when designing a lighting scheme is the fact that shadows are a must! Without them, your scenes will look very mediocre, a sure sign of a nonprofessional—not to mention the fact that all of your objects will appear flat and floating. Not having shadows in your renders makes for the old cliché 3D images that look quite fake. Shadows are what ground your objects to other objects and help make them appear more solid. You will quickly get into the habit of using shadows in your own renderings.

As we discussed earlier in the chapter, virtual lights work a bit differently than real light. By default, virtual lights will pass through

objects, meaning that if you have a cylinder sitting directly behind a bigger cylinder and you aim a light at the bigger object the smaller cylinder will also receive light from the light source. This can definitely be an undesirable effect, so to prevent this from occurring you will need to turn on shadow casting in the light's parameters. There are a total of five different shadow types within 3ds max 7. These are outlined in the following.

- *Area:* Creates a nice soft edge on the shadow that increases as the shadow moves away from the object. The closer to the object the shadow is the sharper its edges will appear. The further the shadow is from the object the fuzzier and less defined it appears.

- *Shadow Map:* This type of shadow uses a bitmap generated during a pre-rendering pass of your scene. This bitmap is then "projected" by the light onto other objects in the scene. Unfortunately, transparency and translucency are not able to be depicted with this shadow type. However, soft, realistic shadows can be created by adjusting the shadow map parameters. This is the default shadow type given to lights when they are initially created.

- *Ray Traced:* With raytraced shadows, 3ds max will calculate each light ray being emitted by the light source. During the rendering process, if a light ray passes through a transparent or translucent object the color of that transparency or translucency will be shown in the resulting shadow. The biggest problem with raytraced shadows, however, is that they produce very crisp shadows due to the fact that they are much more precise than shadow maps. This is a catch-22, so to speak, because most shadows that occur in nature do not have a hard edge to them. What is usually done to correct this is to utilize two lights: one with a shadow map to get the soft shadow edges and the second with raytracing, which will depict the filter color of transparent objects.

- *Advanced Ray Traced:* This shadow type is the same as the standard Ray Traced shadow option, except you get more options available to you, giving you more flexibility when setting up a raytrace light. Be warned, however; that Advanced Ray Traced shadows do not respect colors that contain transparency.

- *Mental Ray Shadow Map:* These are almost exactly the same as the standard shadow map shadows except that they are calcu-

lated using the mental ray shadow map algorithm. You can make changes to specific settings in the Renderer tab within the Render Scene dialog window when the mental ray Render is the assigned renderer.

Having a good understanding of shadows will prove very helpful to you as you paint your scenes with light. Knowing what type of lighting will be used in a scene can tip you off to what type of shadows will be required. For instance, if you were building a space scene you would want very dark, almost black, shadows that are very crisp. This harshness in the shadows occurs because on Earth (and other planets) the atmosphere diffuses the light, which softens the shadows. Figure 6-11 shows the Shadow Map Params rollout that can be found in the light parameters in the Modify panel.

figure | 6-11

Shadow Map Params rollout.

These settings allow you to control the softness, resolution, and position of the shadow. The shadow Bias setting controls the position of the shadow and lets you move the shadow closer or farther away from the shadow-casting object. Sometimes a shadow will appear to "bleed" into areas where the shadow shouldn't be, or sometimes be isolated from the object casting the shadow. Figure 6-12 shows you the effects of manipulating the map bias. Adjusting this value will correct this.

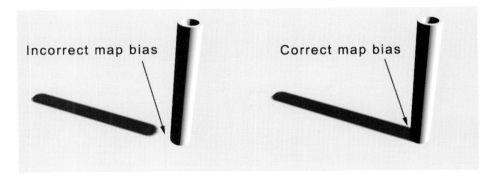

figure | 6-12

Controlling a shadow's position with the map bias.

Shadow maps, like their bitmap counterparts, are resolution dependent. This means that the larger the falloff used on a light the higher your Size value must be. If the size of the map is set too small, your shadow will have tremendous pixelation, giving you a rather horrible result. By default, your map size is set to 512, although a size of 1024 is a nice resolution to use for most instances. You do have to be careful not to set the size of your shadow too high, however, because you will risk running out of memory. Shadow maps are calculated with your computer's RAM. We recommend not going any higher than 4000 on the size. Otherwise, you could run into some serious problems when you render. Figure 6-13 shows a shadow at various resolutions.

figure | **6-13**

Various shadow resolutions using the Size parameter.

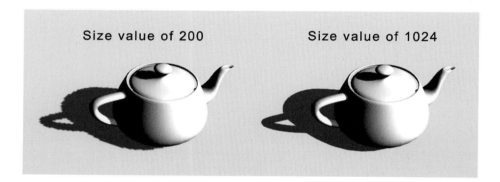

Size value of 200 Size value of 1024

The Sample Range setting gives you control over the "softness" of the shadow by calculating an average of the total shadow area. You can use any value between 0.01 and 50.0. The higher the number the softer the shadow will appear. We can see this in action in Figure 6-14. The Absolute Map Bias setting is used to provide added control over the bias of your shadows. When this box is left unchecked (the default), the bias will be normalized in relation to your scene and will generally be set to a low value one of about 1. When the box is checked, the value of the absolute map bias will relate directly to the scale of your scene, making it possible for that value to reach into the hundreds, depending on your scene's scale. Generally, though, leaving this option unchecked will give you good results in most situations.

There is also an option for enabling two-sided shadows. This feature, when turned on, will include the backfaces of an object to be included in the shadow, preventing outside light sources from illuminating the interior of an object. When this is turned off, any

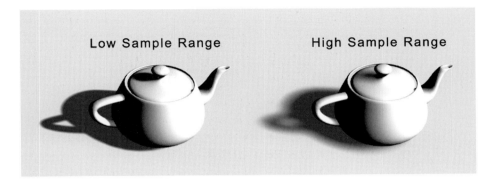

Low Sample Range High Sample Range

exterior lighting will appear to pass through the object and light the inside. Normally, you will want to keep this option checked.

figure | **6-14**

Adjusting the shadow's softness by changing the Sample Range.

Setting Up a Basic Light Rig

Now that you have a little background knowledge on virtual lighting within 3ds max, why don't we now set up a basic two-point lighting rig? This exercise will allow you to get accustomed to setting up light objects. As we progress through the exercise, we'll be sure to explain the light parameter rollouts as we go, giving you insight into some of the more common settings you will be working with. Before we start painting with light, we will need to set up a simple scene with a couple of objects in it so that we can see the results of our light. Remember that when lighting a scene it is always a good idea to apply a nice white matte material to all objects in the scene to better see how the light and shadows react to the objects in your environment. Once we have our scene constructed, we will apply what we like to call a "blank canvas" material to everything. Let's get started!

1. Reset your software to start with a clean workspace by selecting File > Reset from the menu.

2. Activate your Top viewport and select the Plane object from the Standard Primitives. Using the Keyboard Entry option, type in the following values and then click on the Create button. Name the new plane object *floor*.

 X = 0 Y = 0 Z = 0
 Length = 100 Width = 100

3. In the Front viewport, you're going to generate another plane to simulate a wall. You're going to make it the same way as the

floor, except that you will use the following parameters in the Keyboard Entry setting. Name the new object *left wall*.

X = 0	Y = 25.0	Z = -50
Length = 50	Width = 100	

4. Activate the Left viewport so that another wall can be built. You can use the same Keyboard Entry parameters as you did for the left wall. Just make sure your Left viewport is active. Name this plane *right wall*.

5. Alright, at this point a ceiling needs to be made. Select your floor object and activate the Front viewport. In the main toolbar, click on the Mirror Selected Objects tool (shown at left) and enter the following settings:

Mirror Axis = Y Offset = 50.0 Clone Selection = Copy
Uncheck Mirror IK Limits.

This will clone and flip the floor object and move it to the top edges of the wall. Name this new object *ceiling*.

6. In the Top viewport, generate a teapot with the following settings:

Radius = 10 Segments = 8

Select the Rotate Transform tool from the main toolbar and activate the Angle Snap icon and rotate the teapot -25 degrees. Type in the following coordinates in the Transform type-in fields at the bottom of the 3ds max window. They appear directly above the animation track-bar. These act as a shortcut alternative to the Transform Type-In dialog box.

X = -14.0 Y = 15.5 Z = 0

7. Go ahead and save your work up to this point as *ch6_2point_01.max*.

At this stage in the game you should have a room with a floor, ceiling, and two walls, with a teapot sitting on the floor. We don't need the other two walls because we will never see them in the final render. It is pointless to create unnecessary geometry that could possibly increase the rendering time. Figure 6-15 shows our progress to this point. Things are looking great. Keep up the good work!

We should put at least one additional object in our room to keep it interesting. A "blank canvas" material will also be applied to our objects in the scene via the following steps. We're really close to light time, so get ready. Continue with the following steps.

1. Let's add a stylized torus knot to the room. In the Extended
 Primitives rollout in the Create panel, activate the Torus Knot
 object. In the Top viewport, click and drag to make the object.
 In the Modify panel, change the properties of the torus knot to
 match the following settings.

Base Curve settings:	Radius = 11.0	Segments = 150
	P = 2.0	Q = 3.0
Cross Section settings:	Radius = 1.75	Sides = 12
	Eccentricity = 1.65	Twist = 4.0

2. Using the Transform type-in areas, position the knot at the
 following coordinates. Name the new object *sculpture*.

 X = 21.75 Y = -14.5 Z = 13.75

3. Open the Material Editor (M key) and select the first empty
 sample slot. In the Material Name field, rename the material
 Light Canvas. Leave the shader set to the default Blinn shader.
 Change the color in the Diffuse setting to white (255, 255,
 255), and set the Specular Highlights value as follows:

 Specular Level = 0

figure | **6-15**

The scene so far
for our basic light-
ing environment.
Feel free to position
your Perspective
viewport to get the
angle you want.

4. Select all objects in your scene by selecting Edit > Select All from the menu or by using Ctrl + A on the keyboard. With your entire scene selected, click on the Assign Material to Selection button (shown at left) in the Material Editor toolbar to apply the light canvas to our objects.

5. Save the project as *ch6_2point_02.max.*

Wonderful! You should now have a completed scene depicting a room with a teapot and a funky sculpture sitting in it. Yes, we know that the teapot is really huge, but it's a cool object to use for lighting demonstrations due to its curves. Figure 6-16 shows us our scene to this point. All of the objects in the scene now have the Light Canvas material applied to them to better help us out in the next section, where we actually set up a couple of lights to brighten up our "clean room."

figure | 6-16

The "clean room" with the Light Canvas material applied to the scene.

NOTE: When saving files, it's a good idea to save often and in increments (i.e., *file_01.max, file_02.max,* and so on). This will cover you in case the current version of your project goes kaput. You will have earlier versions to fall back on, which will save you the time of creating everything from scratch again. We generally keep the five most current versions for a project handy. You can easily save files incrementally by either clicking on the + in the Save File As dialog box or by going to the Customize > Preferences menu and check-

ing the Increment on Save option in the Files tab. The second method will automatically save your file incrementally when using the standard File > Save method.

The following exercise will have you create a two-point lighting scenario, in which the scene will only contain two light sources. This will provide a little challenge for us, in that it will be our job as the lighting artist to make the scene interesting merely by using light. It is also up to us to help generate the ambiance and mood of the scene by making adjustments to the light parameters. In case you're wondering why we are going to limit ourselves to just two light sources in our room, later in the chapter we will use radiosity to simulate global illumination, which will create the bounced light that occurs naturally in the real world. With only two lights in the scene, you will be able to see this effect better than if we were using more lights. Well, enough talking, let's get down to business.

1. Make sure your *ch6_2point_02.max* file is still open, if it's not already.

2. We're going to go ahead and create a target spot light in the Front viewport. After the Target Spot button is active, just click and drag the light from about the ceiling to the floor. Don't worry too much about position, because we'll take care of that next.

3. In the Transform type-in, assign the following coordinates for the spot light object:

 X = -20.24 Y = -40.244 Z = 48.798

4. Select the light's Target object and enter the following coordinates:

 X = -15.631 Y = 20.596 Z = -1.902

5. In the Modify panel, set the spot light parameters to the following. Make sure your light is selected.

 General Parameters:
 Shadow Map = selected Shadows On = Checked
 Spotlight Parameters:
 Hotspot/Beam = 5.2 Falloff/Field = 58.6
 Intensity/Color/Attenuation: Multiplier = 1.2
 Far Attenuation: Start = 15.8 End = 152.181
 Use = checked
 Shadow Parameters: Color = dark gray (52, 52, 52)
 Density = 0.9

Shadow Map Parameters:

Bias = 1.2 Size = 1024 Sample Range = 35.0

2 Sided Shadows = Checked

6. Name this light *Spot_teapot*. Figure 6-17 shows the spot light parameters. Figure 6-18 shows the result of the spot light.

This first light you just created is not the main light in our scene. You could almost consider this the fill light of the room. Figure 6-18 shows what the resulting light will look like. Note that once a light object is created, the default lighting will be turned off. Therefore, don't freak out if everything goes dark at first. The main light source is going to be an omni light positioned within the torus knot. This should create some nice dramatic shadows within the scene, and produce some interesting shapes in the room. Because this omni light object will be the main light source of our scene, we will make it brighter than the spot fill we just made. Ooh, this is getting exciting, let's get cracking on that second light. Continue with the following steps.

7. Activate your Top viewport and click on the Omni light button. Click directly in the middle of the torus knot

figure | 6-17

Spot light parameter settings.

and then activate the Move Transform tool and enter the following coordinates in the Transform type-in fields to get it into its final position:

figure | 6-18 |

Spot light result.

X = 21.24 Y = -14.827 Z = 16.0

8. With the light still selected, go to the Modify panel and set the light's properties to the following settings, just as you did for the spot light:

General Parameters:
 Shadow Map = selected Shadows On = Checked
Intensity/Color/Attenuation:
 Multiplier = 2.0
Far Attenuation:
 Use = checked
Start = 18.048 End = 51.47
Shadow Parameters: Color = dark gray (52, 52, 52)
 Density = 0.9
Shadow Map Parameters:
 Bias = 1.2 Size = 1024 Sample Range = 35.0
 2 Sided Shadows = Checked
 Name this light *Omni_torus*.

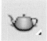

9. Activate your Perspective view and perform a test render via the Quick Render icon (<shown at left>) to see how the light is shaping up.

10. Save your scene as *ch06_2point_03.max*. Figure 6-19 depicts the omni light settings used for the example, and Figure 6-20 shows the end result.

Well, there you have it. You have just created a basic lighting rig, and you only used two lights. The end result is quite a dramatic piece! You might notice that there is still a lot of darkness in the room, especially in the corners. In just a moment, we'll take a brief look at how to use a radiosity solution to calculate the bounced light that would naturally occur in our room. Without the radiosity, you would actually have to create more light objects to "fake" the bounced light in the room. You will be using the previous project in later exercises, so make sure you keep it around for awhile. If you like, you could play around a little bit, giving some color to the lights by changing the color swatch next to the Multiplier value in the light parameters. Because of the white material on our objects, the colored lights will have a huge impact on the overall mood of the room. Have some fun with it! Although the previous exercise was a very simple rig, lighting

figure | 6-19 |

The omni light parameter settings.

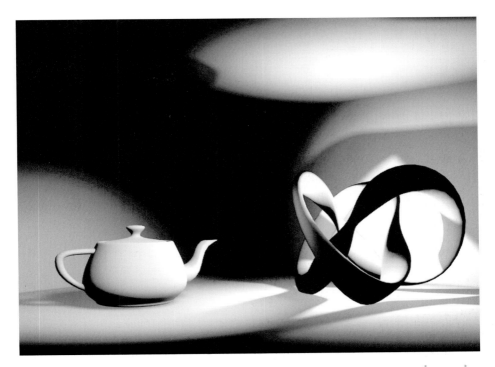

takes a while to get proficient at. The more you experiment with it, the better your eye will be in determining how to approach different lighting scenarios.

figure | 6-20 |

The end result of the two lights in the room.

Additional Tidbits

There are a few more basic things you should be aware of when it comes to lighting in 3ds max. The first is something called the Exclude button, which is found in the light parameters in the Modify panel. This can be an extremely useful tool when lighting a scene. You might be creating additional lights to simulate radiosity and you want the light to illuminate and/or cast shadows on only certain object in the scene. If the light were applied to all objects, the entire environment would be way too bright. The Exclude button, shown in Figure 6-21, allows you to specify which objects to light up and which ones to keep out of the light.

There is also a handy little tool in 3ds max called the Light Lister, which is used as a quick link to the main settings of each light in your scene. The Light Lister displays every light you have generated in your file and provides you with basic parameters such as the

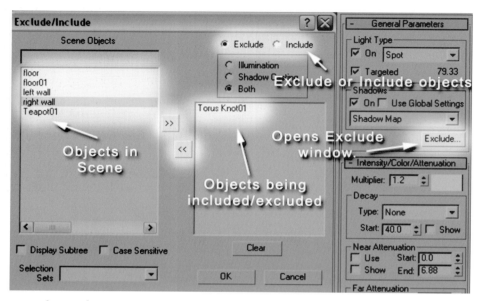

figure | 6-21

The Exclude button and Exclude/Include dialog window.

multiplier value of the light. The multiplier is basically the light intensity or brightness. Higher positive values produce a brighter light. Negative numbers, however, create darkness. Thus, if you need to add a shadow or dark area to a scene a negative light will darken up that area. Additional settings that can be accessed by the Light Lister include shadow type, basic shadow parameters, and light color. This gives you very quick access to your lights and saves you the time of having to select each light individually and adjusting a setting. This tool is a definite time saver! To access the Light Lister, shown in Figure 6-22, go to your menu bar and select Tools > Light Lister.

NOTES: The Light Lister tool is invaluable when constructing complex lighting rigs. It keeps your lights organized and accessible, which is extremely important in large scenes. By having all of your lights at your fingertips, you can make changes on-the-fly, saving a lot of valuable production time.

The last helpful feature that we want to make you aware of is the ActiveShade feature. One of the more tedious aspects of 3D illus-

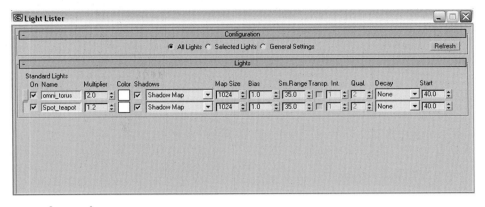

figure | 6-22 |

The Light Lister tool window.

tration is the fact that you constantly have to render the scene to see what it will all look like in the end. The viewports don't give you an accurate representation of the final output, so rendering is really the only way to see what your hard work looks like. The only way, that is, until now. Version 5 of 3ds max introduced a new feature that has carried through to version 7, which allows you to see a rendered version of your scene in your workspace. This is what the ActiveShade view is all about.

There are two ways to implement the ActiveShade view: as a floating window or within a viewport. The really cool thing about this utility is that as you make changes to your scene the ActiveShade view will automatically update to reflect your changes. Basically what it's doing is rendering your scene within the window, which allows you to keep working without having to constantly perform test renders. You should bear in mind, however, that the ActiveShade still performs a render. Thus, if you have very large, complex scenes with a lot of raytracing or a high face count it may take a minute for your ActiveShade to update. In addition, when using the floating window the size of the window is determined by your render output size, which can be changed in the Render Scene dialog window. To access the ActiveShade viewports, look to the Rendering menu. Figure 6-23 shows the ActiveShade view being used as a floating window, and Figure 6-24 shows this view being used within a viewport.

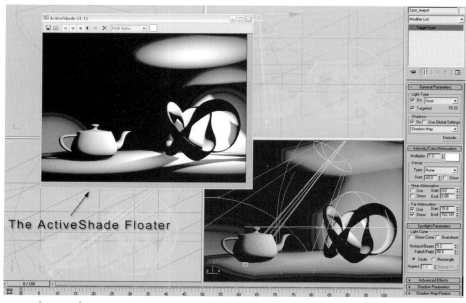

figure | 6-23

The ActiveShade view being used as a floating window.

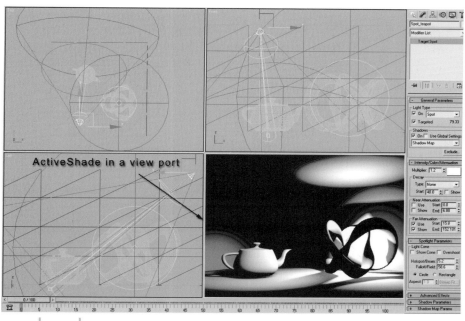

figure | 6-24

The ActiveShade view being used within a viewport.

ADVANCED LIGHTING

As mentioned at the beginning of this chapter, there are some advanced lighting features and tools that can be used to produce extremely realistic lighting effects. We could write an entire book on just lighting itself. In fact, there are books out there dealing solely with virtual lighting. Our point is that there is a ton of information and techniques associated with lighting, and because this book is meant to be an introduction to 3D design we will only be able to scratch the surface of some of these more advanced concepts. Although basic, the following couple of exercises should prove useful in your future projects.

The following exercises will have you creating a radiosity solution to calculate the bounced light within a room. You will also set up a basic skylight to simulate daylight. You will be using the Radiosity plug-in to make the bounced light, and the mental ray rendering engine to produce the skylight. Let's begin by talking a little bit about radiosity first.

Most of the time, radiosity is used in conjunction with photometric lights, because actual real-world light parameters can be used for the radiosity solution. Not to worry, though, because we can still apply radiosity to a rig utilizing standard light objects. To do this, some preparation must be done first to prep the scene. First, you will need to make sure that all of the objects within the project utilize the same unit system. For instance, if you built a scene in feet and inches and you import a model that was created using meters, that object's units will need to be converted to that of the scene. If the units don't jive, the radiosity solution will definitely go screwy, giving you a very bad result. Next, you need to prepare every object in the scene to receive the bounced light by "meshing" the flat surfaces in the scene. There are two ways this can be done. The first is by applying a Subdivide modifier to each mesh and specifying the maximum size each face is subdivided down to. This can prove to be very tedious, especially if you have a lot of objects in the scene. The more efficient way to perform radiosity meshing is to apply global subdivisions to the scene as a whole. This is done by going into the Radiosity Meshing Parameters rollout in the Advanced Lighting tab located in the Render Scene dialog window. The smaller the meshing size the more detailed the lighting will be. You will get less detail in the lighting if a larger meshing size is used. However, you will also use less memory to calculate the final

rendering. Figure 6-25 shows objects with radiosity meshing applied and without radiosity meshing applied.

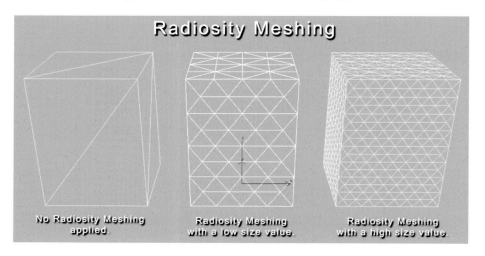

figure | 6-25

Objects with and without radiosity meshing applied.

NOTE: There is no need to utilize a high subdivision count in your meshing parameters if you have Regather Indirect Illumination checked in the Rendering Parameters rollout.

The last main item you need to do is to set the exposure controls of the scene, shown in Figure 6-26. This is done in the Environment tab of the Environment and Effects dialog window. This allows you to adjust the brightness and contrast of the bounced light. You are given a preview window of the scene, which allows you to see the changes you make in your exposures. You should note that although the lights also get brighter when adjusting the exposure settings the only thing the exposure affects is the radiosity of your scene; the actual lights will render as you wanted them to. You could almost think of this step as a photo darkroom, where you "develop" your shots to get the lighting just right in the final rendering.

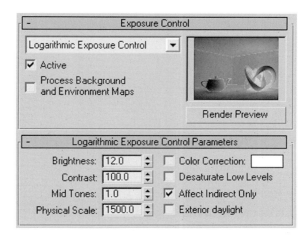

figure | 6-26

Exposure controls for applying the radiosity solution within a scene.

Follow the Bouncing Light

Remember that cool little scene we built in the last exercise? We hope you held on to that because now we are going to expand on that scene and add some radiosity to it to make it look more like a real place (even though that is the biggest teapot we've ever seen). If you didn't save the last project, you can find it in the *Ch 6 > Projects* folder. With a bit of practice, you will really like this technique. Let's get started.

1. Open the *ch6_2point_03.max* file you created in the previous exercise, or open the *ch6_radiosityStart.max* file found in the *Ch 6 > Projects* folder located on the companion CD-ROM. In the scene produced for the book, we played with the light colors a bit to produce a predominantly blue scene. It establishes a bluesy sort of mood don't you think? If you left your lights white, it's no big deal. The radiosity solution will work with any light color.

2. From the menu bar, select Rendering > Advanced Lighting > Radiosity. You might be prompted to set up exposure control at this point, but just click on No at that prompt for right now. We'll set up the exposure control in just a moment. You should now see Radiosity selected in the Advanced Lighting tab of the Render Scene dialog window.

3. Under the Radiosity Processing Parameters rollout, set the following values:

 Process: Initial Quality = 85%
 Leave the Process Refine Iterations option checked.

 Interactive Tools: Filtering = 0
 Check the box next to Display Radiosity in Viewport.

4. Now it's time to apply the radiosity meshing by setting the following parameters in the Radiosity Meshing Parameters rollout. The radiosity parameters are shown in Figure 6-27.

 Check the box next to Enabled.
 Meshing Size = 15.0

5. Once the radiosity parameters have been set, click on the Start button at the top of the Radiosity Processing Parameters rollout in the Advanced Lighting tab. This will calculate the radiosity solution, which in turn will be applied to your scene. If you have Smooth & Highlights turned on in your viewport,

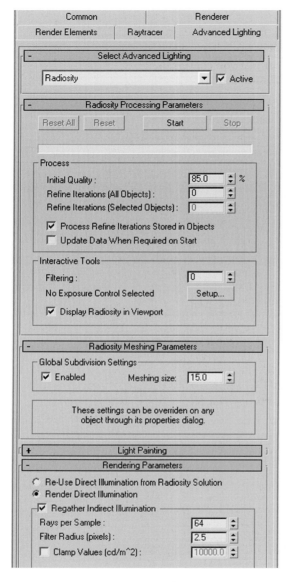

figure | 6-27 |

The radiosity
parameters.

you should see the results of the solution once it has been calculated.

6. Great! Now it's time to set your exposure settings for your indirect light. Under the Interactive Tools area under the Radiosity Parameters, click on the Setup button to access the exposure controls. You can also get there by selecting Rendering > Advanced Lighting > Exposure Control. See Figure 6-28 for the exposure settings.

7. Once you have the Exposure Control active, select Logarithmic Exposure Control from the drop-down list and make sure Active is checked. Anytime you use standard lighting with a radiosity solution you should always use the logarithmic control for your exposures.

8. Directly below the exposure control, make sure the Affect Indirect Only option is checked. This will prevent the exposure from affecting the actual light sources, but will affect the exposure of the bounced light.

9. Go ahead and play around a little with the Brightness and Contrast values until you have the scene exposed to your liking.

10. Once you have set your exposure, go ahead and perform a test render by clicking on the Quick Render button to see the radiosity in action.

It should be noted that when working with radiosity it is generally good practice to adjust the units in your scene. For instance, when

using photometric lights (which is the most common type to use with radiosity) set the scene units to either US Standard or Metric, depending on what your model was built for. When using radiosity with standard lighting, it isn't essential that you convert the units, although you will still need to utilize exposure control for your render. The final rendering of the room is shown in Figure 6-29.

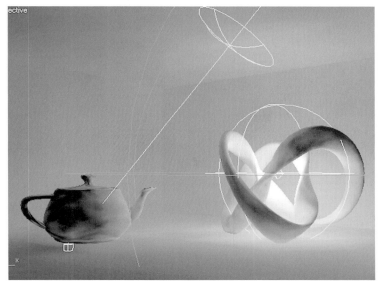

figure | **6-28**

Radiosity preview within the view-port.

figure | **6-29**

Radiosity seen after a Quick Render has been performed.

Setting Up a Sky

At this point you have successfully created basic lights and adjusted their parameters, as well as set up a radiosity solution for the bounced light. In this upcoming exercise you will be creating a lighting rig that will simulate the light found in exterior outdoor scenes. Remember when we were discussing some of the available standard lights? There was one in there known as a skylight, which will be the light you will use as the foundation for the exterior lighting. Because we will use the Default Scanline Renderer (which is what the default renderer is in 3ds max), some form of advanced lighting will need to be performed for the skylight to work. This means that we have a choice of radiosity or light tracing. Because you already have a little experience with radiosity, let's expose you (no pun intended) to light tracing. The Light Tracer function, like radiosity, is used to help depict how light will react and interact as it would in real life. With light tracing, you can generate nice soft-edged shadows, as well as the color bleeding that occurs from brightly lit scenes. This makes it ideal for exterior or outdoor scenarios. Even though you could use radiosity for skylight objects, the advantage of using light tracing is that it can be much easier to set up than a radiosity solution. An example of the use of light tracing is shown in Figure 6-30.

figure | 6-30

Example of a scene using light tracing with a skylight.

The Light Tracer parameter settings are found in the Rendering menu, as are the Radiosity settings. Once you have the Advanced Lighting tab open, simply select Light Tracer in the advanced lighting methods in the drop-down list. For this tutorial, we will pretty much leave the light tracing parameters at their default values. The only settings we need to manipulate are the exposure controls, as was the case in the previous radiosity exercise. The following exercise will introduce you to the skylight object and the Light Tracer plug-in. It will be a simple exercise, short and sweet, to wet your whistle and give you a taste of light tracing. Note that changing between different rendering plug-ins will generate a warning box, so don't freak if something pops up.

1. Go ahead and reset 3ds max (File > Reset). Feel free to save the previous radiosity project if you like.

2. In the Top viewport, create a plane that is 150 x 150 units.

3. Place some random primitives on the plane. It doesn't really matter what type of objects you use or what color they are. We used a hedra, a chamfered cylinder, and a loft.

4. Create the skylight object. Go to the Lights section of the Create panel and select Skylight. In your Top viewport, click above the area where your objects are. Use the Move Transform tool to move the skylight object above the scene.

5. Orient your Perspective viewport so that your objects create a nice little composition, as shown in Figure 6-31.

6. Once the skylight has been built, we need to assign advanced lighting to the scene. Go to Rendering > Advanced Lighting > Light Tracer. To speed up our preview renderings, lower the Rays/Sample value substantially. We set ours to 150 or so. This will help speed up the rendering time while we preview the results. It will appear splotchy in the final render, but the effect will be noticeable. For now, leave the other values at their defaults.

7. Now we need to adjust the Exposure Control. Go into the Rendering menu and select Environment. Within the Exposure Control rollout, select Logarithmic Exposure Control from the drop-down list. Click on the Render Preview button to get a gist of what the result will be.

8. Make adjustments to the brightness and contrast until you have the desired exposure set. Make sure the checkbox next to Affect Indirect Only is checked.

figure | 6-31

9. Once you are satisfied with the exposure, go ahead and click on the Quick Render button to test it out.

10. If you like what you see, you can increase the Rays/Sample and Filter Size values. Figure 6-32 depicts the skylight effect. Note that we added some materials to our scene to show how the skylight interacts with different surface types.

As shown in Figure 6-32, our objects don't have any specular highlights on them. This is because the skylight system by nature produces very diffused lighting, which spreads out quite substantially. This would be fine if you were attempting to simulate a cloudy day, but if you wanted to depict a brighter exterior scene you would definitely want to have those specular highlights in your final render. To do this, it's very easy. All you need to do is create a standard light (a direct spot works well) in your scene that is parallel to your skylight object. In the Advanced Effects rollout in the direct spot's parameters, uncheck the box next to the Diffuse option. By turning off the diffuse light the direct spot is casting, you will ensure that your scene doesn't end up becoming way too bright. Now when you render with the additional light the specular highlights will appear on your objects. Figure 6-33 shows this technique in action, using a skylight object and a direct spot. See the difference?

figure | 6-32 |

Our finished scene using a skylight object to generate our light.

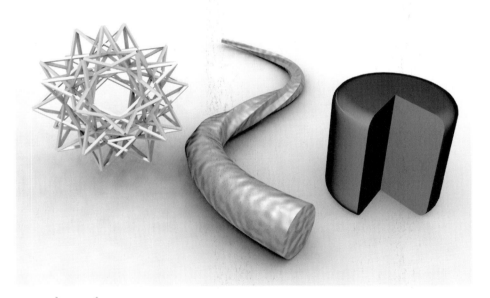

figure | 6-33 |

Here is the same scene with a direct spot added. Now the specular highlights are noticeable.

You should give yourself a pat on the back! You made it through some cool advanced lighting techniques. As you build and create more 3D work of your own, play around with different lighting approaches to see what type of results you get. Half the battle is knowing, but the other half is actually doing, which is why we always advocate plenty of practice when it comes to lighting. Don't get discouraged if you have difficulty initially with your light rigs. We guarantee that with practice you will get better at it. It took us at least a month or two to get decent with lighting, and we are still learning. You will find, especially with the ever-evolving technology associated with 3D design, that the learning process never ends, no matter how good you are. Well, this will wrap up the section on lights. The next part of this chapter will give you a brief overview of virtual cameras and rendering techniques.

READY FOR YOUR CLOSE-UP?

Now that you have some skills with lighting rigs, you are at a point where you will need to produce your final renderings of your work. This next section will talk a little about setting up virtual cameras, as well as some rendering techniques you can use for your final output. We plan on just covering some of the basic essentials pertaining to cameras, so this should be relatively easy for you to get through. Buckle up; here we go!

Virtual Cameras

Much like the light object we discussed in previous sections of this chapter, the virtual cameras 3ds max utilizes have their roots in traditional video and cinematography. Each camera type offers settings and parameters that are also considerations on real-world cameras. For instance, traditional film and video cameras allow you to use a variety of lens types. The lens determines the field of view (FOV) of the shot. The FOV is basically what the camera is able to see. A panoramic image would have a much larger FOV than an image that used a 35-mm lens.

There are two main 3ds max camera types: target cameras and free cameras. These different camera objects work in much the same way as the target and free spot lights. Target cameras have both a camera object and a target object, whereas the Free camera only

has the camera object. Another wonderful thing these cameras can do is simulate depth of field (DOF) within a shot. DOF is the blurring of objects in the shot that are not the focal point of the image. For example, let's say we were taking a picture of a person standing in a field of tulips. The person we are photographing is in the midground of our shot, there are tons of tulips in the foreground, and a large tree way back in the background. Because our person will be the focal point of the image, he will be completely in focus. Other aspects of the image will appear blurry. The tulips in the foreground and the tree in the background will appear out of focus. This makes realistic cinematography a lot easier when creating animation or even still renderings. Figure 6-34 shows the two different camera types, as well as their simple "anatomy," and Figure 6-35 depicts the DOF effect that can be achieved in 3ds max.

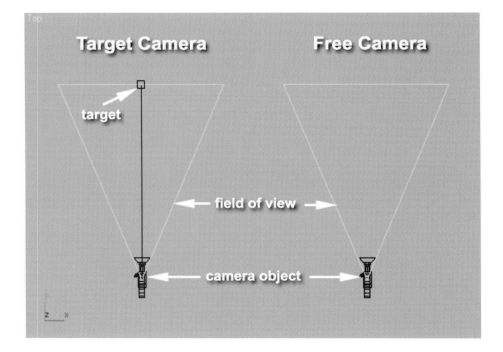

figure | 6-34

Target and Free cameras with visible field of view.

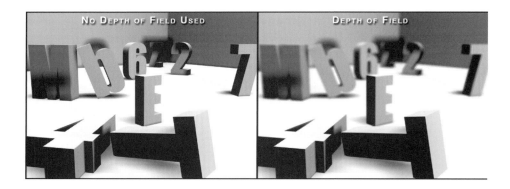

No Depth of Field Used

Depth of Field

figure | 6-35

The same camera shot with and without depth of field.

In Figure 6-35, you'll notice that the picture on the left is completely in focus, with everything in the shot crisp and clean. The picture on the right utilized the DOF effect with the camera's focal point set to the 4 and the *t* in the foreground of the shot. If the camera were focused on the *e*, the foreground and background would appear blurry. Logic then dictates that if the camera were trained on the background objects both foreground and midground elements would be blurred out. This is a perfect way to achieve more realism in your work. In addition, this effect helps keep your work from looking like it was computer generated, which is the point in most cases.

Blur Out the Low-Res

When building elaborate scenes, it's really easy to get a very high face count, which can dramatically increase the rendering time. One common practice 3D illustrators and animators use is to vary object mesh resolutions (how many times the mesh is segmented), depending on objects' positions relative to the camera. Subjects close to the camera would need extremely high detail with a lot of faces, whereas those objects that would appear in the background could be a lot lower in detail with far fewer faces. This could have a big impact on the final rendering time, which could save both the artist and client money. The DOF effect is very helpful in this scenario, because the image blurring will help cover up any unwanted angles and faceting that would be undesirable in the final render.

Building a Shot

Why don't we try setting up a simple camera shot with some DOF
thrown into the mix? This will be a nice, easy exercise that should-
n't give you any headaches whatsoever. Let's get started.

1. Start a new 3ds max scene and create a plane
 in the Top viewport that is 200 x 200 units.
 You can use the Move Transform type-in to
 position the plane at (0, 0, 0).

2. In the Create panel, click on the Cameras
 button below the Command panel tabs.
 Select the Target camera type, as shown in
 Figure 6-36.

3. We're going to click-drag a target camera in
 the Top viewport. Start the drag toward the
 lower left corner of the plane object and drag
 the target to the center of the plane, as shown
 in Figure 6-37.

figure | 6-36

Selecting the Target camera type.

figure | 6-37

Click-dragging a target camera in the Top viewport.

figure | 6-38 |

Camera parameters..

4. Now we're going to use the Transform type-in to position our camera better. With your Top viewport active, select the Move Transform tool and use the Transform type-in regions at the bottom of the interface to enter the following:

X = -111.4 Y = -119.931 Z = 20.636

You can set the coordinates for the camera's target to the origin if you like.

5. Now we need two objects in our scene in order to see this effect in action. Why don't we start with the good old teapot. In the Top viewport, use the Keyboard Entry rollout to create a teapot with the following settings:

X = -68.0 Y = -59.0 Z = 0.0
Radius = 12.0

6. Once the teapot has been made, turn Angle Snap on and using the Rotate Transform turn the teapot around the Z axis clockwise by -30 degrees.

7. For our second object, how does a pyramid sound? Make yours with the following parameters:

Width = 28.0 Depth = 28.0 Height = 43.0
X = 42.0 Y = 8 Z = 0.0

8. Great! Now we can start to set up the DOF. Make the Perspective viewport the active viewport and press the C key to switch to your camera viewport. Now we can see what the camera is seeing.

9. Select the camera and go to the Modify panel to bring up the camera parameters, shown in Figure 6-38.

10. Now we're going to enable DOF. In the Parameters rollout, find the settings for Multi-Pass Effect. Check the box next to Enable. Set Target Distance to 198.

11. Under the Depth of Field Parameters rollout, set the Sampling settings as follows:

Total Passes = 15 Sample Radius = 1.5
Sample Bias = 0.24
You can leave the checkboxes checked.

12. Under Pass Blending, set Dither Strength to 0.64 and Tile Size to 10.

13. If you look under the Multi-Pass Effect settings, you'll see a Preview button. Go ahead and click on it, which will give you a preview of the effect in your Camera viewport, as shown in Figure 6-39. Make sure your Camera view is active first! Looking pretty good so far.

figure | 6-39

Preview in Camera viewport.

14. In our example, we chose to focus the camera on the pyramid, which caused the teapot to appear out of focus. To see what the finished render will look like, in the menus select Rendering > Environment and change the background color to white.

15. Make sure the camera viewport is active and then click on the Quick Render button.

16. There you have it! A convincing DOF test. Feel free to save your work if you like.

Cameras play an important role in 3D art, especially when it comes to motion graphics. Virtual cameras are used when performing motion capture and video tracking with live video footage. Cameras can be animated along spline paths to create awesome fly-through and walk-through animations.

Show Me the Money

Rendering is the process software goes through to calculate what your final scene will look like. By default, 3ds max utilizes what is called the Default Scanline Renderer. This rendering engine generates the final image by building the image from many, many horizontal lines. This rendering system is probably most used for projects that are not utilizing photometric lights, which utilize real-world light properties. To render scenes that do use photometric lighting, you could use the mental ray rendering engine, which up until 3ds max 6 was a third-party plug-in. Mental ray is also great for recreating raytraced reflections and caustic effects. The mental ray Renderer makes it a heck of a lot easier to simulate those lighting effects you would normally have to do by hand and with radiosity solutions.

One of the big differences between mental ray and the Default Scanline Renderer is the way the final images are built. The Scanline Renderer creates images one horizontal line at a time. Mental ray renders the image in big chunky blocks known as buckets. Mental ray is also optimized for multiprocessor machines, allowing you to best utilize the technology that's driving your creativity. This is also a great rendering system because mental ray can also act as an interpreter of sorts. You are able to save your scene as an MI file, which can be loaded into mental ray later on to be rendered or even rendered at a different computer somewhere else. This is a relatively easy rendering engine to use once you get everything set up correctly.

Selecting the mental ray Renderer

Okay, this might be a good time to show you how to switch from the Default Scanline Renderer to the mental ray Renderer. This is a real quick and painless little exercise.

1. To activate the mental ray renderer, from the menus select Rendering > Render.

2. Under the Common tab in the Render Scene dialog window, open the Assign Renderer rollout.

3. Here you can adjust the renderer for production renderings, for the rendering of materials in the Material Editor, and for the ActiveShade views. To adjust the renderer, click on the "…" button and select *mental ray Renderer* from the Choose Renderer pop-up window.

4. If you click on the Save as Defaults button, the mental ray Renderer will be the default renderer for all new scenes, which can make it easier for you in that you won't have to spend a lot of time with setup.

Output Sizes and Rendering for Print

One issue a 3D illustrator always ends up encountering is that of output size. Many times, a client will tell the artist they want a cool 3D abstract sculpture for an magazine cover or billboard or something, and the artist of course asks what size they want the piece. Inevitably, the client says something like 300 dpi, which we all know refers to the image resolution and not the actual size. You could ask the client what pixel dimensions they need, but if the contact person with whom you are dealing isn't savvy with graphics they might not know what a pixel is. Your best bet is to ask what the dimensions are in metrics, which most people can better relate to. Once you have those dimensions, a neat little trick you can use to determine your output size is to create a new document in Photoshop or other imaging software. Enter the metric values for the piece and then switch the unit type to pixels. You should now see the pixel values for the width and height. These values would be entered into the Output Size section in the Common tab of the Render Scene dialog box. Well, this used to be the best way to print 3D art, but in version 6 a great feature was added to make this process a whole lot easier. Max now has a Print Size wizard (see Figure 6-40) that allows you to output a rendering that is of a size and resolution suitable for print. You can access this wizard through the Rendering menu.

figure | **6-40**

Print Size wizard.

Speaking of output size, the drop-down list above the Width and Height fields (where it says *Custom*) actually provides you with some common output sizes for various deliverable formats. For

instance, if you wanted to render an image that was the proper size for NTSC video, you could select NTSC from the drop-down list. Once an output size has been determined, it may be necessary to see what the aspect ratio is while working on a project. Your viewports will allow you to see the renderable area while you work if you activate Show Safe Frame. The safe frame, an example of which is shown in Figure 6-41, is a viewport feature overlaid on the viewport. It basically defines the frame in the view to show you exactly what will be seen in the final render. This is extremely helpful when placing elements of a scene together. Access the Safe Frame by right clicking on a viewport name.

figure | 6-41

Show Safe Frame active, depicting the viewable area of the scene using one of the cinematic formats.

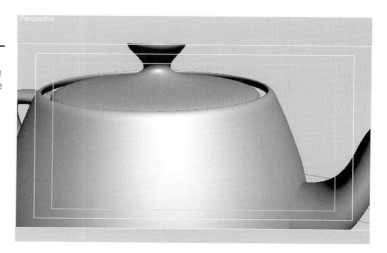

SUMMARY

Okay, you can start breathing now; we're done cramming all of this information into your head, and you have come out unscathed. You should be very proud of yourself. This stuff isn't all that easy, and you still seem to still be standing, which is marvelous! Do you realize that you now have a wealth of foundation concepts within your information arsenal? Now you're ready to practice with these techniques in the following chapter.

In this chapter we have discussed various lighting rigs as well as how they relate to virtual lights. We have also talked a lot about some of the more advanced lighting techniques, such as radiosity and light tracing. In addition to lights, basic camera and rendering techniques were also addressed. This was a tough chapter and you did great! And just think that you'll only get better as you practice setting up lights and cameras.

in review

1. Is it better to apply scene materials before or after setting up the lighting rig, and why?

2. List the various standard light types.

3. Describe what attenuation is and why it's important.

4. Discuss the importance of using shadows in a scene.

5. Earlier in this chapter, we mentioned that a flat white material works well when lighting a scene. Why is that?

6. Describe the Depth of Field effect.

7. What is ActiveShade and how is it helpful?

8. What does the term *buckets* refer to?

↗ EXPLORING ON YOUR OWN

1. Try creating more interesting lighting rigs, utilizing more than just the three-point lights. Also try using different types of lights.

2. Experiment with radiosity and light tracing to achieve different types of lighting scenarios.

3. Give mental ray a try, using it to achieve some cool lighting effects such as raytraced reflections, transparency, and caustics.

ADVENTURES IN DESIGN

LIGHTING FX

Lighting can arguably be one of the more important aspects of 3D design. It's right up there with great materials and surfaces. In the previous chapter, you were introduced to various lighting objects as well as various techniques of calculating lighting schemes. You also had the opportunity to play with some advanced lighting techniques, utilizing lighting plug-ins such as Light Tracer and Radiosity. These advanced lighting options enable you to create and reproduce more realistic renderings by more closely matching the realistic behavior of light in the real world. This really allows 3D artists to push the boundaries of photorealism in their work. There are, however, other elements you can add to your lighting rigs to enhance your renderings.

Additional Effects

There are other features within the 3ds max 7 lighting arsenal that can aid you in your photorealistic quest for awe-inspiring imagery, such as projector maps and volumetric lighting. Projector maps are image files, loaded into the light parameters, which are literally projected by the light onto whatever objects the light is aiming at. This is a wonderful way to create more interesting shadows within your virtual environment. A good example would be the intricate shadows cast by the leaves and branches of a tree canopy in the great outdoors. By using a projector map, you can create this effect without actually having to model the trees and foliage. That would add unnecessary geometry to your scene that would do nothing but bog down computer memory and take much longer to render. Projector maps are a way to fake these types of shadows. They work on much the same principle as the opacity maps do within the material editor.

Volumetric lighting enables you to actually see the light beams in your scene by simulating the dust, fog, or smoke particles in the light beam's path. Have you ever seen a car drive down a foggy road at night? If you have, you more than likely noticed the "cones of light" being emitted from the headlights. Even though the light is always there, even in clear weather, it is the "volume" of the fog that makes the light visible to the naked eye. This effect is also good if you want to add ambience and mood to your scenes. For instance, say you have created a nice outdoor scene with some trees and early morning sunshine. You can simulate sunbeams filtering through the trees by adding volumetric lighting. By applying volumetrics to your lights, you begin to take some of the 3D "crispness" out of

your renderings and enhance the emotional qualities of your work.

Projecting Your Light

Let's try out some of these additional lighting effects. We'll start by adding a projector map to an existing spotlight object.

1. Go to the Adventures folder on the companion CD-ROM and copy the AID C folder to your computer. In that folder you will find the .max scene file and the corresponding JPEG image that will be used as our projector map. Once the folder is copied, open the light-FX.max scene.

2. You should see a flashlight object pointing at a "wall" object, as shown in Figure C-1. The light and shadow parameters have already been set for you. Select the Spotlight object and go to the Modify panel to access the light's parameters.

3. Under the Advanced Effects roll-out, shown in Figure C-2, click on the None button under the Projector Map section to open the Material Map browser. Select Bitmap from the material list and then click on OK.

4. Load the *leaves.jpg* image into the light's map channel.

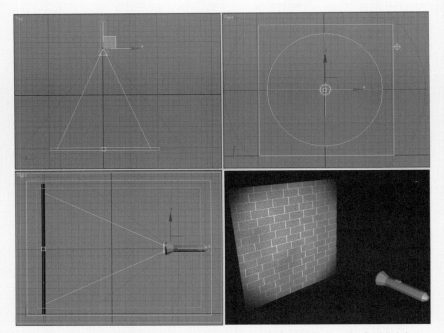

Figure C-1. Flashlight pointing at a wall. A target spot was positioned at the flashlight's lightbulb.

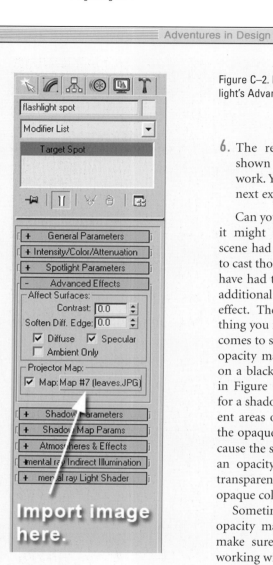

Figure C–2. Map channel within the spotlight's Advanced Effects rollout.

6. The result of this operation is shown in Figure C-3. Save your work. You will need this file for the next exercise.

Can you imagine how much longer it might have taken to render this scene had we actually modeled a tree to cast those same shadows? We would have had to have added thousands of additional faces to achieve the same effect. There is one very important thing you need to be aware of when it comes to shadow maps. Much like the opacity map, the shadow map works on a black-and-white basis, as shown in Figure C-4. The difference is that for a shadow map image the transparent areas of the image are white and the opaque areas (the shapes that will cause the shadows) are black, whereas an opacity image uses black as the transparent color and the white as the opaque color.

Sometimes it can be easy to mix up opacity maps and shadow maps, so make sure you pay attention when working with these. Now let's see how this would look with some volumetric effects added.

Moon Beams and Sun Rays

Okay, you've added the shadow effect to the light, but now it's time to throw volumetric lighting into the mix. This

5. If you activate the Active Shade viewport, or perform a quick render, you should see the result of our projector map. Now it appears as though there is a tree in front of the light, even though the light is clearly unobstructed. Already the mood has changed!

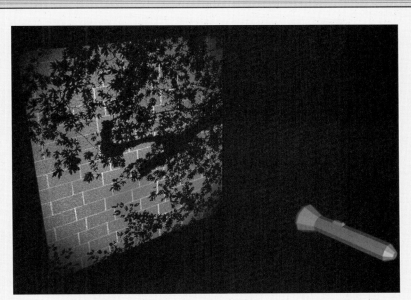

Figure C–3. A nice shadow of leaves and tree branches is now seen on the wall object..

Figure C–4. Black-and-white image used as a shadow map.

can make a big improvement to the ambience of the rendering. It helps to add atmosphere to the scene to aid in photorealism.

To apply volumetrics to a light, we add a Volume Light effect under the Atmospheres and Effects rollout within the light parameters. Once added, you can manipulate the effect settings to adjust the color of the "fog," as well as the density and attenuation of the effect. You can even add noise to the fog to give it irregularities in the light beams for a more natural look.

The settings used by the volumetric light are located in the Environment and Effects window. In addition to accessing the parameters through the Atmospheres and Effects rollout in the light parameters, you can access these through the Render > Environment menu. Let's finish this up.

Figure C–5. Atmospheric and Effects rollout.

1. Make sure your flashlight scene is open, with your projector light set up.

2. Under the Atmospheres and Effects rollout in the light parameters, click on the Add button.

3. From the pop-up window, select Volume Light from the list and then click on OK.

4. You should now see the Volume Light effect in the Atmospheric and Effects list, as shown in Figure C-5.

5. Select Volume Light in the effects list in your light settings and then click on the Setup button. You will

automatically be taken to the Environment and Effects window.

6. In the Atmosphere list, select Volume Light to bring up your Volume Light settings.

7. Leave all of the settings at their default except the following:
 Exponential = checked
 Atten. Mult. = 3.0
 Attenuation Start % = 100
 Attenuation End % = 75

8. Close the Environment and Effects window and go to the spot light parameters.

9. Within the Intensity/Color/Attenuation rollout, check both Near Attenuation boxes (Use, Show) and the Far Attenuation boxes. Set the Start and End values to the following (see Figure C-6):
 Near Attenuation
 Start = 0.0 End = 229.176
 Far Attenuation
 Start = 254.612 End = 356.457

10. Render the Perspective view to see what we've done.

Congratulations! You have just created your first lighting effects. Now you can explore further lighting creations with this easy but often-needed technique. The result of this process is shown in Figure C-7.

Figure C-6. Environment and Effects window and spot light settings.

Figure C-7. Finished lighting effect with shadow maps and volumetric lighting.

innovate

| populate your portfolio! |

7

 charting your course

After all of the hard work you have been doing throughout your journey through the pages of this book, you're now ready to stretch your legs as well as your brand new 3D muscles and make some great 3D illustrations. This final chapter will allow you to work on some really great projects you might encounter in the industry. The tutorials found on the following pages increase in difficulty as you complete them. Each one is written in such a way as to accommodate changes you could make to customize each project to make them more personalized, which is a great way to diversify portfolios within a class environment. So brew a pot of coffee and get ready for some fun because it's time for some real production work.

 goals

- Generate industry-relevant illustrations utilizing techniques learned, as well as some new techniques

- Generate photorealistic renderings utilizing HDRI images

- Simulate sunlight in an outdoor environment

- Utilize both the Default Scanline Renderer and the mental ray Renderer

- Manipulate project parameters to personalize the projects for portfolio use

- identify production methods used in the industry

PROJECT 1: MAGAZINE COVER ILLUSTRATION

Difficulty Level: *Beginner*

This project will walk you through the process of creating a beautiful magazine cover illustration. You will see all of the steps involved in the production pipeline, including the planning, production, and layout of the final cover design. This is a great project for those who think that 3D illustration might be their calling.

Getting the Job

Imagine yourself working as an extremely successful freelancer running a very lucrative gig with tons of great clients (for some of you, this might already be true). You get a call one day from the art director at *3Design* magazine wanting you to design a 3D illustration for next month's cover layout. Of course, you enthusiastically say yes and begin to ask some specifics. The art director tells you that they want a cool 3D abstract "sculpture" rendering that shows off some of what 3ds max can do, in that they have a big feature article on the new release of the software. You learn through your conversation that the trim size (dimensions) of the cover needs to be 9.125 x 11.125 inches at 300 dpi. They would like the final rendering as a TIFF, which will then be laid out in Adobe InDesign (or other layout software such as QuarkXPress). After your conversation with the art director, you jump up and down at the chance for such great exposure and begin planning out the project. After your head has deflated a little, you sit down to begin mapping out exactly how you will tackle this project.

Planning the Cover

Before starting any project it is of the utmost importance that you plan out exactly what you intend to do. This is to avoid any possible roadblocks in the midst of production. If you think you have things under control and you could bypass this step, we highly recommend that you reconsider. Trust us, you'll thank us later!

Unfortunately, you were unable to obtain an existing cover to look at, so we'll look at an example of another 3D publication. *3D World*

magazine, shown in Figure 7-1, is an excellent and well-respected industry mag, so we will model our layout around this. At this point, you can sit down and start sketching out the layout of the cover. By coming up with a rough layout for the cover, we will have a better idea of how to compose the shot for our rendering. We used a layout that is pretty similar to the example that was provided to us, jut to keep things simple. Figure 7-2 shows our proposed layout.

Alright, now it's time to figure out what exactly we're going to model for this design. The editor wanted an abstract sculpture that

figure | **7-1**

3D World magazine cover.

depicted a cool design. It might be neat to create a sort of rainbow-swirl-glass type of object. We could utilize mental ray and some special material shaders to generate some caustic effects, although because the editor wants this ASAP we'll keep it short and sweet and use the Default Scanline Renderer and standard materials to keep things simple. You'll still be able to make a great illustration without using all of the bells and whistles. After some playing around, we arrive at the concept shown in Figure 7-3.

figure | 7-2 |

Proposed layout sketch of cover design.

figure | 7-3 |

Sketch of proposed sculpture design.

Let Production Begin

Alright, now that we have some idea what we're doing, we can start the modeling process. The client wants an abstract sculpture thingy on the cover, and in our concept sketches we came up with something that should look pretty cool once we have materials and lights set up. The model itself, although simplistic in form, will have enough interesting aspects to be quite interesting once finished. For the process of this piece, we will construct the sculpture and the backdrop first and then set up the lighting rig. Once the lighting is set up, we will then generate the material, which is where most of the magic will be.

Model Building

To begin building the model, perform the following steps.

1. Start a brand new 3ds max scene. Let's go ahead and set up some of our initial rendering settings right off the bat. This will help us out later when we set up our camera shot. Go to Rendering > Render and in the Common tab change the Width and Height dimension settings in the Output Size settings to 492 x 600 for now. Later, when we're ready to perform our final render, we will increase the size to 2,738 x 3,339, which is equivalent to the 9-1/8 inches x 11-1/8 inches (at 300 dpi) trim size of the magazine. The smaller frame size will give us much quicker render times during test renders. After setting the dimensions, click on the small lock icon next to Image Aspect to constrain the proportions. You can close the Render Scene window.

2. Activate the Perspective viewport and right click on the viewport name to open the fly-out menu. About halfway down, select Show Safe Frame. This will indicate in your viewport what your final shot will look like when you render the view. You should note that the shape of the safe frame is directly affected by the output size you set in the Render Scene window. By turning this on, we will have a much easier time composing our shot later.

3. Save your file. Go ahead and name it whatever you like.

4. In the Front viewport, create a Torus object with the following parameters (use the Keyboard Entry feature for correct placement):

X = 0.0	Y = 0.0	Z = 0
Major Radius = 50.0	Minor Radius = 10.0	
Segments = 24	Sides = 7	Smooth = None

Name this new object, shown in Figure 7-4, *sculpture 01.*

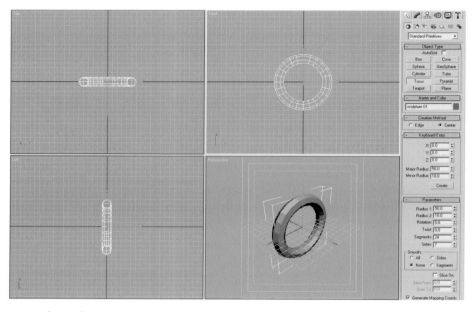

figure | **7-4**

Torus object created.

5. Convert the torus to an Editable Poly. Activate the Polygon sub-object mode and select all the polygons. Under the Edit Polygons rollout in the Modify panel, click on the tiny window icon next to the Bevel button to open the Bevel Polygons dialog. We're going to apply two bevels to the selected surfaces. The first will inset our polygons and the second will extrude them out and scale them down to form a nice array of spiky fins. Use the following settings for the bevels (see Figure 7-5):

Set Bevel Type to By Polygon

Bevel 1:	Height = -1.0	Outline Amount = -2.0
	Click on Apply	

Bevel 1:	Height = 13.0	Outline Amount = -2.0
	Click on OK	

You should now have something that looks like a sea urchin. Turn off the Polygon sub-object mode. Under the Subdivision Surface rollout, check Render Iterations and Smoothness, then check Use NURMS Subdivision and set Display Iterations to 1 and Smoothness to 1. Give the Render Iterations a value of 2 and a Smoothness of 1. Believe it or not, we're done modeling the sculpture! All we need to do now is apply a few modifiers to this rather prickly-looking object, shown in Figure 7-6.

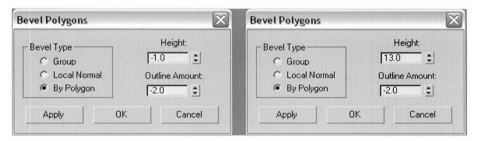

figure | 7-5 |

Bevel options within Editable Poly.

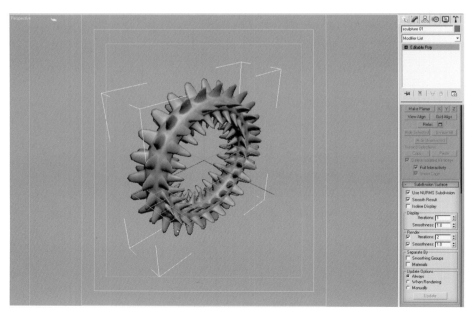

figure | 7-6 |

Object after NURMS smoothing.

▶ The Editable Poly Object

The Editable Poly object is very similar to the Editable Mesh object, except for the Subdivision Surfaces capability within the Editable Poly option. Subdivision surfaces utilize NURMS (nonuniform rational MeshSmooth) to tessellate (subdivide) the mesh to create a more organic form. This makes it much more flexible than the Editable Mesh objects because you can see the smooth result throughout the modeling process. The Editable Mesh option, on the other hand, requires you to apply a MeshSmooth modifier to the object to create the final smooth mesh. The Editable Poly object type is more widely used in the industry due to its flexibility and ease of use.

6. Go to File > Save As. Click on the + button next to the Save button to save your scene file with a numerically incremented name. By saving your work this way, you can always have a backup in case your most recent file gets corrupted or lost.

7. Apply three Twist modifiers to the object. Make sure you still have your Front viewport active. We will be setting the Angle value and the axis orientation for each twist we assign.

 Twist 1: Angle = 79.0, Twist Axis = Z
 Twist 2: Angle = 218.0, Twist Axis = Y
 Twist 3: Angle = 48.5, Twist Axis = X

 This is starting to look really cool!

8. Click on the Percent Snap Toggle icon (shown at left) and using the Uniform Scale tool press the Shift key and drag the sculpture in the Front viewport. Scale down the object to 40 percent. By holding down the Shift key you will generate a clone of the original object. When the Clone Options dialog opens, set the Object type to Instance. You will see that the clone is automatically given the name *sculpture 02*. Activate the Angle Snap icon (right next to the Percent Snap icon) and rotate the smaller object around the Y axis -100 degrees and then again around the Z axis 75 degrees, as indicated in Figure 7-7. Note: It will be easier to get the proper rotation on the objects if you use the Transform Type-In fields at the bottom of the interface to rotate the sculpture objects.

figure | **7-7**

Rotating an object.

9. At this point we should have our shot established in our Perspective viewport. If you haven't moved your view around yet to get your shot, go ahead and do it now. Go to Views > Create Camera From View. This will automatically create a camera that will match the exact angle as the Perspective viewport. Press the C key to switch the Perspective viewport over to the Camera viewport, as shown in Figure 7-8.

10. We need a backdrop for this shot to add some interest. In the Top viewport, create a sphere with the following parameters:

Radius = 110.0 Segments = 15
Generate Mapping Coordinates = Checked

Depending on how you oriented your camera shot, you might need to reposition your newly created sphere slightly. What we need to do is make sure the camera object and both torus objects are fully contained within the sphere. Figure 7-9 shows how we set ours up. You've probably also noticed that all we see in our Camera viewport is the surface of the sphere. This is because the sphere's surfaces are facing the wrong way; they're facing outward instead of inward, toward our scene. To correct this, go to the Modify panel and apply a Normal modifier. Make sure Unify Normals and Flip Normals are checked.

figure | 7-8 |

Perspective view-
port changed to
Camera viewport.

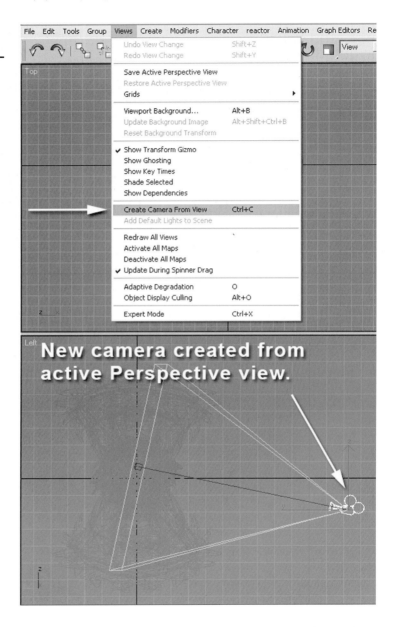

You should now see your shot with the inside of the sphere
nicely positioned as your background. Rename the sphere
backdrop.

11. Save your work as another increment.

Give yourself a well deserved pat on the back! The modeling phase
is finished and we were also able to get most of the render settings

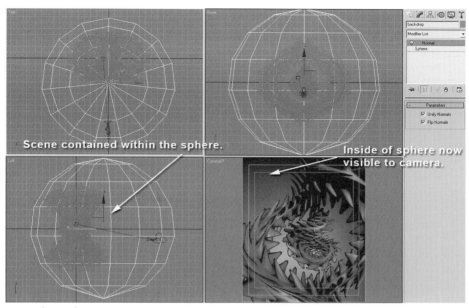

Scene contained within the sphere.

Inside of sphere now visible to camera.

figure | 7-9 |

Camera and torus objects set up.

out of the way. Our camera shot is set up and now all that is left is the lighting rig and materials.

Light Rigging

For this design we are going to use a sparse lighting setup. Standard light objects will be fine to use and will help keep things simple. We'll create a spot light as our key light and an omni light as a backlight.

1. In the Top viewport, create a Target Spot light within the sphere. We want to position the spot light so that it is above and to the left of our camera, so we started the light creation in the lower left region of our sphere and dragged toward the torus objects in the scene. Using the Move Transform tool, we then positioned both the light object and the target objects accordingly until the light was aimed correctly, as shown in Figure 7-10. Depending on how your shot is set up, your light might be placed differently than ours. The important thing is that the light shines from above, left of the camera. Name the new spot light key light.

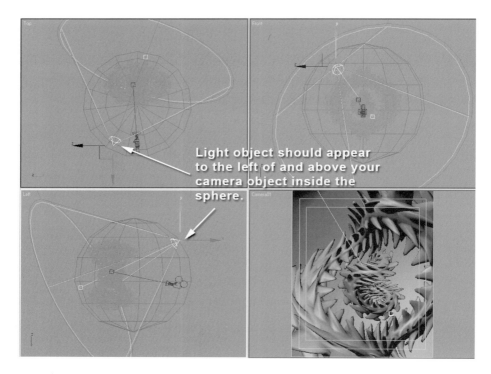

Light object should appear to the left of and above your camera object inside the sphere.

figure | 7-10

Position of the spot light. Note that grids have been turned off in the viewports to better illustrate this.

2. In the Modify panel, adjust the following light parameters for the Direct light:

> Shadows = On
> Keep the default Shadow Map for shadow type

Click on the Exclude button and select the Sphere from the list. Exclude the Sphere from both illumination and shadow casting by selecting *backdrop* from the Scene Objects list on the left and clicking the ">>" button to move it to the column on the right. Establish the following settings, shown in Figure 7-11.

Under the Spotlight Parameters rollout:

> Hotspot/Beam = Approximately 80.0

Under the Shadow Parameters rollout:

> Color = (20, 20, 20) in the RGB values
> Density = 0.8

Under the Shadow Map Params rollout:

> Size = 1024 Sample Range = 15.0
> 2 Sided Shadows = Checked

3. To create some backlighting, create an omni light in the Front viewport. Use the Move Transform tool to position the light

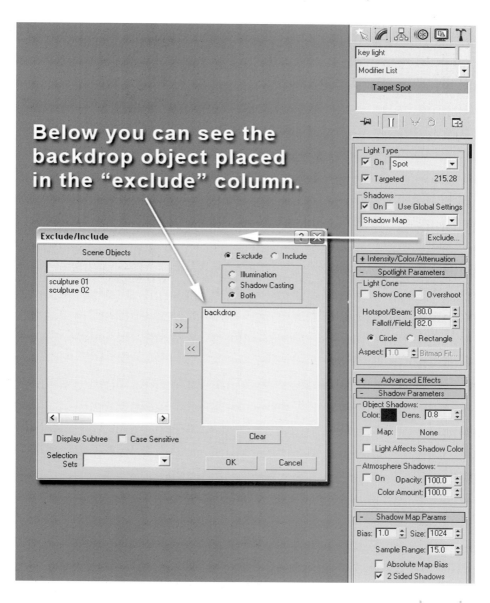

Below you can see the backdrop object placed in the "exclude" column.

somewhere behind the sculptures and slightly off-center. You can play around with this a bit to get the effect you want. Like the spot light, the positioning of your omni light will largely depend on the positioning of your torus objects. Just make sure the omni is behind them in order to correctly backlight them. Okay, we want the omni light to have the exact same parameters as the spot light, except that we do not want to exclude the sphere this time from being lit up. When the omni

figure | 7-11

Rollout settings.

light was created, it automatically matches the settings set up in the spot light. All you need to do is make sure the Shadows option is turned On. Change the following settings for the omni light:

Under the Intensity/Color/Attenuation rollout:
Multiplier = 2.5 Far Attenuation:
Start = 96.0 End = 165.0
Check the Use and Show boxes under Far Attenuation.

Name this light *back light* and activate your Camera viewport. Click on the Quick Render teapot in the main toolbar (the lonely one on the far right of toolbar). You should see the final rendering of the cover design up to this point. You should see the sculpture objects, a backdrop, along with shadows and shading. It's starting to look pretty spiffy, as shown in Figure 7-12. All we need now are some materials. That will wrap things up for the lighting, so let's move on to the fun part...materials!

4. Save your work.

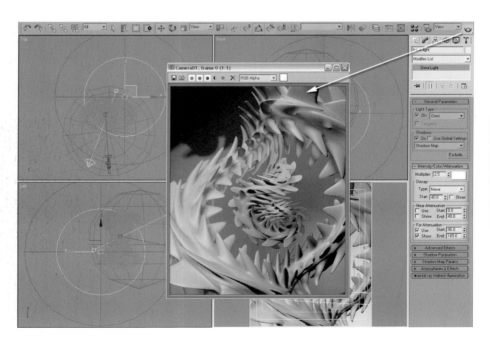

figure | 7-12 |

Scene to this point.

Mixing Materials

In the following exercise we're going to build two materials for this scene. Both will be fairly simple. The first will contain a gradient that will depict the rainbow effect we're going for and will be a semitransparent texture. The second one will be a simple slate-gray material with some bumpiness to it to add some interest to the background.

1. Open the Material Editor (M key) and select the first empty sample slot. Rename this material *Rainbow Glass*. Click on the Standard button next to the material name and select Raytrace from the Material/Map browser. Under the Raytrace Basic Parameters rollout, check 2-Sided and change the Transparency color setting's RGB values to 117 for each. This will make the material somewhat transparent. Set the Reflect color setting's RGB values to 42 for each. Change the Specular Level setting to 120 and the Glossiness setting to 55. On the vertical tool set to the right of the sample slots, click the icon that looks like a checkerboard. This will turn on our checker background in the sample slot (see Figure 7-13), which will allow us to see the results of the transparency, reflection, and refraction aspects of this material.

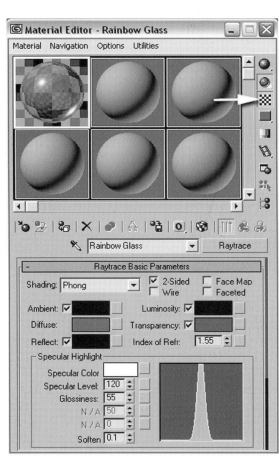

figure | **7-13**

Checker background activated.

2. Under the Maps rollout, click on the Diffuse map button. From the Material/Map browser, select Gradient Ramp. Name this map *rainbow gradient* in the material name region. Under the Gradient Ramp Parameters rollout, right click on the middle color flag at the bottom of the ramp. Select Delete from the Right-Click menu.

3. Create 7 new color flags by left clicking between the two end color flags. You should now have a total of 9 flags. Right click on the first flag on the left and select Edit Properties to adjust the flag properties. Set the RGB color and Position for each flag in the gradient. You can use the spinner to move from one flag to the next, in the order they were created. That way, you do not need to leave the dialog window. Use the following settings:

Flag 1: Color = (120, 0, 120), Position = 0
Flag 2: Color = (255, 0, 0), Position = 100
Flag 3: Color = (255, 0, 255), Position = 12
Flag 4: Color = (0, 0, 255), Position = 24
Flag 5: Color = (0, 204, 255), Position = 37
Flag 6: Color = (0, 255, 0), Position = 50
Flag 7: Color = (255, 255, 0), Position = 64
Flag 8: Color = (255, 165, 0), Position = 76
Flag 9: Color = (255, 0, 0), Position = 88

Directly beneath the newly created gradient, set the Gradient Type to Pong and the Interpolation to Ease In Out. Now to add some Noise to the gradient. Set the following Noise parameters:

Amount = 0.25 Noise Type = Turbulence
Size = 0.84 Levels = 5
Noise Threshold:
Low = 0.15 High = 0.69

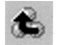

Once the noise has been set up, as shown in Figure 7-14, click on the Go to Parent button (shown at left).

4. For the second material, select another empty sample slot and name this material *Sphere Backdrop*. Make this a Raytrace material, as you did for *Rainbow Glass*. Set the Diffuse color to dark gray (25, 25, 25). Give this texture a Specular Level of 120 and a Glossiness of 55. In the Bump map channel, add a Noise map. Keep the default parameters for the noise, but change Size to 5. That's all there is to it!

figure | 7-14

Noise parameters set up.

5. Activate the *Rainbow Glass* material and assign it to the two sculpture objects. Then assign the *Sphere Backdrop* material to the sphere object.

6. Save your work.

7. At this point you can open the Render Scene window (Rendering > Render) and set Width and Height to the final output size (2,738 x 3,339). Make sure your Camera viewport is active and click on the Render button to produce your final image, shown in Figure 7-15. Once the rendering is finished (it may take awhile due to the Raytrace materials we used), click on the disk icon in the upper left of the Rendered Frame window to save the image. You can now save it as a TIFF. If you prefer, you can also use the Print Size wizard to set up your Render Scene dialog window to render out your final image for print. Either way will work.

figure | 7-15 |

Saving out the final rendering.

Final Layout

Okay, the hard part is over with. The next step is to create the final layout of the cover in a page layout program such as Adobe InDesign or QuarkXPress. We won't go into this step in detail. However, if you wanted to generate a final cover the necessary *3 Design* logo is included in the *Magazine* folder within the *Ch 7 > Projects* folder. Feel free to make up headlines and subheadings. Figure 7-16 shows what we came up with.

Congratulations on completing your first 3D design and on a job well done! Hopefully you are feeling good and are proud of your creation.

SUBSCRIBE NOW & SAVE BIG!!
Look inside for details.

3Design

3ds max 7 Unleashed!
Check out the new features.

Animator At Large
An interview with animator Steven Till

Frizzed Out?
In-Depth Ornatrix Hair Tutorial

Environmental Effects using Maya.

• Volcanic Euruption
• Tidal Wave
• Tornado
• Lightning Storm

On the CD-ROM:

| Over 1,000 tileable textures. | 10 great Maya video tutorials. | 3ds max 7 demo software. |

figure | 7-16

Final magazine layout with the final rendered image of our sculptures.

PROJECT 2: JEWELRY DESIGN VISUALIZATION

Difficulty Level: *Beginner to Intermediate*

So you just finished your first 3D illustration gig with that magazine cover and it looks spectacular. The editor at *3 Design* magazine absolutely loved it and promises other opportunities for more covers

in the future. This sounds like music to your ears, as you slowly make your way into your career as a 3D illustrator. After letting this stroke your ego for awhile, you get a phone call.

Getting the Job

You answer the phone and are surprised that the voice on the other end belongs to a fellow named "Joe" who owns a prestigious jewelry store in New York. After talking with him for a few minutes, you learn that he saw your cover design for *3 Design* and was very impressed with the quality of your work and the creative approach you used. Upon further discussion, Joe says he has been hired by a very wealthy and important client in New York to design an elegant pendant that is to be a gift for the client's wife. For another fifteen minutes or so, you and Joe discuss further details about the job and the rates and payment for the work to be done. Basically what he would like is a 3D visualization of the design that can be presented to the client. This will help Joe save a lot of time and will prevent him from having to resculpt the jewelry if the client wants any major changes to the design. You happily accept the job and begin work right away on some designs.

Planning the Pendant

Because Joe is extremely busy with other clients, he has entrusted to you the distinguished honor of actually conceptualizing the overall design of the piece, as well as the final visualization. Joe's client wanted something simple, yet elegant, with a large gemstone being the focal point of the design. You are armed with two key important pieces of information that will become very important once it's time to model the jewelry in 3ds max. The first tidbit is that the client's wife absolutely loves silver. Just about all of her other jewelry is silver. She is also a big fan of blue topaz, so it would probably be a good idea to incorporate that in the design.

For added realism in the scene, we can use what are known as high dynamic range images (HDRIs). Normal images produced by digital cameras and computer graphics are known as LDRs, or low dynamic range images. The reason they are said to have a low dynamic range is because the brightest area of the image can only go to a value of 255. HDR images, on the other hand, can go well beyond that, using luminance values that are comparable to what

we see in real life. Because of this, HDR images are an ideal way of lighting a scene. For instance, we can take an HDR image and use it as a light map within a Skylight object. The Skylight object emits the light and uses the pixel values of the HDR image to determine the intensity of the light in the scene. The result is an ultra-realistic lighting scheme that might have normally taken hours to set up with standard lighting approaches. To create HDR images, you can use a software program called HDR Shop, which is a free download. Developed at USC, it's one of the commonly used applications for HDRI creation and editing. You can find HDR Shop and its information, tutorials, and plug-ins at *www.debevec.org/HDRShop/*.

After a few hours of sketching out different designs, a prime candidate has emerged, shown in Figure 7-17. You e-mail the sketch to Joe to get his input and he replies with very positive feedback. He feels that the client would be very happy with that design and that you should run with it. Wonderful! Now we can begin.

figure | 7-17 |

Rough sketch of proposed jewelry design.

Modeling Phase

Now that there is a preconceived notion about how we're going to go about modeling this piece, it's time to start building it. You will approach this job in much the same way as you did with the

magazine cover design: build the objects, set up the lighting, and mix the materials. Okay, enough chatter, it's time to get to work.

1. Start a new Max scene and go to File > Import. For this project, we will be importing an AutoCAD DWG file created in Adobe Illustrator to use as a template for our modeling. Go ahead and import *jewel_template.dwg* from the *Ch 7 > Projects > Jewelry* folder. In the AutoCAD DWG/DXF Import Options dialog, uncheck the box next to the Combine Objects by Layer option. Click on OK.

2. Select the largest circle and name it *Ornament Path*. Select the middle circle and name it *Pendant Body*. Select the smallest circle and name that *Ornament*.

3. Select the Pendant Body and Ornament Path splines. Select and then right click on the Move Transform tool to open the Move Transform Type-In window. Set the X, Y, and Z Absolute World coordinates to the origin (0, 0, 0). This will center those splines, which will set us up for the upcoming steps, as shown in Figure 7-18. Feel free to move the Ornament spline closer to the other splines to make it easier to keep track of it.

figure | 7-18 |

AutoCAD DWF file
import setting.

4. Press Ctrl and click on the Ornament and Ornament Path splines to select them. Right click in the active viewport. In the pop-up menu, select Hide Selection to hide those two objects, in that we don't need them just yet.

5. Select the Pendant Body spline. In the Modify panel, apply a Bevel modifier to the spline. This will allow us to give the object some volume and to manipulate the mesh a bit. Enter the following settings for the bevel:

Curved Sides = Selected Segments = 2
Smooth Across Levels = Checked
Generate Mapping Coords. = Checked
Keep Lines From Crossing = Checked
Separation = 1
Bevel Values: Start Outline = -1.0
 Level 1: Height = 1.0, Outline = 1.0
 Level 2: Height = 2.0, Outline = 0.0
 Level 3: Height = 1.0, Outline = -1.0

Once the bevel has been set up, right click in the viewport and convert the object to an Editable Poly.

6. In the Modify panel, activate the Polygon sub-object mode, check the box next to the Ignore Backfacing option, and select the top surface of the pendant (it might be helpful to turn on Smooth + Highlights in the Perspective viewport). Right click on the top surface to open the Quad menu, and open the Bevel dialog by clicking on the window icon next to the bevel option. Set Bevel Type to By Polygon, set Height to -1.1, and Outline Amount to -1.26. Turn off the Polygon sub-object mode. The foundation for our pendant is complete. This piece, shown in Figure 7-19, will be the part that holds the main jewel of the necklace.

figure | **7-19**

Jewel setting of necklace.

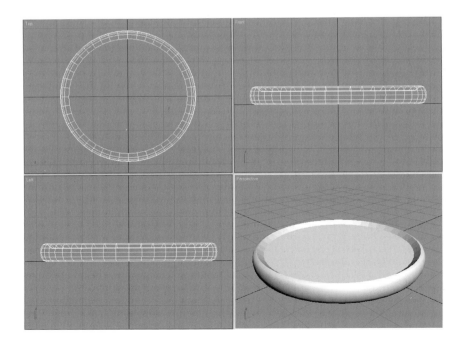

7. Right click in the active viewport and hide the Pendant object. Right click again and select Unhide by Name. Select the Ornament and Ornament Path splines from the list and click on Unhide. At this point, we're going to create the embellishments that will surround the jewel.

8. Save your work!

9. Select the Ornament spline and apply a Lathe modifier. Use the default values except for the Output setting, which should be Output = NURBS. Apply a UVW Map modifier to the lathed object and set the mapping type to Spherical. Next we're going to use the Spacing tool to copy and distribute the newly created sphere along the ornament path.

10. With the ornament still selected, go to Tools > Spacing Tool. In the dialog window, activate the Pick Path button and select the Ornament Path spline. Set Count to 47, set Context to Centers, and check the box next to the Follow option. Set the Type of Object for the clones to Instance and click on the Apply button. These settings are shown in Figure 7-20.

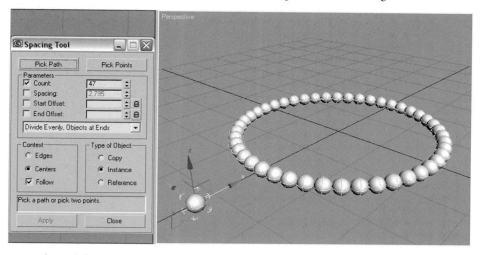

figure | 7-20

Settings for the
Spacing tool.

11. Open the Select Objects window by pressing the H key. Press the Shift key and click on *Ornaments01* through *Ornaments47*. Click on the Select button to select all of the ornaments. Group the ornaments by selecting Group > Group. Name the group *Main Trim Beads*. Right click in the viewport and hide the new group of beads.

12. Activate the Move Transform tool and select the Ornament object. Press Shift and drag the Ornament object to clone it. Set Object to Copy. Turn on the Percent Snap Toggle and using the Uniform Scale tool scale down the clone 50 percent to make it half the size of the original ornament. Name this new object *Small Ornament*, shown in Figure 7-21.

13. With the Small Ornament object selected, repeat step 10, except this time set Count to 150. Perform another Select by Name (H key). Select *Small Ornament01* through *Small Ornament150* and group them (Group > Group). Name the group *Top Trim Beads*.

figure | **7-21**

New object created.

14. In the Front viewport, select the Top Trim Beads group and open the Move Transform Type-In window. Move the group 0.9 units using Y Offset > Screen. Activate the Uniform Scale Transform tool and using the Scale Transform Type-In, type in *95* under the Offset > Screen value to scale down the bead group by 5 percent. Right click in the viewport and select Unhide by Name. Select the Main Trim Beads group and the Pendant Body object and click on Unhide. Looking pretty good so far!

15. Select the Pendant Body object and in the Hierarchy panel turn on the Affect Pivot Only button. Click on the Center to Object button. Turn off the Affect Pivot Only button. This will center the pivot point to the precise center of the object. Next, in the Move Transform Type-In setting, reset the position to (0, 0, 0) under the Absolute World coordinates.

16. To make the loop for the chain to go through, create a torus in the Left viewport with the following settings:

Radius 1 = 1.35 Radius 2 = 0.25
Segments = 20 Sides = 9

Make sure Generate Mapping Coords. is checked. Use the Uniform Scale tool on the Y axis of the transform gizmo to create an oval. Then use the Move Transform tool to position it on the pendant. Name the new torus, shown in Figure 7-22, *Chain Loop*.

figure | 7-22 |

New torus.

17. Now for the jewel. In the Top viewport, create a GeoSphere with a Radius setting of 18.0 and a Segments setting of 4. Set Geodesic Base Type to Octa, uncheck the Smooth option, and check the Hemisphere box. You can use the Keyboard Entry or the Transform Type In features to make the GeoSphere object so that the gemstone will automatically be positioned in the right spot at (0, 0, 0,). In the Left viewport, scale the GeoSphere object down to 30 percent on the Y axis to flatten it out. Apply a UVW Map modifier and set it to Spherical mapping.

18. Select all pendant objects, including the chain loop, and group these. Feel free to name it what you like. In the Hierarchy panel, turn on the Affect Pivot Only button to adjust the posi-

tion of the pivot point of the group. Using the Move Transform tool in either your Front or Left viewport, move the pivot on the Y axis to the very bottom of the pendant group. Turn off the Affect Pivot Only button and use the Transform Type-In area again to position the pendant group on the origin of the Y axis so that the group is "resting" on the origin. This will allow the pendant to rest on the ground object once we create it.

19. Save your work.

20. Activate the Top viewport and go to Shapes in the Create panel. Using your Line tool, draw out a shape for the necklace chain. Edit vertices as needed to create a nice smooth shape. Make sure the spline goes through the center of the pendant's chain loop by moving necessary vertices and adjusting the Bezier curves. Name this object, shown in Figure 7-23, *Link Path*.

figure | **7-23**

Link Path object.

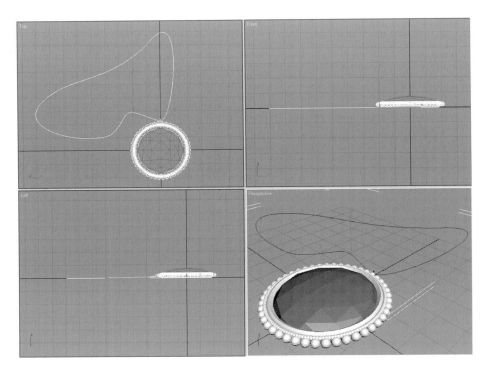

21. To make the chain links, we're going to make one and use the Spacing tool again to distribute the link along the spline you just made. In the Top viewport, create a torus and set Radius 1 to 1.25, set Radius 2 to 0.25, and give it 8 Segments and 4 Sides.

Make sure Generate Mapping Coords. is checked. Take the Uniform Scale tool and scale the new torus on the X axis to form an oval, similar to what you did with the chain loop object, but orient the oval so that it's longest along the Y axis. Then convert the torus to an Editable Poly and name it *Chain Link*.

22. Activate the Vertex sub-object mode and using a window selection select the top three sets of vertices. With the Rotate Transform tool and your Angle Snap Toggle active, rotate the selection on the Y axis -85.0 degrees, and then select the bottom three sets of vertices and rotate them on the Y axis 85.0 degrees. In the Subdivision Surface rollout, turn on Use NURMS Subdivision and set the following values:

Display: Iterations = 1, Smoothness = 1
Render: Iterations = 2, Smoothness = 1

This will give us a nice smooth appearance to the chain links, as shown in Figure 7-24.

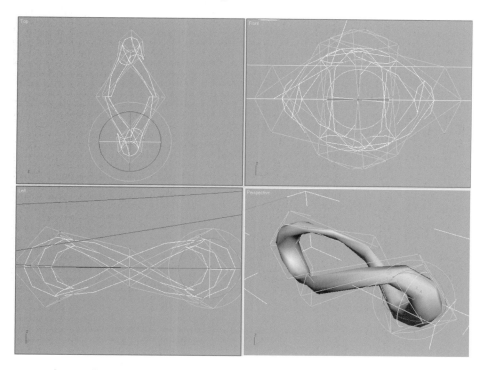

figure | 7-24

Chain links

23. You're doing great! Turn off the Vertex sub-object mode. With Chain Link selected, rotate the link 90 degrees on the Z axis in the Top viewport. Open the Spacing tool (Tools > Spacing Tool), click on the Pick Path button, and select the Link Path spline. Make sure that Centers, Follow, and Instance are checked, and then input a fairly high number for your Count value. This number will vary, depending on the length of your chain path. You may have to play with this value a bit. Our example uses a count of 300, though you may need a different value. (A high number can simulate herringbone and braided chains.) When you're happy with the results, click on the Apply button. (Note: You may need to rotate the original link on the X and/or Y axis before using the Spacing Tool for the links to follow the path appropriately.)

figure | **7-25**

Chain links spaced along the path.

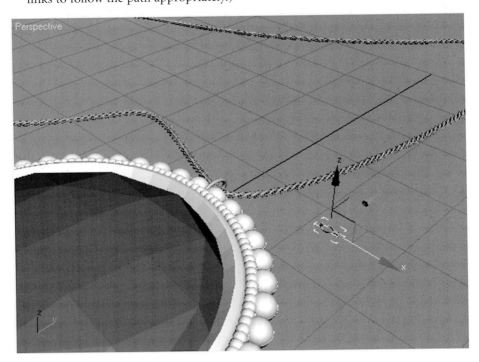

24. The last step is to create a ground plane for our necklace to rest on. In the Top viewport, create a plane approximately 300 x 300 units at a position of about (0, 0, -0.2). This will offset the ground enough for our pendant to rest on. You can move the plane on the X and Y axis in the Top viewport once you have arranged your shot in the Perspective view. In the Modify

panel, apply a UVW Map modifier to the plane and set the mapping type to Planar and set the V Tile value to 10. Name the object *Ground*. Excellent, the modeling phase is done and we can now move on to lighting and rendering setup! Feel free to rotate and position your Perspective viewport to show an interesting angle of your creation.

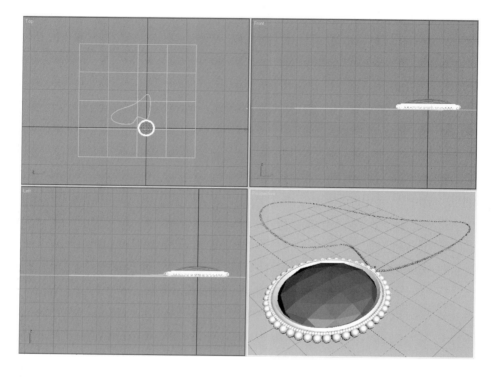

figure | 7-26

Completed model of the pendant.

Lighting and Rendering Setup

During the planning stages of this project, we talked a little bit about the use of HDR images to produce photorealistic renderings. We also decided to utilize the powerful mental ray Renderer, which will allow us to generate some very realistic lighting. Setting up the lighting in this scene will be very easy because we will be utilizing an HDR image for our environment. The way we will be approaching this is by creating a Skylight object and using the HDR image as a map within the skylight. Max will use the pixel values to determine the luminance or brightness of the lighting. This will be a big help, in that we will not need to set up additional lighting rigs, which could take some valuable production time away from us. Let's continue, shall we?

1. We first need to change the renderer from the Default Scanline Renderer to the mental ray Renderer. Go to Rendering > Render to open the Render Scene dialog. Under the Common tab, open the Assign Renderer rollout. Next to Production, click on the "…" button next to where it says *Default Scanline Renderer*. Select the Renderer dialog, select *mental ray Renderer* out of the list, and click on OK. Figure 7-27 depicts the Assign Renderer options.

2. Now we'll set up the environment. Select Rendering > Environment to open the Environment tab of the Environment and Effects window. Under the Common Parameters rollout, click on the Environment Map button. Here is where we will load our HDR image. From the Material/Map browser, select Bitmap from the list. In the Select Bitmap Image File window, select the *hdri_sim.tif* file from the *Ch 7 > Projects > Jewelry > Maps* folder.

3. Open the Material Editor (M key) and click on and drag the map channel from the Environment Map button to the first empty mate-

figure | **7-27**

Assigning the mental ray Renderer.

rial slot. Set the Method to Instance. If we need to modify the map at some point, we can make changes within the Material Editor and it will update in the Environment Map. In the

Coordinates rollout, change the Environ Mapping type from Screen to Spherical Environment. Name the material Environment HDRI. That finishes up this part. Now on to the lighting. Figure 7-28 shows the HDRI within the Material Editor.

figure | 7-28

Environment setup.

4. Go to your light objects in the Create panel and in the Top viewport create a skylight positioned to the side of your scene, as shown in Figure 7-29.

figure | 7-29

Positioning of skylight.

5. Go to the Modify panel and in the Skylight Parameters rollout click on the None button to load a bitmap. We will import the *hdri_sim.tif* file into this map channel, just as we did with the environment map. Click on and drag this map to the next empty Material Editor slot and make an instance as you did with the environment map. Again, set the mapping type to Environment and the select Spherical Environment from the drop-down list. Under the Blur offset setting, enter a value of *0.1*. Name this material *Skylight HDRI*. The material for the skylight can be seen in Figure 7-30.

figure 7-30

Skylight setup.

You're doing great. Keep up the good work! That's all there is to the light rigs. Pretty cool, huh? It still amazes us that one simple image

can generate all of the necessary illumination in a scene. Aahh, the wonders of technology! Now let's get going on these materials.

Mixing the Materials

This is where things start to get really fun. At this point all of the objects have been constructed and the lighting has been set up. Now we can begin setting up the materials that will give us that nice photorealistic render the client expects to see. Because we are using mental ray to render this project, we will use some materials that are especially suited to working with this type of rendering setup.

1. Open the Material Editor and select the empty sample slot next to the Skylight HDRI material. Name this new material Blue Topaz. Next to the material name, click on the Standard button and select *mental ray* from the Material/Map browser. Under the Material Shaders rollout, click on the map channel next to Surface and select a Glass (lume) shader from the Material/Map browser.

2. In the Glass (lume) Parameters rollout, set the Surface Material color to White and give the Index Of Refraction a value of 1.61. Check the box next to Lights and add the skylight to the lights list by clicking on the Add button and then selecting it in the viewport. Refer to Figure 7-31.

figure | 7-31 |

Setting up the refraction index.

Refraction Index

Different gemstones have specific surface qualities unique to each gemstone. One of these is the index of refraction, which is the value assigned to how the gem refracts and bends light after it has passed through the surface of the jewel. The following are IOR (index of refraction) values for some of the common gemstones. If you want to customize your pendant by using a different type of stone, use these IOR values.

Amethyst/quartz = 1.54	Diamond = 2.147
Emerald = 1.57	Glass = 1.44 – 1.68
Opal = 1.45	Peridot = 1.67
Ruby/sapphire = 1.77	Topaz = 1.61
Tourmaline = 1.62 – 1.65	Zircon = 1.94

These IOR values are very important, especially if you are designing a piece for a jeweler to work from.

3. Click on the small box next to the Diffuse color swatch and add a Falloff map. Name this map *refraction mix*. Click on the Swap Colors/Maps button to switch the order of the colors. Change the white color swatch to the RGB values 85, 100, and 255 to make a nice blue for our topaz. Set Falloff Direction to Object.

4. In the map channel next to the black color swatch, add a gradient ramp. Under the Gradient Ramp Parameters rollout, right click on the middle color flag and delete it. Set the Gradient Type option to Normal and the Interpolation option to Solid.

5. Click on the gradient preview area to add color flags between the two end flags. Add a total of seven (7) new flags. Right click on the first flag on the left and open the flag's properties. Using the number spinners next to the flag name, cycle through each of the new flags and set the Position and Color options for each. Use the following position and RGB values:

Flag 1: Color = (175, 0, 255), Position = 0
Flag 2: Color = (0, 0, 0), Position = 100
Flag 3: Color = (105, 0, 255), Position = 40

Flag 4: Color = (0, 0, 255), Position = 45
Flag 5: Color = (0, 185, 0), Position = 50
Flag 6: Color = (255, 255, 0), Position = 55
Flag 7: Color = (255, 155, 0), Position = 60
Flag 8: Color = (255, 0, 0), Position = 65
Flag 9: Color = (255, 255, 255), Position = 70

figure | 7-32

Control points
established.

Name this gradient ramp map *refraction colors* and click on the
Go to Parent button to return to the Falloff map parameters.

6. In the Falloff setting's Mix Curve rollout, add two new control
points and move them to the positions shown in Figure 7-32.

In the right-hand set of Material Editor tools, activate the Background button (the Checkerboard icon) to turn on the background in the sample slot, which will show us how the final material will behave in terms of reflection, transparency, and so on. Select the pendant group and ungroup it. Select the jewel object and apply the Blue Topaz material to it.

7. Pick an empty material slot and name this new texture Wood Base. Leave the material type to Standard and keep the Blinn shader. Set Specular Level to 90 and Glossiness to 75. In the Maps rollout, add a bitmap in the Diffuse Color channel. Load the *lightwood01.bmp* image into the channel and click on Go to Parent to return to the Maps rollout. Click on and drag the Diffuse Color channel to the Bump channel and select Instance. Set Bump Amount to 20. In the Reflection map channel, add a raytrace map and use the default settings. Click on the Go to Parent button and set Reflection Amount to 10. Turn on the Background button in the Material Editor to activate the sample slot background. You can also activate the Show Map in Viewport button if you like. Apply this new wood material to the Ground object. Figure 7-33 shows the reflection setup.

8. Select a new material slot and name this *Silver*. Click on the Standard button and change the material to a *mental ray* material. In the Surface map channel, select Metal (lume) from the Material/Map browser and keep the default settings. Figure 7-34 depicts the new silver material.

figure | **7-33**

Reflection map added.

figure | 7-34 |

Silver material added.

figure | 7-35 |

New material added for the *Top Trim Beads.*

Apply the finished Silver material to the chain (you can group the chain links if you like), Chain Loop object, Main Trim Beads group, and Pendant Body object. We'll create one last material for the top trim beads.

9. Choose an empty sample slot for the last material. Name this texture Top Trim Black. Use the default Blinn shader and set Diffuse and Ambient to black. Set Specular Level to 125 and Glossiness to 55. In the Maps rollout, add a Metal (lume) shader in the Reflection channel. Leave the Metal (lume)

Parameters at their default. Activate Go to Parent to get back to the Maps rollout and set Reflection Amount to 75. Apply this material to the Top Trim Beads group. Figure 7-35 shows the new material added in the editor.

The necklace is looking really nice. The materials have been mixed and applied to the model. We're in the home stretch here. There are just a few odds and ends we need to take care of before we put this job to rest. Now you need to set up a camera and finish up with the rendering setup.

1. Activate your Perspective viewport and make sure you have the view framed for your final shot. Once you've framed your shot, go to Views > Create Camera From View to generate a camera from your Perspective view angle, as seen in Figure 7-36.

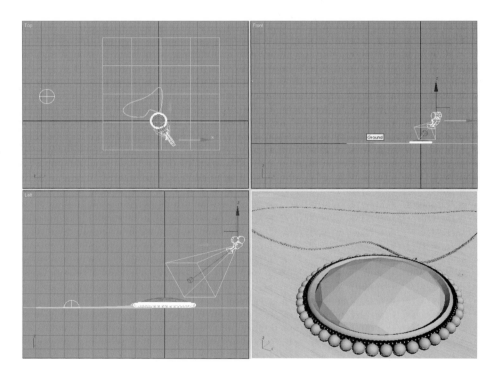

2. The next thing you need to do before you render out the final image is to adjust the exposure of your shot. Open the Environment tab of the Environment and Effects window by going to Rendering > Environment. Under the Exposure Control rollout, select Logarithmic Exposure Control. Check

figure | 7-36

Final camera shot.

the box next to Process Background and Environment Maps. Under the Logarithmic Exposure Control Parameters rollout, check the box next to the Exterior daylight and click on the Render Preview button. Adjust the Exposure Control values until you're satisfied with the results.

3. In the Common tab in the Render Scene window (Rendering > Render), set Output Size to 1024 x 768. Make sure your camera viewport is active, and then click on the Render button. Figure 7-37 shows the final render of the pendant and necklace.

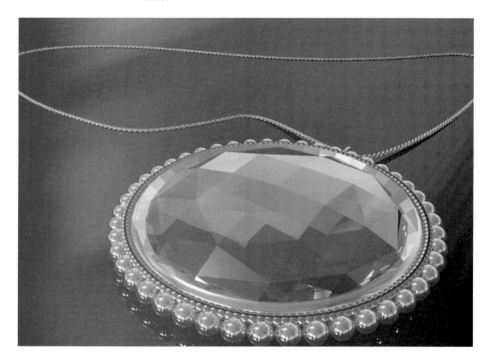

figure | 7-37

Final render of pendant and necklace.

Fantastic! This piece definitely looks great. Joe is ecstatic at the quality of the render and he later tells you that his client raved about how wonderful the design was. It looks like you were able to impress the right people on this job, because both Joe and his client plan on referring you to others they come in contact with. A big career booster indeed! Now would be a great time to take a breather and catch your wind. You have a feeling you might be getting another call soon.

PROJECT 3: ARCHITECTURAL VISUALIZATION

Difficulty Level: *Intermediate*

Sure enough, no sooner did you sit down to enjoy a great movie on television than you heard your telephone start ringing your name. On the other end of the line was a woman who we'll call Diana, who was in the final stages of finishing her final project for her architectural degree. She contacted you to see if you would be able to help her out with an architectural visualization of her blueprint. Since she's willing to pay, you happily agree. Looks like that movie will have to wait.

Getting the Job

After chatting for some time, you come to find out that it's a rather simple design, which shouldn't take too much time to complete. The concept deals with a partial outdoor/indoor scene. For all intents and purposes, the design is very sparse and utilizes a very simple form. This is music to your ears because the simpler the forms the faster this job will go. Diana tells you that she will send over an AutoCAD DWG file that shows the rough layout of the scene, which is perfect because this will allow you to expand on the diagram to form the scene objects. She also tells you that it is not necessary to put materials on the structure, although you will probably apply some basic textures anyway because you're such a nice person. Diana explains that this space is to be open to the outside to keep it "airy." All of the lighting will utilize natural sunlight. This sounds like it's going to be a really nice piece. She goes on to say that the structure will be predominantly made of cement to withstand the elements. This will make texturing even easier than you initially thought. Because you have the DWG file, we can go ahead and get started right away.

Building the Building

In the following exercise you will create an architectural model.

1. In a new max scene (File > Reset), go to File > Import and select *blueprint.dwg* from the *Architecture* project folder in the *Ch 7 Projects* folder. Accept the default import options. You should now see the floor plan depicted as splines in your viewports. Select all splines and group them (Group > Group).

With the Move Transform Type-In tool, set the position to the origin (0, 0, 0). Once at the origin, ungroup the objects (Group > Ungroup). Feel free to turn off your grids if it would make things easier to see.

2. Select each spline and name each. See Figure 7-38 in regard to naming. You might also want to color code certain objects to make it easier to keep track of what goes on in the viewports.

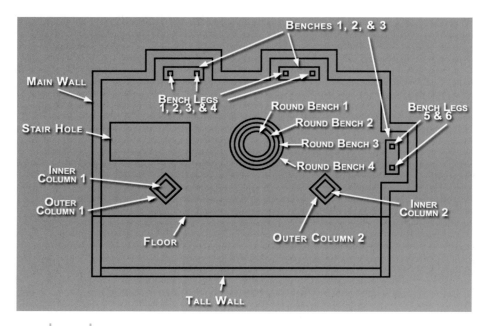

figure | 7-38

Object names in floor plan.

3. Select the Main Wall spline. In the Modify panel, apply an Extrude modifier. Set Amount to 39.0. Make sure the Generate Mapping Coordinates box is checked.

4. Select the two Inner Column objects. Apply an Extrude modifier with an Amount value of 39.0 to these as well. Then select the two Outer Column objects and apply the Extrude and set the Amount to 33.0. With both Outer Columns still selected, open the Move Transform Type-In option within the Top viewport and give the columns a Z Offset > Screen of 3.0.

5. Select all of the Bench Leg objects. Extrude them an Amount of 4.0. Select Bench 1 through Bench 3 and Extrude by 4.0 as well, but then set Z Offset > Screen in the Top viewport to 4.0 units to make them "rest" on the bench legs.

6. Select Round Bench 2 and in Modify panel turn on the Attach button under the Geometry rollout of the Editable Spline settings. With the Attach button active, select the Round Bench 3 object. Turn off Attach and now apply an Extrude and set the Amount to 3.0. Rename this object *Round Bench Base*.

7. Repeat step 6 with Round Bench 1 and Round Bench 4, using the Attach feature to combine the two objects into one. Give this an Extrude of 5.0 and a Z Offset > Screen in the Top viewport of 3.0. Rename this object *Round Bench Top*. Figure 7-39 shows our progress so far.

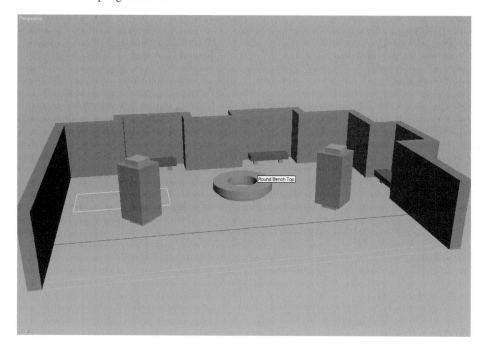

8. In the Top viewport, select the Floor object and in the Front viewport clone the Floor spline by holding down the Shift key and dragging the spline along the Y axis with the Move tool. Set the clone type to Copy. In the Move Transform type-in, set the Z coordinates in the Absolute > World selection to 39.0. Rename this object *Ceiling* and apply an Extrude modifier. Set Amount to 3.0

9. Save your work!

10. Select the Floor object again and apply an Extrude modifier. Set Amount to -10.0. Convert the mesh to an Editable Poly

figure | 7-39

Progress on the room thus far.

and turn on the Polygon sub-object mode. Select the entire bottom surface of the floor and use the Extrude Polygons dialog to extrude by Group 3.0 units.

11. Pick the bottom front polygon and extrude it 44.5, as shown in Figure 7-40.

12. Select both sides of this new extension. Extrude the selection By Polygon 100.0 units, as shown in Figure 7-41.

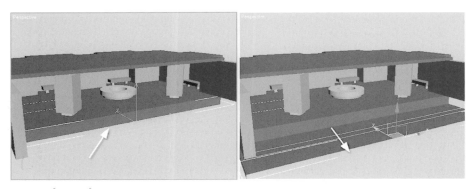

figure | 7-40

Extrusion of front polygon.

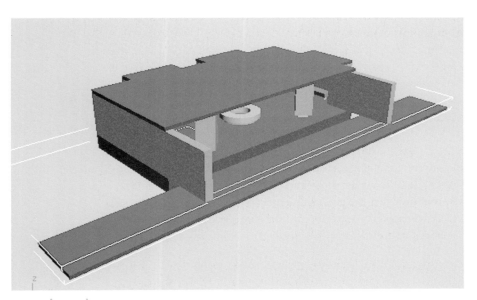

figure | 7-41

Extrusion using By Polygon.

13. We're going to do the same thing with the Tall Wall object. Turn off your Polygon sub-object mode, select the Tall Wall and apply an Extrude modifier with an Amount of 75.0. Convert it to an Editable Poly and activate the Polygon sub-object mode. Select the bottom polygon and use the Extrude Polygons dialog to extrude it 10.0 units. Select the two lower end polygons on the newly extruded section and extrude 110.0 units, as shown in Figure 7-42.

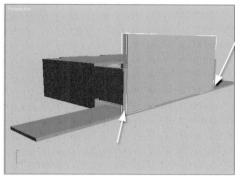 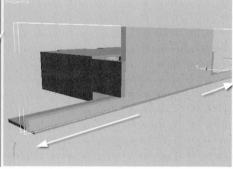

14. Save your work!

figure | **7-42**

At this stage, we're ready to cut the hole in the ceiling that will give us access to the staircase that will lead to this architectural space. After looking at the floor plan that Diana gave you, you notice that the only other openings, aside from the areas by the Tall Wall, is the hole for the stairs. Keeping this in mind, you realize that this might not let enough light into the structure to illuminate it enough. You remember from your previous conversation that she said she wanted this structure to feel very open, yet still have some enclosure to it. You give Diana a call and express this concern to her. She immediately agrees with you and is a bit embarrassed that she overlooked such a detail. She suggests creating a shape like a star or something to create some interest. You agree that this would create a very artistic feel to the overall structure and tell her that you will make the necessary adjustments to the design. After many thanks, she hangs up to leave you to your work.

Extrusion of end polygons.

15. Originally, the "stair hole" shape was to be cut from the ceiling. Now we need to make a star shape that Diana was describing. In the Top viewport, select all of the objects at this point, except the Stair Hole shape. Freeze the selection by right clicking in the viewport and selecting Freeze Selection from the

display quad menu. Go to Shapes in the Create panel and turn on the Star shape. Somewhere to the right of the stair hole, create a star, similar to the one depicted in Figure 7-43. In our example, we made a star with the following parameters:

Radius 1 = 47.25 Radius 2 = 26.5 Points = 7

figure | 7-43

Star shape that will
be cut out of the
ceiling.

16. Select both the Stair Hole shape and the newly created Star object. Apply an Extrude modifier to the selection and set Amount to 20. In the Front viewport, move the selection on the Y axis until the objects pass completely through the ceiling. Select either the Stair Hole object or the Star and convert the selection to an editable poly. Turn on the Attach button and select the other object to combine them. Unfreeze the objects in the scene, and then select the Ceiling object and convert it to an editable poly.

17. With the Ceiling object selected, go to the Create panel and under Geometry select Compound Objects under the drop-down list. Click on the Boolean button. Use the Subtraction A-B operation and click on the Pick Operand B button, as seen in Figure 7-44.

18. With the Pick Operand B button active, select the star and box object that is intersecting the ceiling. You should now see some nice holes in your Ceiling object, as shown in Figure 7-45. This should let plenty of light into the structure.

figure | 7-44

Boolean operation used to cut shapes from the ceiling.

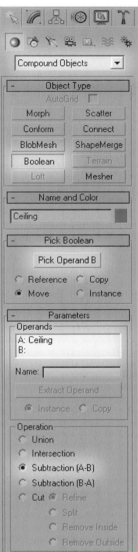

19. We now need to build some stairs so that people can populate this space. For this we will use the built-in stair system in 3ds max. Go to Create > Geometry > Stairs then click on the Straight Stair button. In the Top viewport, click and drag from right to left of the stair hole, starting the click just beyond the lower right of the hole. Release the mouse and move up to create the width of the stair-case. Make sure to set the width to that of the hole. Click again to give the stairs height. Pull them up until the top step is level with the top of the ceiling. Figure 7-46 shows you the completed stairs and the settings we used.

20. The last thing we need to build is the water that flows through the "channel" by the tall wall. In the Top viewport, create a plane with the following set-tings:

Length = 40.0 Width = 413.0
Length Segments = 6 Width Segments = 35
Render Multipliers: Density = 5.0

Make sure Generate Mapping Coordinates is checked.

figure | 7-45

Holes in Ceiling object.

Completed stairs.

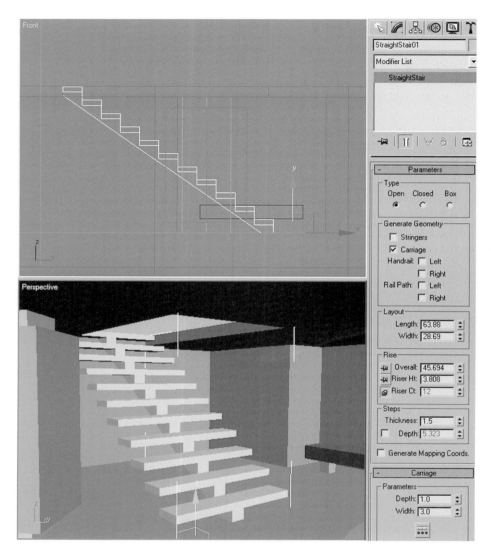

figure | 7-46

Holes in Ceiling
object.

Position the Plane inside the channel and then apply a Noise
modifier to the plane with the following parameters:

 Scale = 15 Z Strength = 3.0

Name the plane *Water*. Move the plane down in the World Z
so that the top of the wave's crests don't go higher than the
floor object.

21. Save your work!

Things are looking very good so far. This wraps up the modeling
phase of this project. Next we'll set up the lighting.

Lighting and Rendering Setup

Because Diana wants the rendering to be seen in sunlight, in the following exercise we're going to set up a two-light rig. The first light will be a Target Direct light to simulate the sunlight, and the second light will be a Skylight object to "fill out" the remaining illumination and add realism to the final renders. You should note that 3ds Max does come with a Daylight system that would produce the same effect. It is primarily used by architects to accurately depict architectural renderings by assigning a precise location on the Earth and a specific time of day. Although this is a neat feature, it can be a bit cumbersome to use. Most of the time, the Direct light and Skylight setup is used in general animation and modeling projects due to the more flexible approach. Once the lighting rig has been set up, we'll use the Light Tracer advanced lighting calculations to help us generate our final render.

1. Activate the Top viewport and go to Create > Lights > Standard > Target Direct. Drag the light so that it shines down and to the right of our scene. Move over to the Front viewport and pull it up above the scene. In the Modify panel, set the following parameters for the Direct light:

 Shadows = On Shadow Type = Ray Traced Shadows
 Multiplier = 1.75 Color = (255, 247, 200)
 Under the Directional Parameters rollout:
 Overshoot = Checked
 Set the Falloff/Field value so that the falloff envelops the entire scene.
 Under the Shadow Parameters rollout, make sure the Density setting is 1.0.
 Under the Ray Traced Shadow Parameters rollout, check 2 Sided Shadows.

2. Go to Create > Lights > Standard > Skylight. In the Top viewport, click off to the side of your geometry to place the skylight object. The precise placement doesn't really matter because it emits the light globally in the scene as if there were a big dome over everything. Just to keep things organized and tidy, we placed ours up by our direct light just to keep the light rig all together. It's entirely up to you whether you do this or not. Figure 7-48 depicts the newly created skylight object. In the Modify panel, set the following parameters for the skylight:

 Multiplier = 0.75 Sky Color = Use Scene Environment

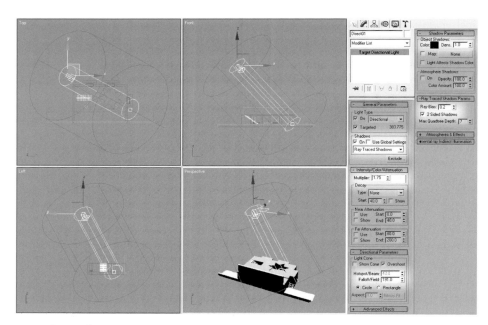

figure | 7-47 |

New direct light added to the scene.

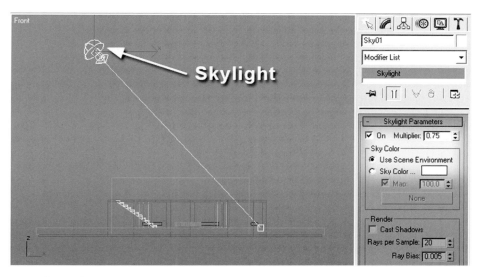

figure | 7-48 |

Skylight setup.

3. That's it for the lighting rig. We now have to set up the light tracer, but before we do that we need to change the renderer from mental ray back to the Default Scanline Renderer. Once you have switched back to the Default Scanline Renderer, you may now proceed to the light tracer setup. Go to Rendering > Render to open the Render Scene window. In the Advanced Lighting tab, select Light Tracer from the drop-down list. We'll use the default settings except we're going to change the Bounces value to 1. We also assigned a flat white material to all of the objects in the scene to better read what the lighting will do in the scene when we set up the rendering and environment settings. We also oriented our Perspective view to depict the scene from within the structure, as seen in Figure 7-49.

4. Now to set up the environment. Go to Rendering > Environment to open the Environment tab of the Environment and Effects window. In the Background region, click on the Environment Map button and select Bitmap from the Material/ Map browser. Import the *sky.jpg* image into the Environment map channel.

figure | **7-49**

Light Tracer setup and new scene orientation.

5. Under Exposure Control, select Logarithmic Exposure Control from the drop-down list. Check the box next to Process Background and Environment Maps. Check the boxes next to Affect Indirect Only and Exterior daylight. Click on the

Render Preview button and once you see the thumbnail of your scene (the Perspective viewport would be good) adjust the Brightness and Contrast settings to your liking. We used the following values for our render:

Brightness = 102.1 Contrast = 93.3 Mid Tones = 2.38
Physical Scale = 740.0

Voilà! The advanced lighting and exposure control is all set up, as shown in Figure 7-50. If you like, you can perform a test render of the scene so far by clicking on the Quick Render button.

6. Save your work!

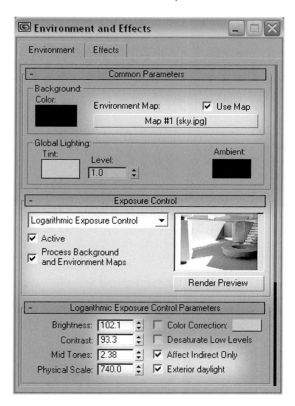

figure | 7-50

Advanced lighting and exposure control set up.

Nice. Now all of the lighting and rendering parameters have been set up. The next phase will take us into materials. Although Diana said they weren't necessary, we thought it would be an added touch to at least add some basic materials to give the viewer a better idea as to what type of structure this will be. We won't need to build too many textures because the structure is predominantly concrete.

Material Creation and Application

Alright, we already know that we need to mix some concrete for most of the building. We also need to create some basic water for the water object in the channel. It might be a nice touch to give the stairs a texture other than concrete. This doesn't have to be a completely drab place after all. Let's see what we can come up with.

1. Before we even touch the Material Editor, we strongly advise you to apply UVW Map modifiers on all objects before we

apply textures to them. This is necessary as it will allow us to control the placement of the textures more precisely than the Generate Mapping Coordinates option will allow us to do. For the staircase, however, it would probably be easier to check the Generate Mapping Coords box.

2. Once that is done, open the Material Editor (M key). Open up the Environment tab of the Environment and Effects window as well (8 key). Click on and drag the *sky.jpg* Environment Map to the first sample slot and make it an instance. This will allow us to make adjustments to the sky if we need to.

3. Save your work!

4. Select another empty sample slot and name this material *Water*. Click on the Standard button to change the material type to Raytrace. Under the Raytrace Basic Parameters rollout, set the following parameters:

Diffuse = (100, 105, 255)
Transparency = (102, 102, 102)
Reflect = (67, 67, 67)
Specular Level = 120
Glossiness = 60
In the Bump channel, add a Noise map with the following parameters:
 Noise Type = Fractal
 Size = 18.0
Go ahead and apply the Water material to the water object, as shown in Figure 7-51.

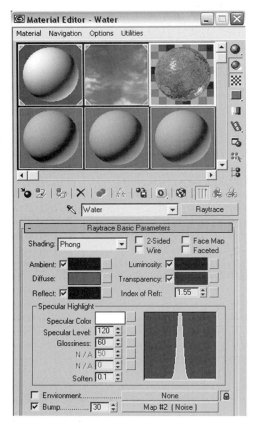

5. Select the next empty slot and name it *Concrete Light*. Use the default Blinn shader and set Specular Level to 0 and Glossiness to 10. In the Maps rollout, click on the Map button in the Diffuse Color channel and select Bitmap from the Material/Map browser. In the Select

figure | **7-51**

Water material applied to water object.

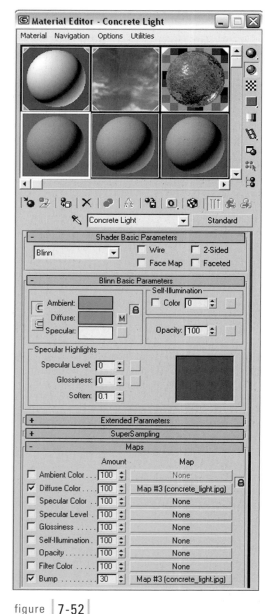

figure | 7-52 |

Cloning the map to the Bump channel.

Bitmap Image File window, select the *concrete.jpg* image from the *Maps* folder in the *Architecture* folder. Click on the Go to Parent button to get back to the Maps rollout. Click on and drag the map down to the Bump channel and make an instance of it, as in Figure 7-52.

6. Click on and drag the Concrete Light material to the next slot over to duplicate it. Rename this new material *Concrete Dark*. Leave all of the shader parameters as is. In the Maps rollout, click on the Diffuse Color map. Under the Bitmap Parameters rollout, click on the bitmap's file path and in the Select Bitmap Image File window select the *concrete_dark.jpg* file from the *Maps* folder, as seen in Figure 7-53. By swapping out the image in the Diffuse Color channel, the Bump channel will also update because it's an instance of whatever the Diffuse Color is.

7. Apply the Concrete Dark material to all of the bench legs, round bench base, and the two inner columns. Select the Ceiling object and in the Modify panel set the U and V tile settings to 10.0. Apply the Concrete Light material to the Ceiling object.

8. Select the two outer columns and apply the Concrete Light material to them as well. Select the Main Wall object and under the Parameters Rollout set the U tile option to 4.0 and keep the V tile option at 1.0. Go ahead and apply the Light Concrete material to it.

9. Select the Tall Wall object and set the U tile option to 38.03 and the V tile option to 8.0. In the Material Editor, select the next open sample slot and name it *Orange Hex Tile.* Set Specular Level to 25 and Glossiness to 25. In the Diffuse Color map channel, select Bitmap from the Material/Map browser and open the *orangeHexTile.jpg* file from the *Maps* folder. Click on the Go to Parent button to return to the Maps rollout. In the Bump channel, select Bitmap again and bring in the *orangeHexTile_bump. jpg* file. Click on the Go to Parent button. Change Bump Amount to 40 and apply the material to the Tall Wall object. Figure 7-54 shows the newly created Orange Hex Tile.

10. We are almost there. Save your work!

11. Select the next empty material slot and name it *Bench Wood Square.* Change Specular Level to 20 and Glossiness to 45. In the Diffuse Color map channel, select Bitmap from the Material/Map browser and select *wood.jpg* from the *Maps* folder.

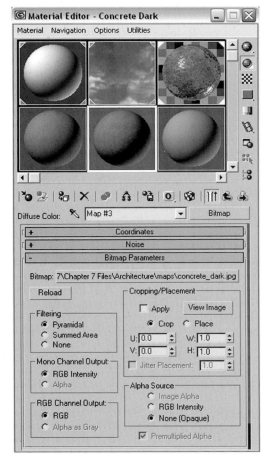

figure | **7-53**

New concrete material.

Click on the Go to Parent button and drag the Diffuse Color map to the Bump map channel and make it an instance of the Diffuse Color map, just as you did with the concrete. Set Bump Amount to 40. On each of the Bench objects, set the U tile option to 2.15 and keep the V tile option at 1.0. Apply the new Bench Wood Square material to all of the benches.

12. Find an empty material slot and name it *Bench Wood Round.* Set Specular Level to 20 and Glossiness to 45, just like the other wood material. In the Diffuse Color map channel, select

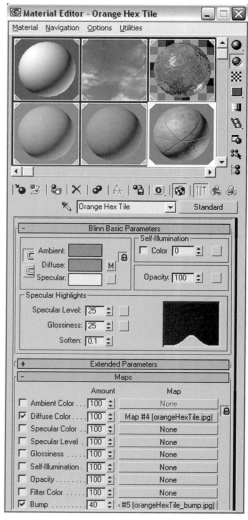

figure 7-54

New hex tile material.

Bitmap from the Material/Map browser and open *wood2.jpg*. Click on the Go to Parent button, drag the Diffuse Color map to the Bump map channel, and make an instance of the Diffuse Color map. Set Bump Amount to 20 and apply the material to the Round Bench Top object.

13. Select the Floor object and set the U tile value to 11.5 and the V tile value to 3.95. Pick a blank material slot and name it *Colored Floor Slate*. Set Specular Level to 35 and Glossiness to 5. In the Diffuse Color map channel, select Bitmap from the Material/Map browser and load the *redtile.jpg* file. Click on the Go to Parent button and then load a bitmap into the Bump channel. From the Select Bitmap Image File window, select the *redtile_bump.jpg* image. Click on the Go to Parent button and set Bump Amount to 20. Apply the Colored Floor Slate material to the Floor object as seen in Figure 7-55. Don't forget that if you want to see your textures in your viewports you must activate the Show Map in Viewport button for each material. It would also be a good idea to enable the viewport Texture Correction feature as well (Right click on the viewport name to access this feature.).

14. Now for the last material. Find an empty material slot and name it *Stair Metal*. Set Specular Level to 165 and Glossiness to 75. In the Diffuse Color map channel, load the *metal_plate.jpg* file and in the Coordinates rollout of the bitmap set the U tiling option to 2 and the V tiling option to 1.5, as in Figure 7-56.

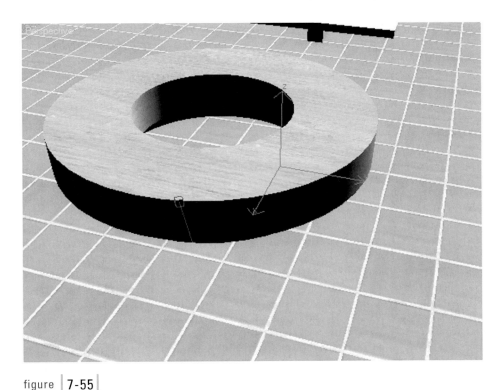

figure | **7-55**

New floor material applied to the floor object.

15. Once the tiling of the bitmap has been set, click on the Go to Parent button, drag the Diffuse Color map to the Bump map channel, and make an instance of the Diffuse Color map. Apply the Stair Metal material to the staircase.

16. At this stage the materials have all been created and applied to all objects in the scene. If you like, you can set up a couple of cameras and render out a variety of angles of the new structure. Figure 7-57 shows some possible angles that might be interesting.

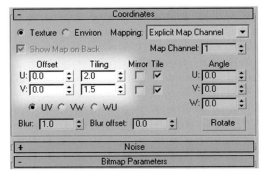

figure | **7-56**

Stair metal tiling.

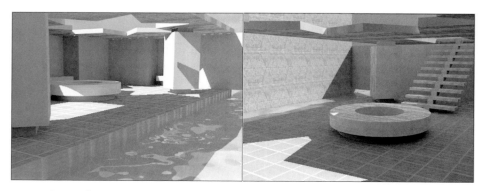

figure | 7-57

Final camera renderings of the architectural form.

Excellent job! After submitting the renderings to Diana, you receive a phone call from her. She is absolutely ecstatic at how nicely they turned out. According to her, the project was a big success with her professors, who gave the design a stellar review. She was particularly impressed with the fact that you applied materials to the scene. After a nice conversation with her, you hang up the phone knowing that she will more than likely recommend you for other jobs in the future. Now you can finally go back to that movie you've been dying to watch!

SUMMARY

In this chapter you were exposed to some design scenarios you could realistically come into contact with in the industry, whether it be as a freelance artist or as a designer within a design firm. Throughout the projects you just completed, you have applied many of the techniques you learned in previous chapters, and have incorporated new techniques in modeling, texturing, and lighting.

Hopefully you are feeling more comfortable within the 3ds max 7 environment and are starting to have some fun with it. As a design tool, max 7 can become a tremendous asset to your design arsenal, empowering you to produce rich, photorealistic (or nonphotorealistic) designs. It basically all comes down to patience and perseverance when learning this type of software, as is the case with most software on the market.

As you might have gathered, there is definitely a lot to this software and we were only able to scratch the surface of what 3ds max 7 can do within the few pages of this book. Luckily there is a vast amount of resources pertaining to 3ds max on the Internet as well as in print. The best advice we can give you if you wish to become truly proficient with 3D design is to read more books, do more tutorials, visit more 3D message boards, and just play in the software as much as you can. This is an exciting field that holds many opportunities for artists like you, who are hungry to create stunning imagery and designs. We sincerely hope you have enjoyed our introductory tour of 3ds max 7 and that you are able to walk away with a sense of satisfaction and pride with what you have accomplished here. It has truly been a pleasure for us to accompany you as you started your journey into the art of 3D modeling and design.

1. Name two rendering engines available in 3ds max 7.

2. What is NURMS and why is it useful in modeling?

3. Describe some possible uses for the Spacing tool.

4. What are HDR images and what are they used for?

5. Describe how to match a camera to a viewport.

6. Describe two ways one could simulate sunlight in a scene.

↗ EXPLORING ON YOUR OWN

1. Now that you have had a chance to build the projects in this chapter, try customizing aspects of the projects, such as creating a different type of material for the sculpture in project 1 or changing the color and index of refraction of the jewel in project 2. If you're ambitious, try constructing different objects of your own and placing them in the scene.

2. Experiment more with HDRI rendering and mental ray. Feel free to download HDR Shop and try your hand at making your own HDR images for use in your scenes.

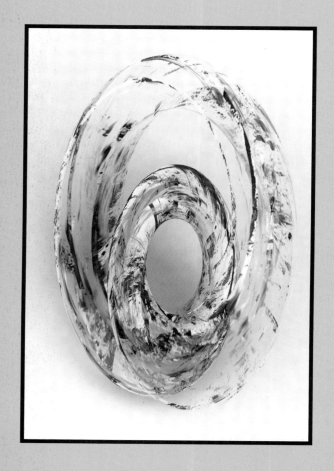

| index |

index